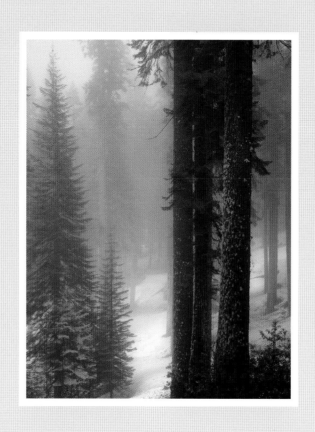

THE NATIONAL PARKS
OF THE UNITED STATES

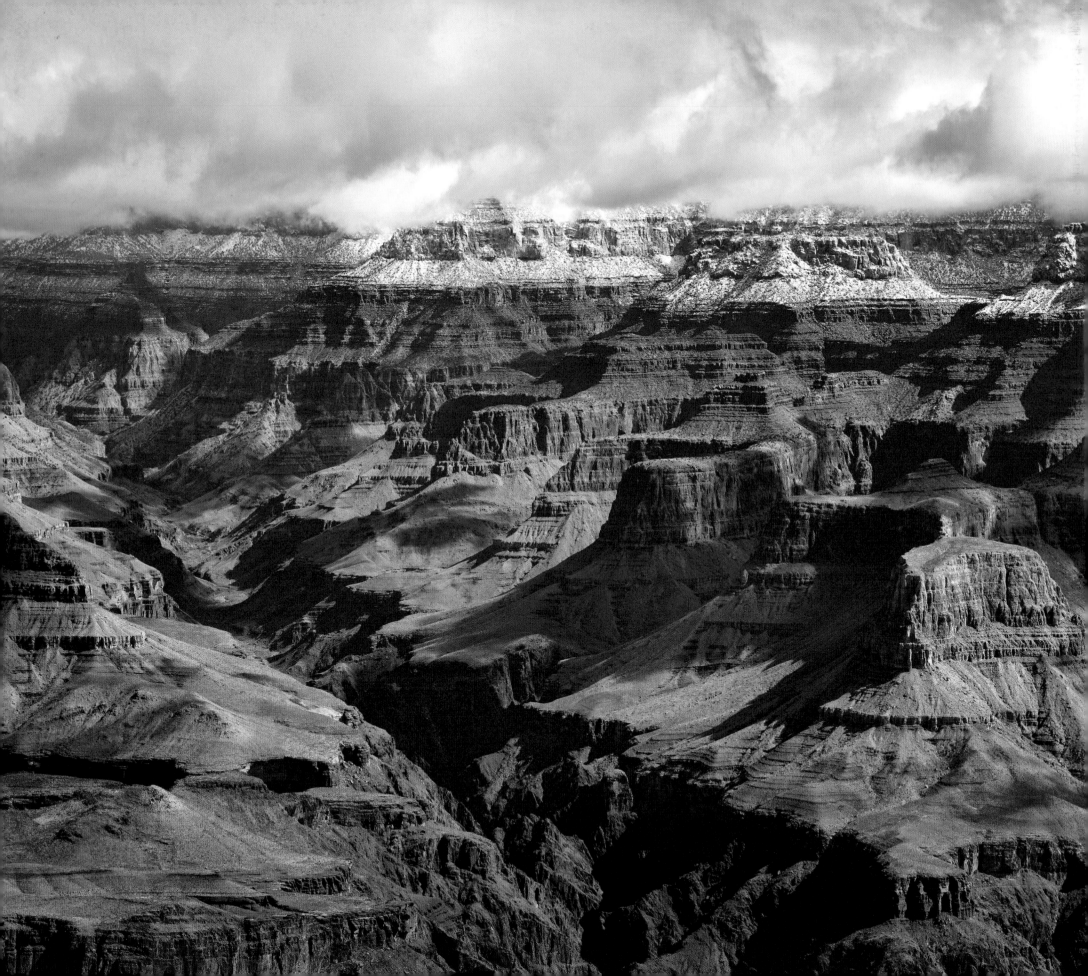

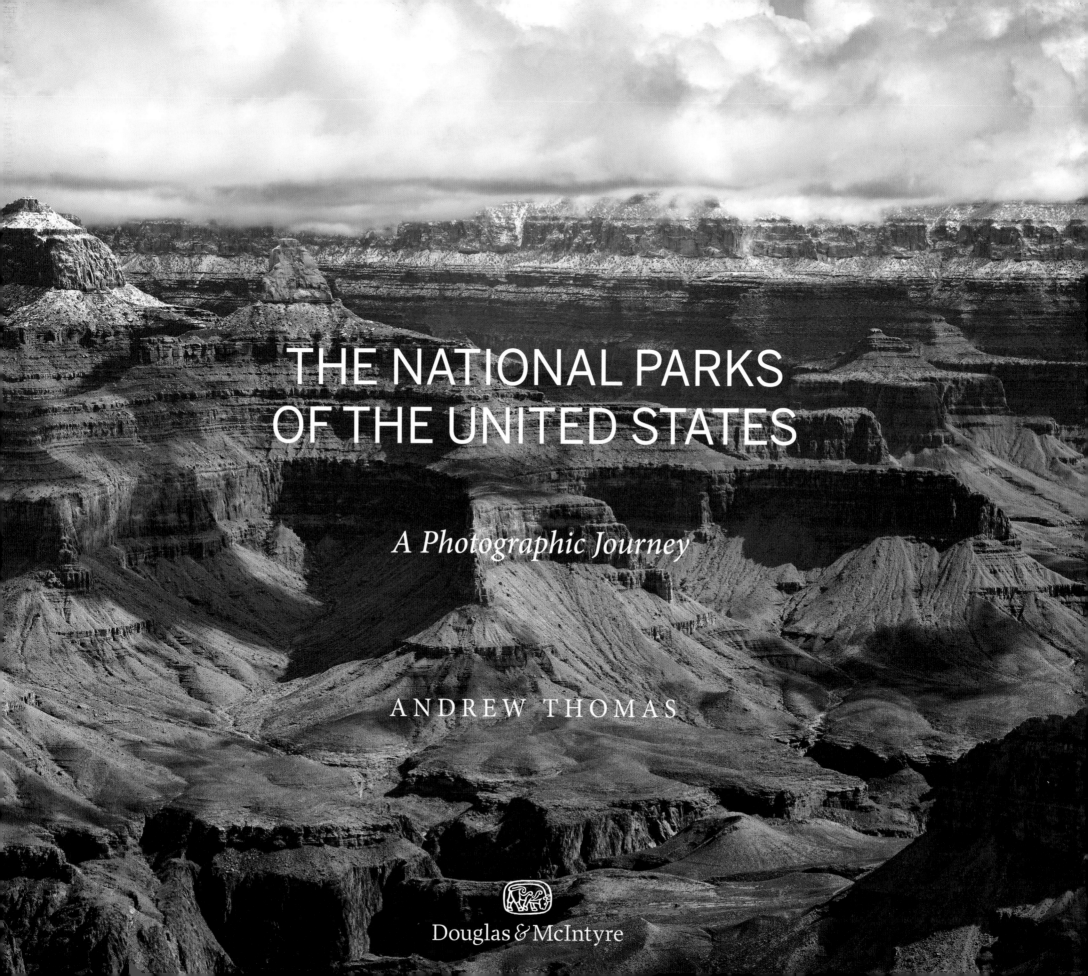

THE NATIONAL PARKS OF THE UNITED STATES

A Photographic Journey

ANDREW THOMAS

Douglas & McIntyre

Douglas and McIntyre (2013) Ltd.
P.O. Box 219, Madeira Park, BC V0N 2H0
www.douglas-mcintyre.com

Dust jacket and text design by Andrew Thomas
Printed and bound in China

BRITISH COLUMBIA
ARTS COUNCIL
An agency of the Province of British Columbia

Canada Council Conseil des arts
for the Arts du Canada

Canada

Douglas and McIntyre (2013) Ltd. acknowledges the support of the Canada Council for the Arts, which last year
invested $157 million to bring the arts to Canadians throughout the country. We also gratefully acknowledge financial
support from the Government of Canada through the Canada Book Fund and from the Province of British Columbia
through the BC Arts Council and the Book Publishing Tax Credit.

Cataloguing data available from Library and Archives Canada
ISBN 978-1-77162-121-2 (cloth)
ISBN 978-1-77162-122-9 (ebook)

CONTENTS

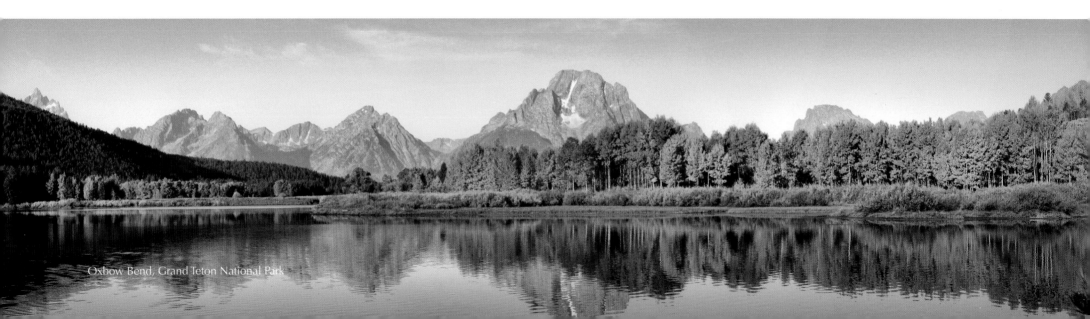

Oxbow Bend, Grand Teton National Park

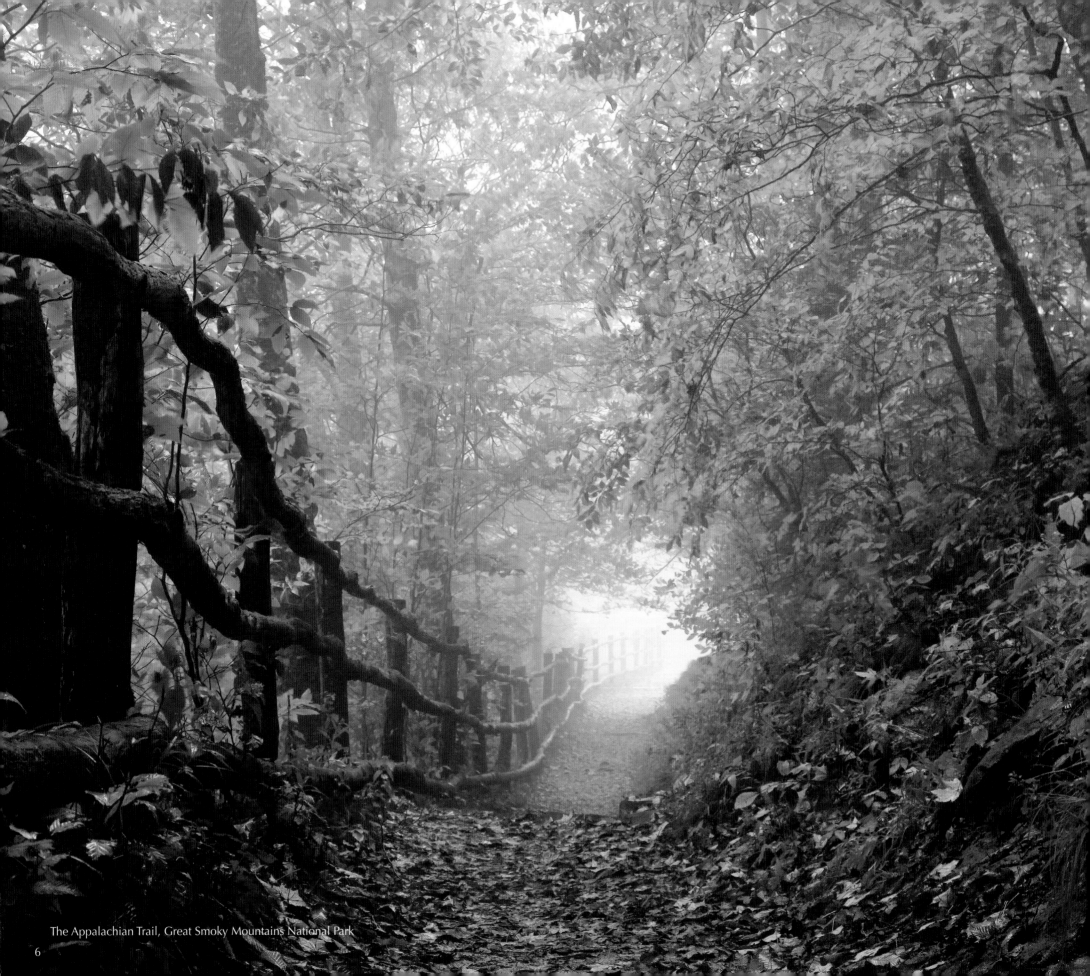

The Appalachian Trail, Great Smoky Mountains National Park

The first national park in the world became a reality on March 1, 1872, when President Ulysses S. Grant signed the legislation that created Yellowstone National Park in Montana and Wyoming. This was a brand-new concept—setting aside an area of land for people to enjoy while at the same time conserving its wildlife and natural features from exploitation—and it proved to be the start of a worldwide movement. Today there are more than 1,200 national parks or equivalent preserves around the globe.

In the United States, the creation of Yellowstone National Park was just the first step in constructing one of the world's most remarkable park systems. Over the next forty years, Congress passed legislation that protected another thirty-five parks and monuments, among the earliest being Sequoia, General Grant and Yosemite. All were designated as national parks in 1890.

However, in these early days, the Department of the Interior, which was responsible for the parks, had neither the budget nor the means to deal with the squatters, vandals or poachers who were encroaching on the parks, especially in the West. To protect Yellowstone, in 1886 the Department appealed to the US Army, which took on the task of patrolling and dealing with offenders. The Lacey Act of 1894 gave the Department the authority to arrest and prosecute lawbreakers, but this still was not enough to keep offenders at bay. The situation was finally rectified on August 25, 1916, when President Woodrow Wilson approved the National Park Service Organic Act, which inaugurated a service that was *to conserve the scenery and the natural and historic objects and the wild life* in all the parks already designated as well as those yet to be established *and to provide for the enjoyment of the same in such manner and by such means as will leave them unimpaired for the enjoyment of future generations."*

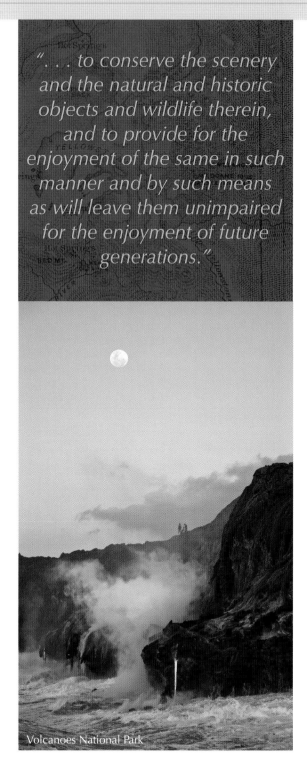

". . . to conserve the scenery and the natural and historic objects and wildlife therein, and to provide for the enjoyment of the same in such manner and by such means as will leave them unimpaired for the enjoyment of future generations."

Volcanoes National Park

Today there are fifty-nine national parks in the United States, all of them managed by the National Park Service. Fourteen of them are designated UNESCO World Heritage Sites. The state of California has the most with nine, followed by Alaska with eight, Utah with five, and Colorado with four. The four largest are all in Alaska; number one is Wrangell–St. Elias National Park and Preserve, which covers more than thirteen million acres. The smallest park is Hot Springs, Arkansas, with less than six thousand acres. The Great Smoky Mountains Park in North Carolina and Tennessee receives the most visitors in the entire system, with over ten million through the gates in 2015. Arizona's Grand Canyon came second with over 5.5 million. Only 10,745 people visited the Gates of the Arctic in Alaska in 2015; while it is the second largest of all the national parks, it is only accessible by bush plane or on foot.

The scope of the National Parks System was widened in the early twentieth century with the inclusion of national monuments, which are chosen for their historical or archaeological significance, as well as areas that preserve significant Native American history. It was widened again in the 1930s to include Civil War battlefields and cemeteries.

AN EPIC JOURNEY

In May 1982, as a naive world traveler of twenty-two, I stood on the side of a highway just outside San Francisco. My destination was Yosemite National Park, and without too much trouble I had quickly thumbed the lift that was to take me into my future. I spent a couple of nights in the tent village in the park, and during the day I wandered around the magnificence that is the Yosemite Valley. At that stage in my life I was more interested in long-distance running than photography. Little did I know that it would be a desire to run in the Death Valley Marathon in December 2007 that would bring me, with my partner Debbie, back to the US national park system, and this time lay the foundations for my photographic quest to visit and photograph all fifty-nine US national parks.

That short eleven-day visit at the end of 2007, with my partner Debbie, also included visits to the Bryce Canyon and Zion national parks in Utah, followed by a quick visit to the Grand Canyon. The grandeur before me triggered a desire to capture these sights and share them with others. I had dabbled in landscape photography in my late teens in my home state of Victoria, Australia, and this first trip, and what were to become regular trips to the United States, had rekindled that interest.

We soon realized our desire to return, six months later finding ourselves back stateside, this time concentrating on California, Oregon and Washington. The national parks at this stage were not a specific target—we were happy just to experience the

spectacular scenery that the United States is so blessed with. It was after our fourth trip, now becoming a regular twice-a-year journey, that I realized we had been to fifteen or sixteen different parks, and with a bit of research quickly established that there were (at that time) fifty-eight parks. When planning our future

Yosemite National Park, 1982

trips we concentrated on specific routes that enabled us to visit another group of parks. It was also around this time that my photographic aspirations became a lot more serious, which led to a desire to revisit some of the earlier parks to obtain more memorable images.

In August 2015 we embarked on our sixteenth trip to the United States, this time to visit the last three parks in our quest, all based in Alaska. Two of these parks, Kobuk Valley and Gates of the Arctic, are above the Arctic Circle in a true wilderness location, something we both found daunting, yet equally exciting. After

successfully surviving the wild remoteness of these parks, it seemed fitting to finish at Denali, an epic location to be the finale of an epic journey.

If you had told me a decade ago that I would be visiting places as diverse as Hot Springs National Park in Arkansas or the US Virgin Islands in the Caribbean, I would have laughed. If I'd had a "100 Places to Visit" list, I can assure you these two were not on it, and that is one of the great things about this journey: it has taken both Debbie and me to places we would never have dreamed were in our future to experience.

And while the photographic element of the quest was initially the main focus, it didn't take us long to realize the people we were meeting were adding a huge positive aspect to our visits. The friendly welcome that we always receive from locals is a huge bonus on our travels and is a big factor in our desire to return so often. We now have friends scattered across the fifty states, from California in the west to Maine in the northeast, and many in between.

I hope that readers of this book will be inspired, as we have been, to visit the parks—whether for a week in one park or even just a few hours. They are all unique in their own way. You will be better for the experience and take home memories that will last a lifetime.

—Andrew Thomas, January 2016

PHOTOGRAPHING THE NATIONAL PARKS

Never before in the history of man has photography been more popular. The digital camera has revolutionized the ability to easily and quickly record, and share, anything we see in front of us, and nowhere is this more obvious than throughout the national parks.

Photography in the National Parks got its start with images taken by William Henry Jackson. After service in the Union Army during the Civil War, Jackson had headed west and in 1867 opened a photography studio in Omaha. His photos of Plains Indians and the scenery along the Union Pacific Railway were seen by the geologist Ferdinand Hayden, who was organizing the first US government survey of the Yellowstone River region. Hayden invited Jackson to become the official photographer of his 1870 and 1871 survey expeditions, and as a result Jackson captured the first images of this legendary landscape. He worked in incredibly difficult conditions, using the collodion process with glass plates that had to be coated, exposed and developed onsite. All his plates and portable darkroom were carried on the backs of a long line of mules, and on one occasion, when a mule lost its footing, he had to retrace his travels and take the photos all over again. But those photos played an important role in convincing Congress to establish Yellowstone as America's first national park the following year.

In the 145 years since Jackson captured his images, photography in the national parks has attracted many notable image makers. George A. Grant was the first Chief Photographer for the National Park Service. He was hired in 1929 by Horace M. Albright, co-founder of the National Park Service and its second director, to create a documentary file of images for use by the Service.

Perhaps there is no one more famous for his photography of the national parks than Ansel Adams. In 1941, Adams was commissioned by the US government to photograph a range of national parks service units, and in 1946 received a Guggenheim fellowship to photograph every national park. However, there were fewer national parks to visit then than there are now.

Other notable photographers to have spent significant time in the national parks include David Muench, Jack Dykinga and Ian Shive. Only a handful have taken on the monumental task of photographing all fifty-nine parks—among them Stan Jorstad (fifty-eight), Jerry Ginsberg, Mark Burns and QT Luong, the latter having covered the parks to an amazing level.

This book is the result of what is believed to be the first time a single photographer has photographed all fifty-nine parks *and* the delisted, forgotten three.

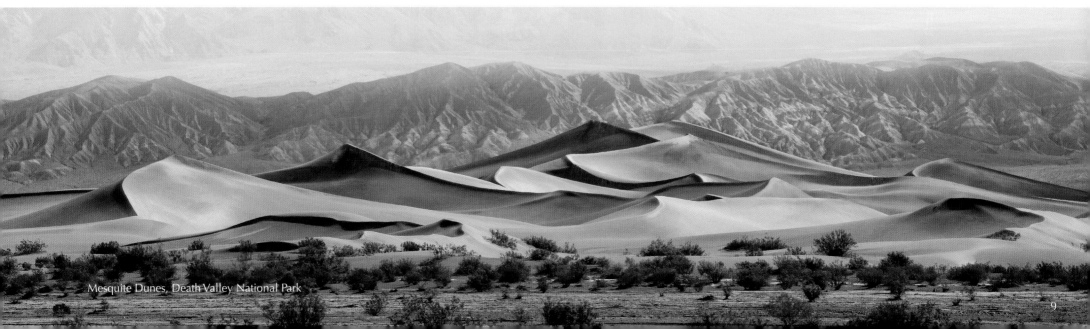

Mesquite Dunes, Death Valley National Park

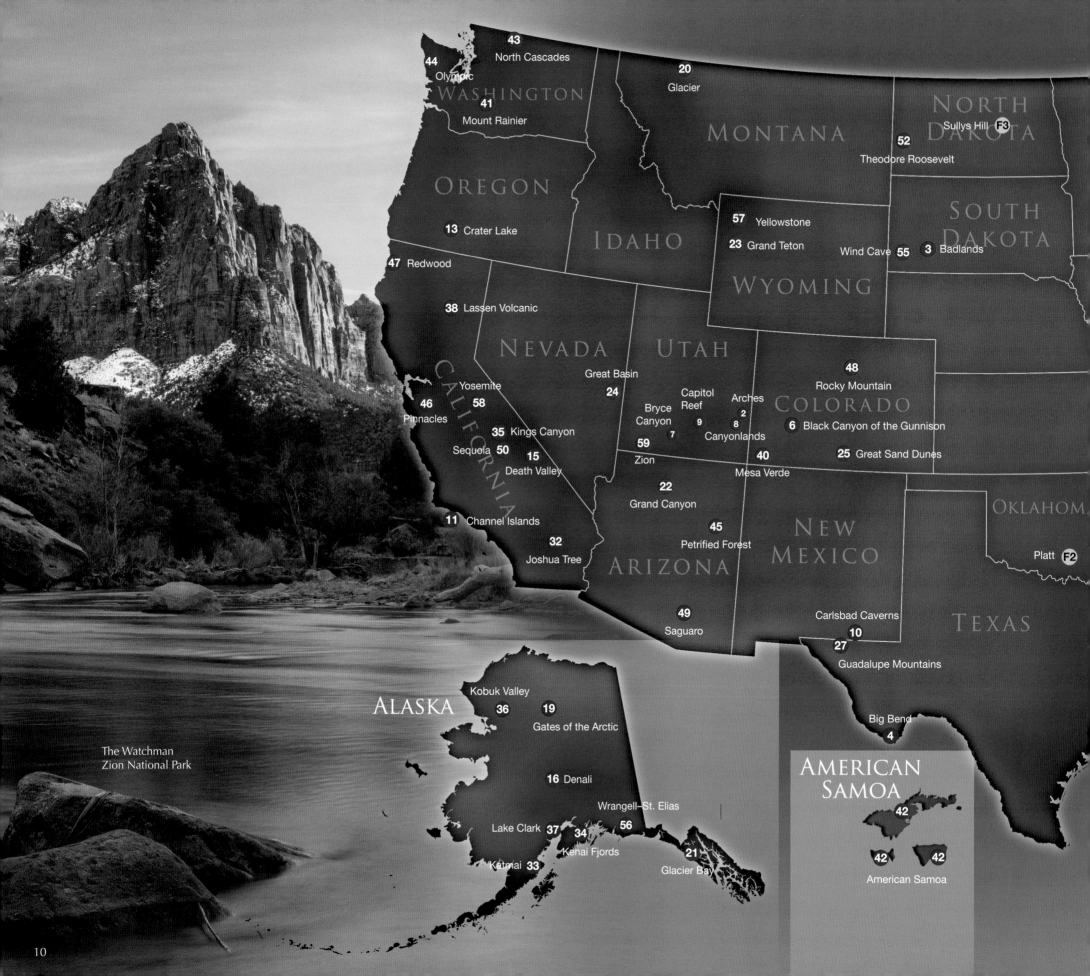

43 North Cascades

44 Olympic

41 Mount Rainier

WASHINGTON

OREGON

20 Glacier

MONTANA

NORTH DAKOTA

Sullys Hill (F3)

52 Theodore Roosevelt

13 Crater Lake

47 Redwood

38 Lassen Volcanic

IDAHO

SOUTH DAKOTA

57 Yellowstone

23 Grand Teton

WYOMING

Wind Cave **55** **3** Badlands

NEVADA

UTAH

Great Basin

24

Bryce Canyon **7**

Capitol Reef **9**

Arches **2** **8**

Canyonlands

48 Rocky Mountain

COLORADO

6 Black Canyon of the Gunnison

25 Great Sand Dunes

CALIFORNIA

Yosemite

46 Pinnacles

58

35 Kings Canyon

Sequoia **50**

15 Death Valley

59 Zion

40 Mesa Verde

22 Grand Canyon

45 Petrified Forest

NEW MEXICO

OKLAHOMA

11 Channel Islands

32 Joshua Tree

ARIZONA

Carlsbad Caverns

10

27 Guadalupe Mountains

TEXAS

Platt (F2)

49 Saguaro

ALASKA

Kobuk Valley

36 **19** Gates of the Arctic

Big Bend

4

The Watchman
Zion National Park

16 Denali

Wrangell–St. Elias

Lake Clark **37** **34** **56**

Kenai Fjords

Katmai **33**

21 Glacier Bay

AMERICAN SAMOA

42

42 **42**

American Samoa

10

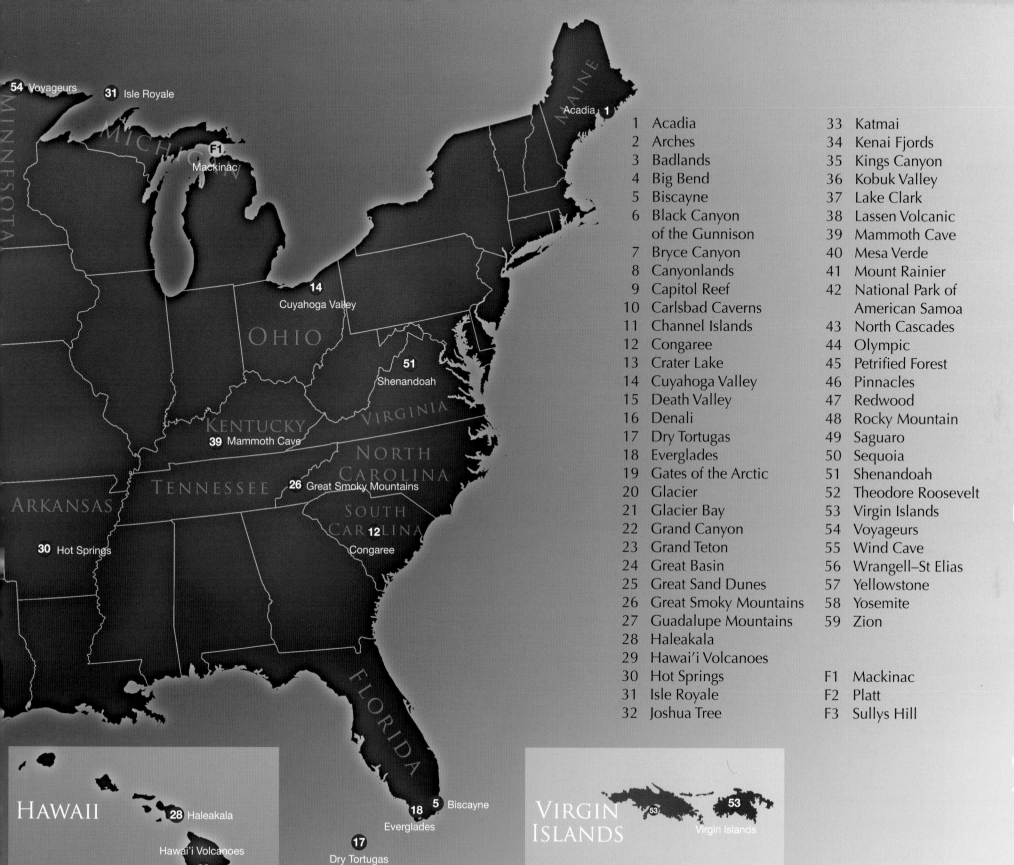

54 Voyageurs
31 Isle Royale
F1 Mackinac
14 Cuyahoga Valley
51 Shenandoah
39 Mammoth Cave
26 Great Smoky Mountains
12 Congaree
30 Hot Springs
18 Everglades
5 Biscayne
17 Dry Tortugas

MINNESOTA
MICHIGAN
OHIO
KENTUCKY
VIRGINIA
NORTH CAROLINA
TENNESSEE
ARKANSAS
SOUTH CAROLINA
MAINE
FLORIDA

1 Acadia
2 Arches
3 Badlands
4 Big Bend
5 Biscayne
6 Black Canyon
 of the Gunnison
7 Bryce Canyon
8 Canyonlands
9 Capitol Reef
10 Carlsbad Caverns
11 Channel Islands
12 Congaree
13 Crater Lake
14 Cuyahoga Valley
15 Death Valley
16 Denali
17 Dry Tortugas
18 Everglades
19 Gates of the Arctic
20 Glacier
21 Glacier Bay
22 Grand Canyon
23 Grand Teton
24 Great Basin
25 Great Sand Dunes
26 Great Smoky Mountains
27 Guadalupe Mountains
28 Haleakala
29 Hawai'i Volcanoes
30 Hot Springs
31 Isle Royale
32 Joshua Tree

33 Katmai
34 Kenai Fjords
35 Kings Canyon
36 Kobuk Valley
37 Lake Clark
38 Lassen Volcanic
39 Mammoth Cave
40 Mesa Verde
41 Mount Rainier
42 National Park of
 American Samoa
43 North Cascades
44 Olympic
45 Petrified Forest
46 Pinnacles
47 Redwood
48 Rocky Mountain
49 Saguaro
50 Sequoia
51 Shenandoah
52 Theodore Roosevelt
53 Virgin Islands
54 Voyageurs
55 Wind Cave
56 Wrangell–St Elias
57 Yellowstone
58 Yosemite
59 Zion

F1 Mackinac
F2 Platt
F3 Sullys Hill

HAWAII
28 Haleakala
Hawai'i Volcanoes
29

18 Everglades
5 Biscayne
17 Dry Tortugas

VIRGIN ISLANDS
53 Virgin Islands

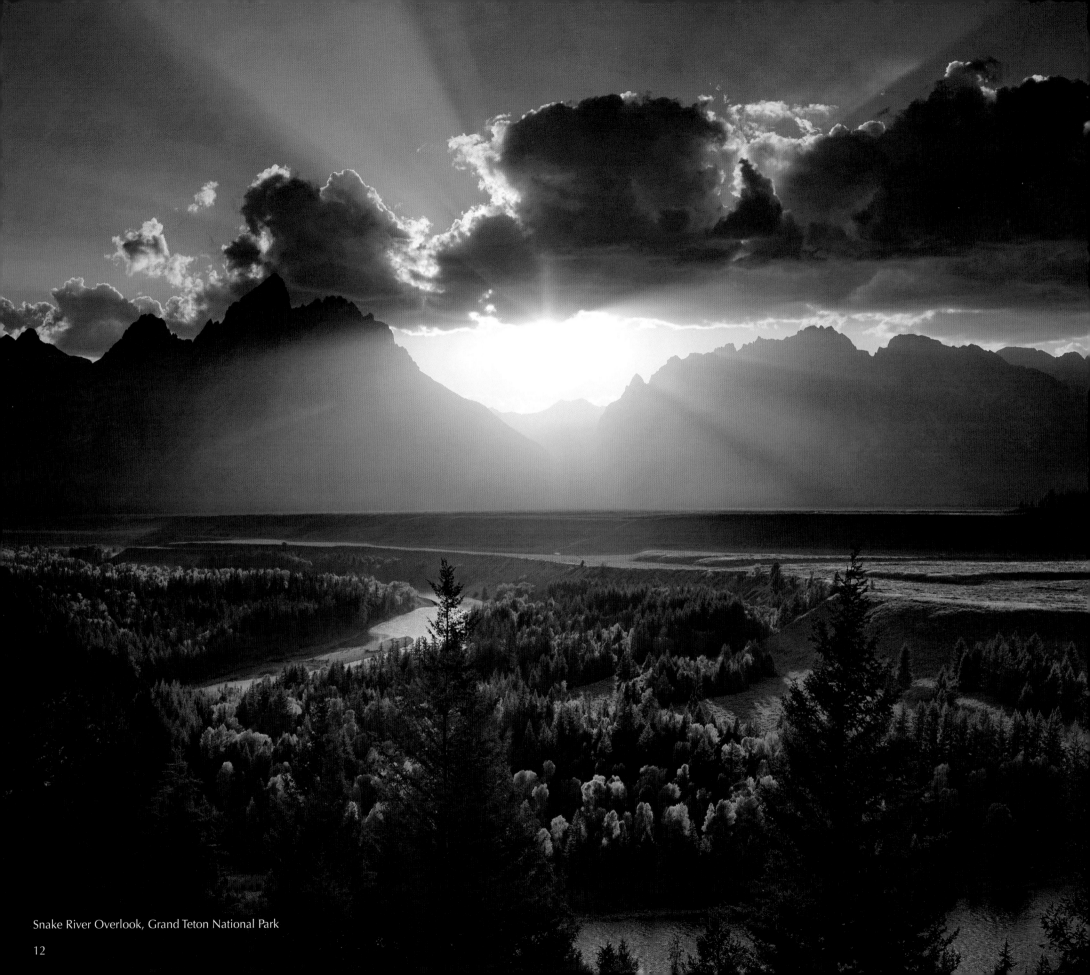

Snake River Overlook, Grand Teton National Park

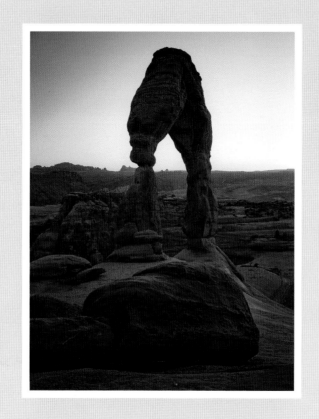

THE PARKS

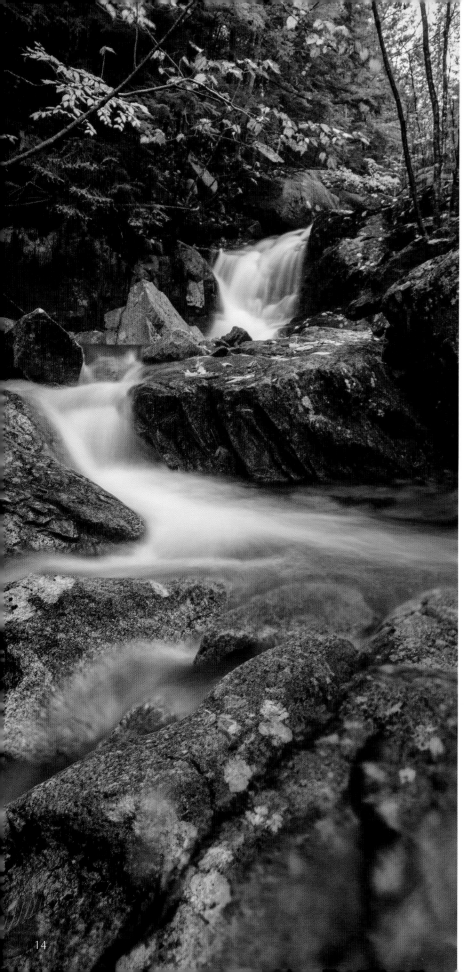

ACADIA
NATIONAL PARK
MAINE

The First Eastern National Park

Old carriage roads intertwine with the new and weave their way through the lichen-covered granite that is characteristic of Acadia National Park. The park is home to Cadillac Mountain, the tallest peak on the US Atlantic coast. It rises from the mass of tumbled boulders lining the rugged ocean edge. The land was donated for the park to preserve its wildness; it continues to provide a visual and spiritual respite for all who visit. A magical time to visit is in the fall, when the turning deciduous foliage provides a colorful contrast to the evergreens.

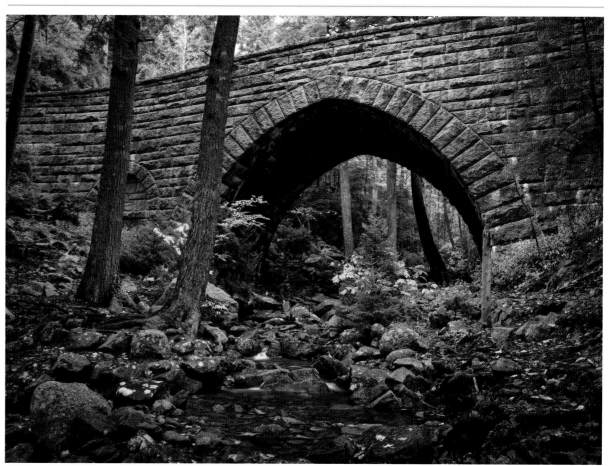

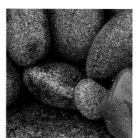

Location: Maine
Nearest city: Bar Harbor
Coordinates: 44°22'52"N 68°16'23"W
Area: 47,452 acres (19,203 ha),
 933 acres (377 ha) private
Established: July 8, 1916
Visitors in 2015: 2,811,184

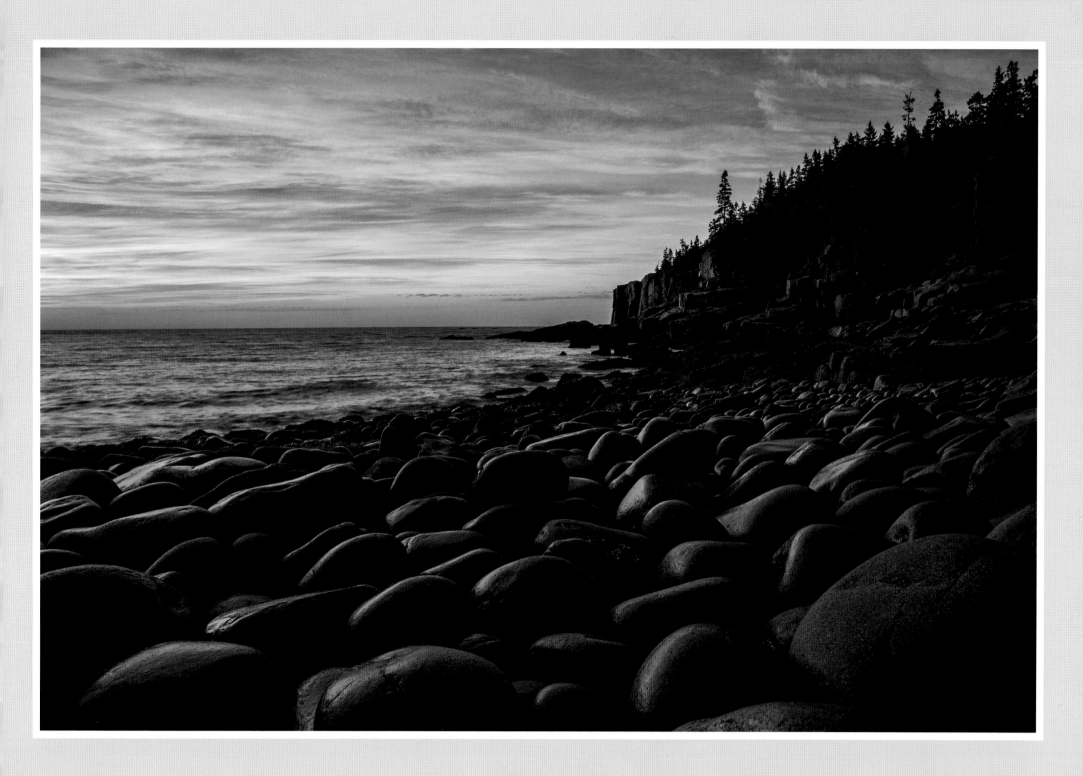

"Pre-dawn in Acadia National Park, as the light climbed over the horizon, the colors were to die for. The weathered granite, sculptured by the elements over thousands of years, offered boundless opportunities for exploring engaging foregrounds . . .
Have I mentioned lately . . . I love Acadia."

—David Patterson,
"Stories From Home," 2013

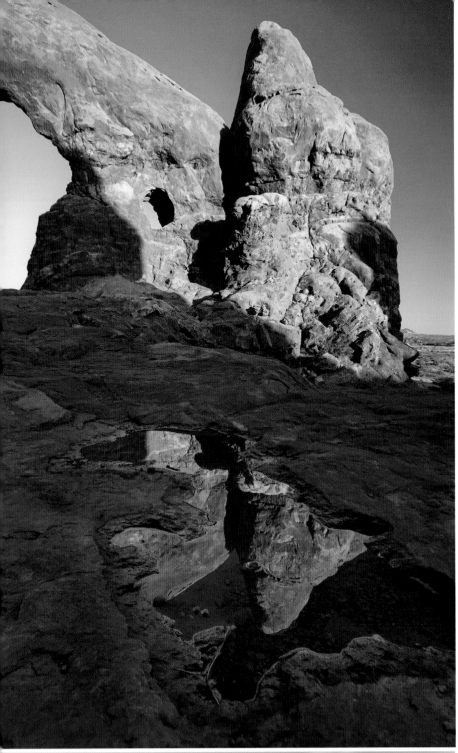

ARCHES
NATIONAL PARK

Nature's Curves

Weathering and erosion have sculpted a red rock paradise bordering the adventure capital of the west, Moab. There are over two thousand natural stone arches within this park, as well as massive fins, giant balanced rocks, hundreds of soaring pinnacles and slickrock domes. Arches geography is a haven for hikers and bikers, young and old, who on their first visit curiously follow twists and turns and ups and downs, to find what lies next. At day's end a stunning sunset may flame in the sky, reflecting off the sand and rock.

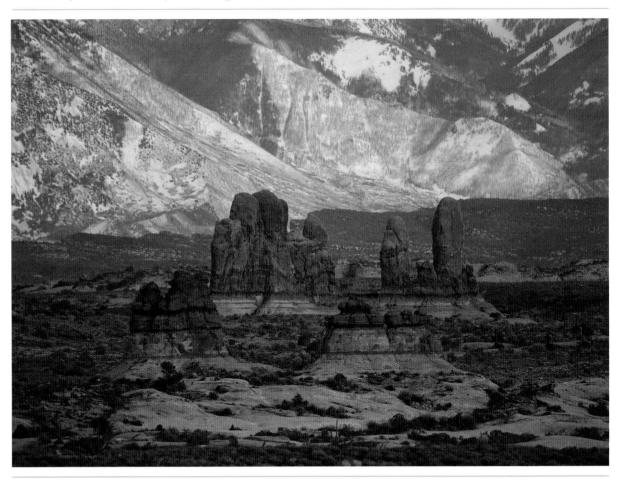

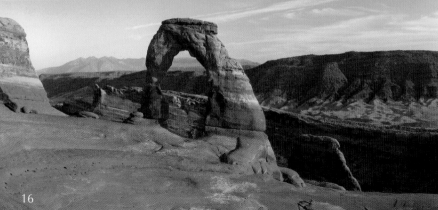

Location: Utah
Nearest city: Moab
Coordinates: 38°41'00"N 109°34'00"W
Area: 76,679 acres (31,031 ha)
Established: November 12, 1971
Visitors in 2015: 1,399,247

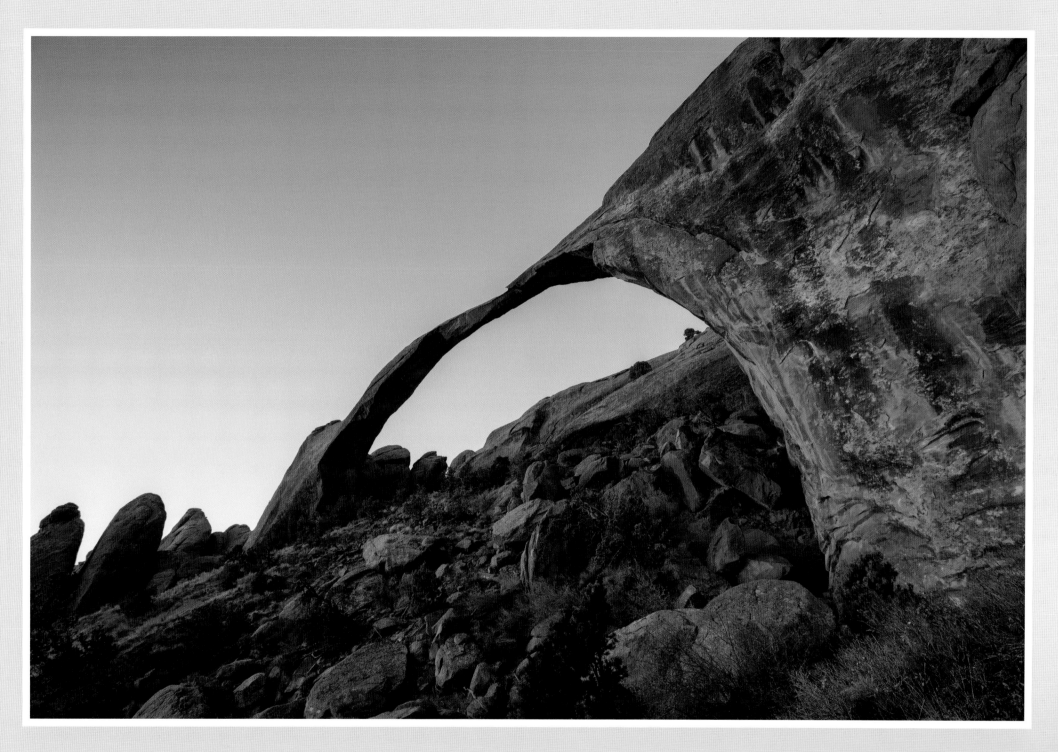

"Have you ever heard a raven's wings softly stroke the air? You will, right here. Wander away from the asphalt parking lot to find that peace, that solitude, that perfect moment to treasure. Close your eyes, breathe in dusty sage and piñon, and listen for the raven."

—Anne Markward, Colorado, 2016

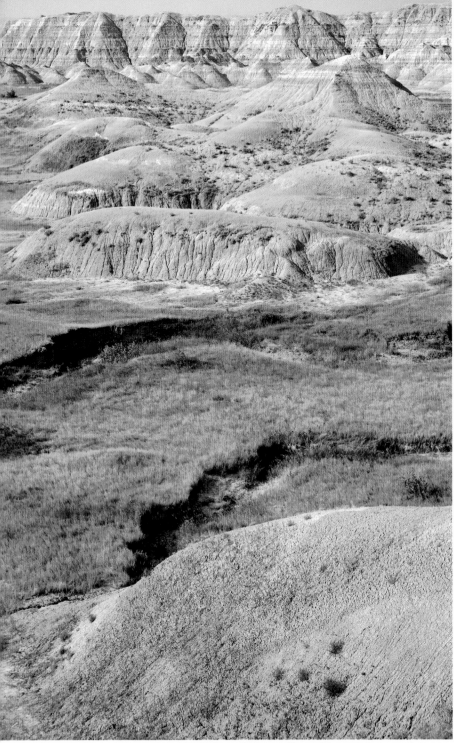

BADLANDS
NATIONAL PARK

Bad to the Bone

Originally named "land bad" by the Lakota people because of extreme temperatures, lack of water and exposure to rugged terrain, the 243,000 acres of this park now protect bison, bighorn sheep, prairie dogs and the black-footed ferret on an expanse of mixed-grass prairie. Hues of red, yellow and green tint the geologic fossil-laden formations that sit beneath a big sky. There is no need to await a sunrise or sunset to color this palette. At every turn you are left contemplating its beauty.

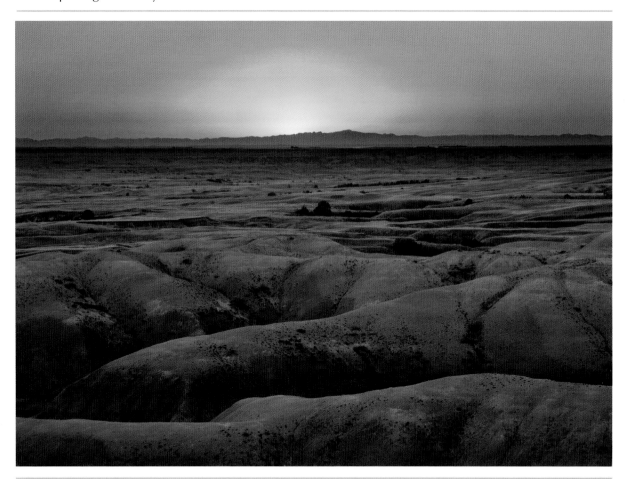

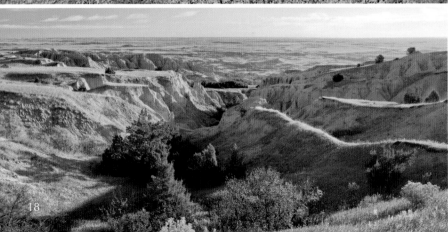

Location: South Dakota
Nearest city: Rapid City
Coordinates: 43°45'00"N 102°30'00"W
Area: 242,756 acres (98,240 ha)
Established: November 10, 1978
Visitors in 2015: 989,354

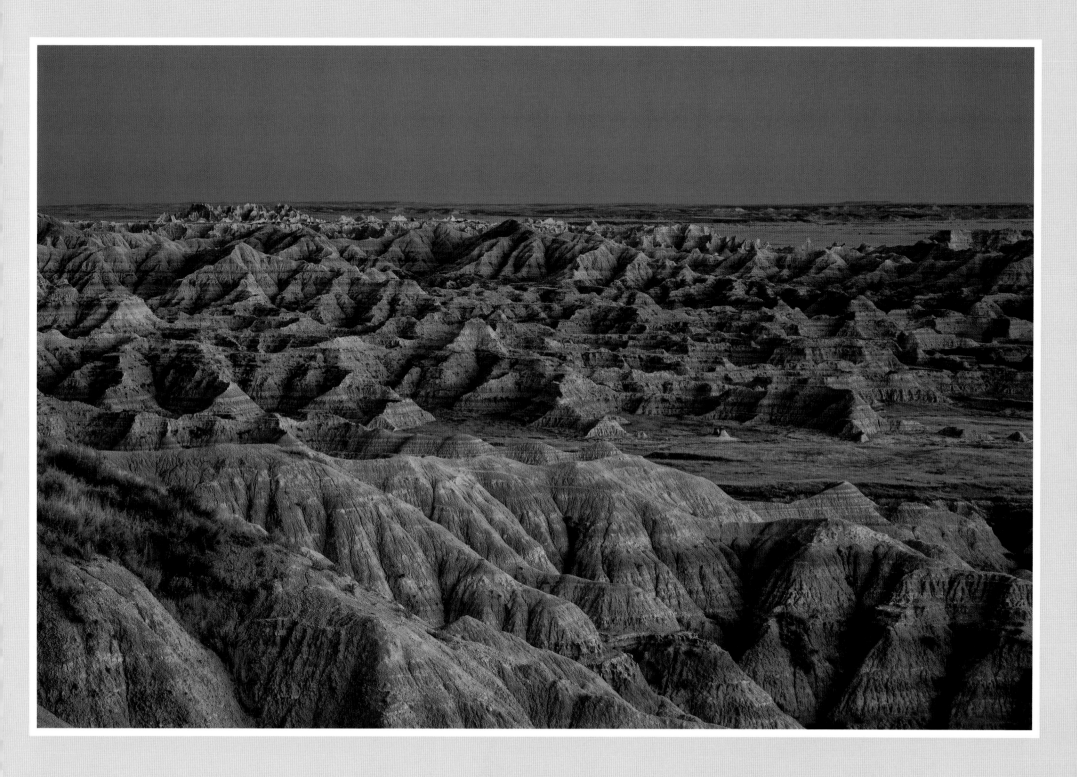

"Anyone can love the mountains and the seashore. It takes soul to love the prairie."

—*John Tsitrian, Wall, South Dakota, 2015*

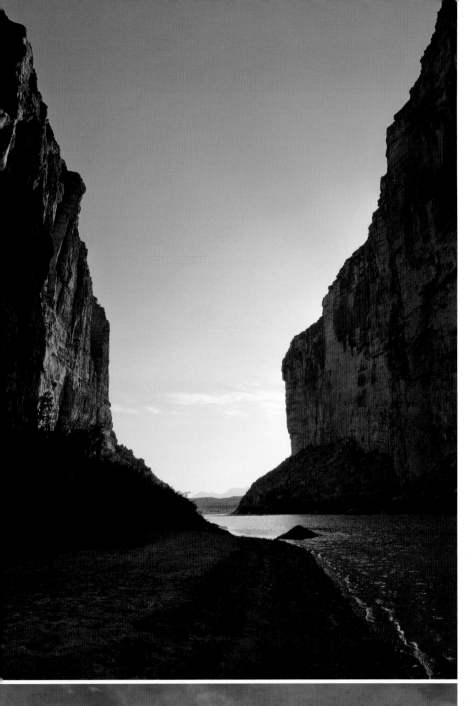

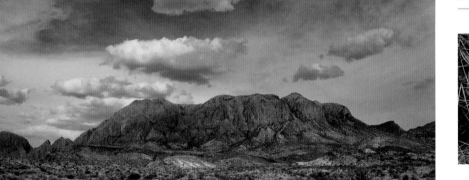

BIG BEND
NATIONAL PARK

It's Big and It's Spectacular

In far west Texas, this remote park rests within a horseshoe bend of the Rio Grande along the Texas–Mexico border. It may feel like the end of the road, but ardent travelers are rewarded on reaching this wild and surprising land. Prolific desert vegetation, diverse wildlife and birdlife, lush floodplains, steep and narrow canyons and the colorful Chisos Mountains are all part of this surprise package in quiet isolation.

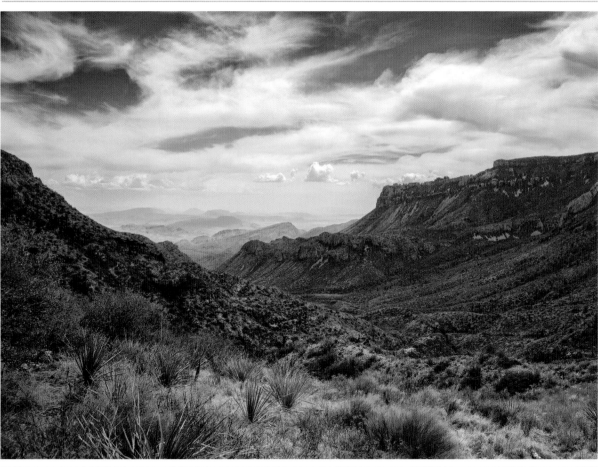

Location: Texas
Nearest city: Alpine
Coordinates: 29°15'0"N 103°15'0"W
Area: 801,163 acres (324,219 ha)
Established: June 12, 1944
Visitors in 2015: 381,747

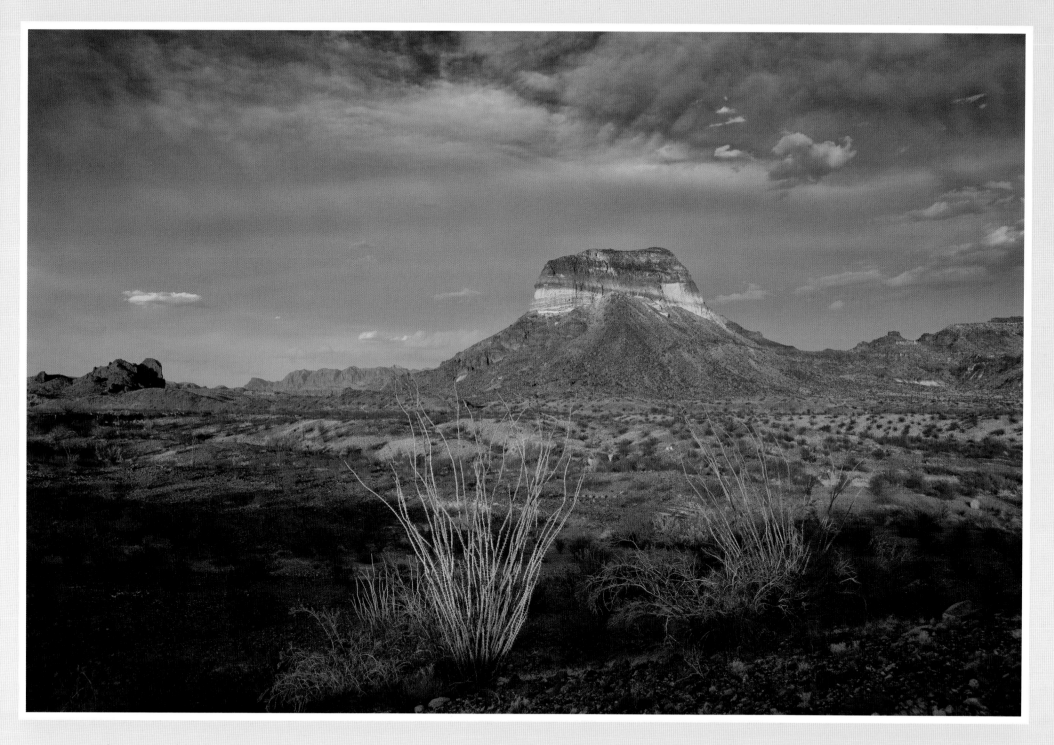

"I wish you would take a map of the State showing the counties, put your pencil point on the Rio Grande, just where the Brewster and Presidio County line hit that stream; then draw a line due East and at a distance of sixty miles it will again strike the River. My dream is to make the area South of this line into a park and I shall live to see it done."

—Everett Townsend,
the father of Big Bend National Park, 1933

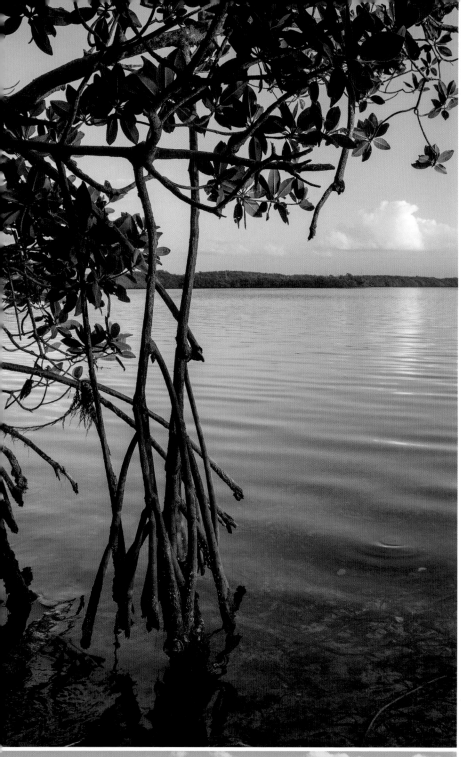

BISCAYNE
NATIONAL PARK
FLORIDA

A Place to Get Wet!

Most of the park's 173,000 acres are covered in water and shielded by the Florida Keys, protecting a colorful seascape teeming with an abundant variety of fish and colorful corals. Small islands are peppered with a history of pirates, shipwrecks and pineapple farmers. Boat and watch wildlife here, but, ideally . . . go under . . . get wet . . . and see what lies beneath.

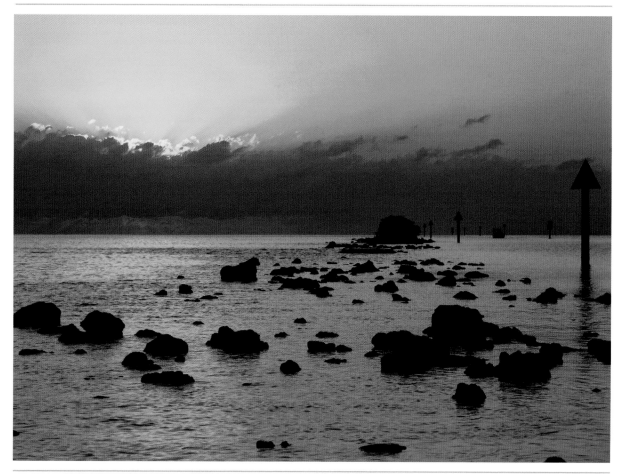

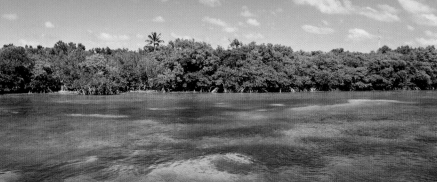

Location: Florida
Nearest city: Homestead
Coordinates: 25°28'10"N 80°11'10"W
Area: 172,971 acres (69,999 ha)
Established: June 28, 1980
Visitors in 2015: 508,164

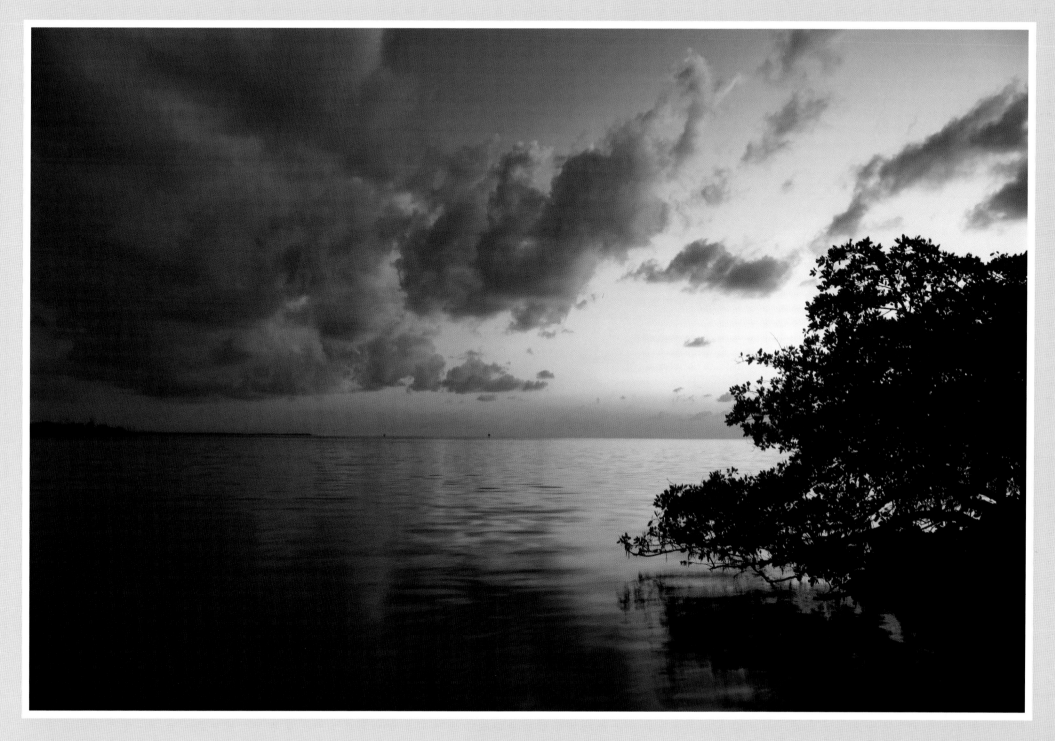

"Drifting over the Florida Reef on a quiet day one may note all the details of its tropical luxuriance twenty feet below, and feel himself afloat on a sort of liquid light, rather than water, so limpid and brilliant is it."

—Commodore Ralph Middleton Munroe, 1877

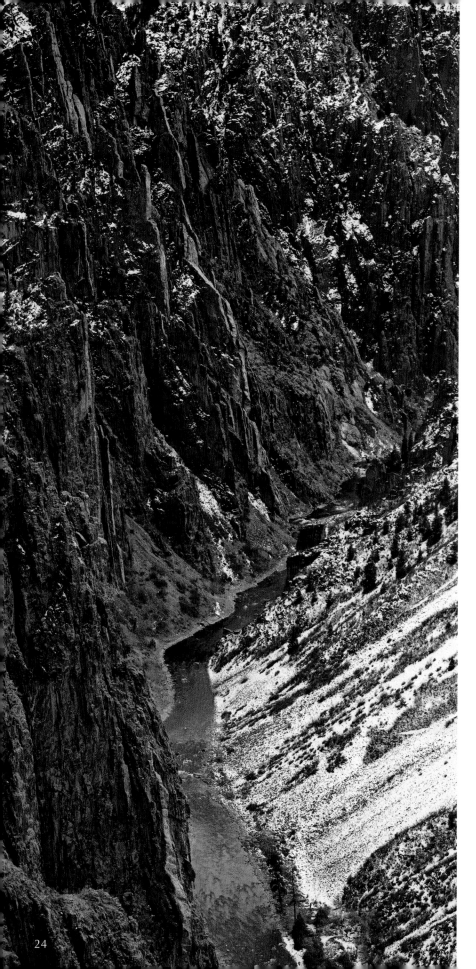

BLACK CANYON OF THE GUNNISON National Park

Deep, Dark and Mysterious

A thunderstorm rolls through, a perfect scenario to view this dark canyon. Steep, narrow, massive walls of hard gneiss and schist plummet 2,600 feet down to the waters of the Gunnison River, interrupted here and there by pink veins of igneous pegmatite. The rain clears and rainbows appear: an exciting and beautiful picture. In winter, snow is the canyon's accessory, almost monochromatic yet stunning in all its darkness.

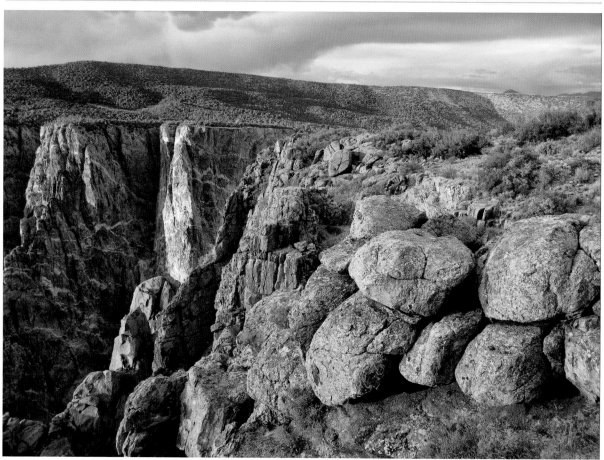

Location: Colorado
Nearest city: Montrose
Coordinates: 38°34'0''N 107°43'0''W
Area: 30,750 acres (12,440 ha)
Established: October 21, 1999
Visitors in 2015: 209,166

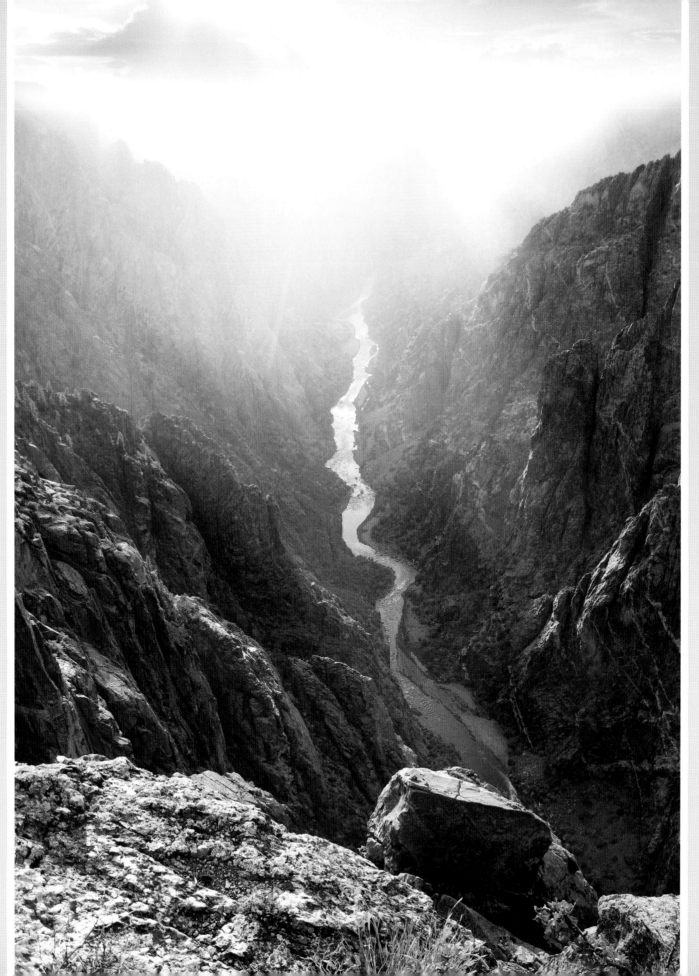

"Sure it's old rock, but it's really just rock. Our whole planet is made of rock. What does it matter that the cliffs are intimidating, steep and sheer? The crags seem so untouchable. But sitting at the precipice it matters because here we come face to face with the world's mighty forces which jolt us out of our urbanized, bondage to the clock. Here, rock has the unique power to put our lives into perspective, to see ourselves vulnerable in nature, and to renew our sense of belonging to Earth and all that lives."

—Paul Zaenger,
Supervisory Park Ranger,
2015

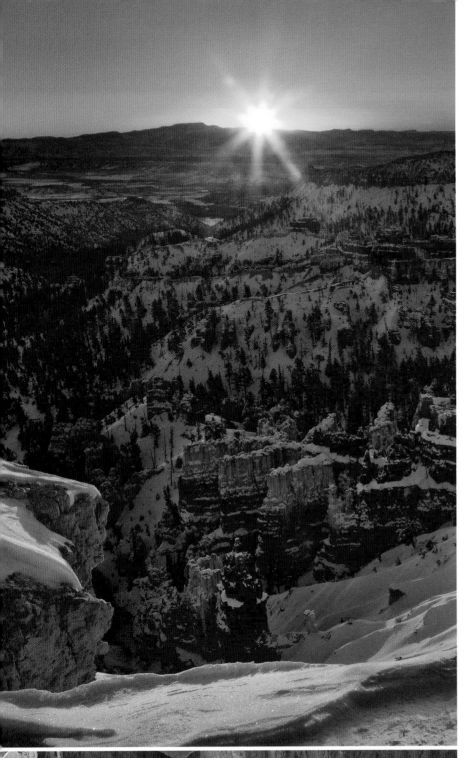

BRYCE CANYON
NATIONAL PARK
UTAH

A Rock Legend

At first sight, from the rim of the main amphitheater, the iconic giant red hoodoos stand tall and strong, rising from the canyon floor. A Paiute legend explains that there once lived animal-like creatures that changed themselves into people. But they were bad, so Coyote turned them into rocks, and the creatures remain stone today. A more stunning display of the power of nature is hard to find. Here you will find a hypnotic force pulling at your curiosity, drawing you deeper into the canyon to find its beating heart.

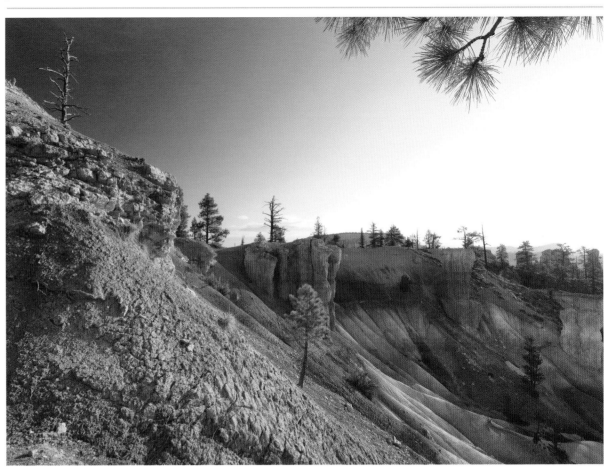

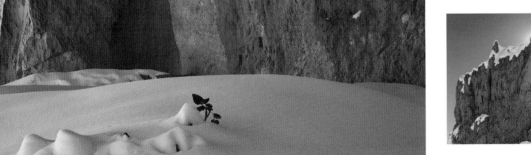

Location: Utah
Nearest city: Tropic
Coordinates: 37°37'42"N 112°10'04"W
Area: 35,835 acres (14,502 ha)
Established: September 15, 1928
Visitors in 2015: 1,745,804

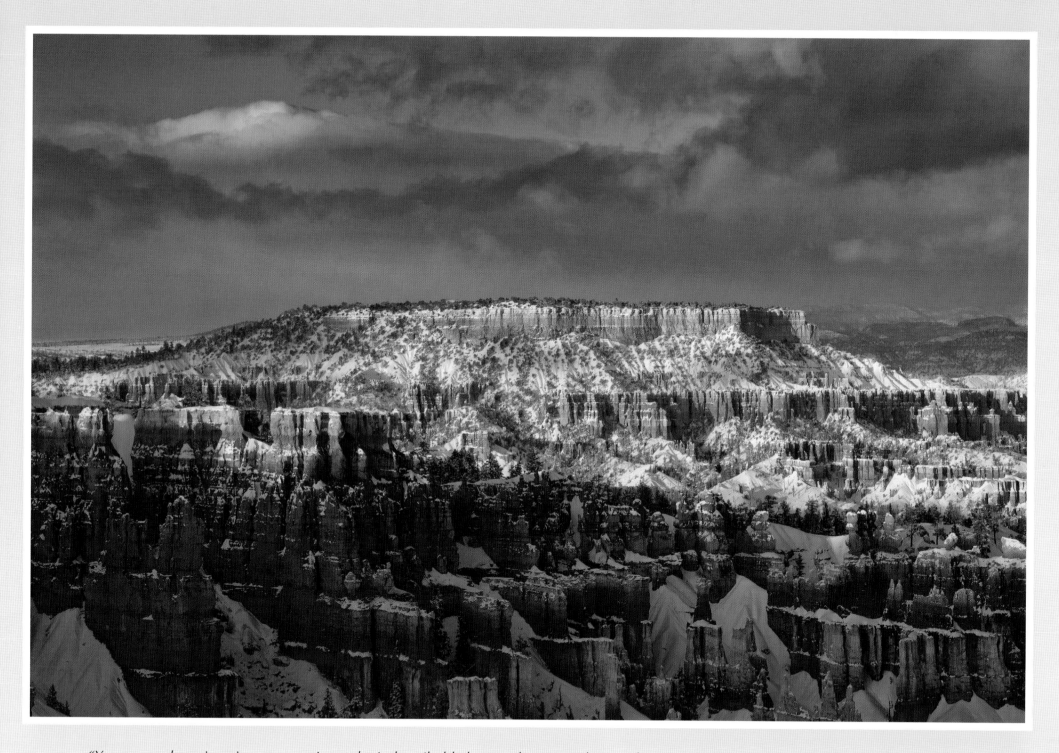

"You can perhaps imagine my surprise at the indescribable beauty that greeted us, and it was sundown before I could be dragged from the canyon view. You may be sure that I went back the next morning to see the canyon once more, and to plan in my mind how this attraction could be made accessible to the public."

—J. W. Humphrey,
US Forest Service, 1915

CANYONLANDS NATIONAL PARK

A Maze of Canyons

Island in the Sky, the Maze and the Needles are three districts within Canyonlands. They are home to plants, rocks, cracks, sand and upheaved domes; the ground is dry, yet rivers run through it. In the winter, icicles hang from the trickling waterfalls and snow dusts the red earth. The sky rules over this land, all 527 square miles of it. It rains and the waters carve canyons; the summer sun sucks it dry. It is forever a salty desert. An amazing sight and a seemingly endless land to explore.

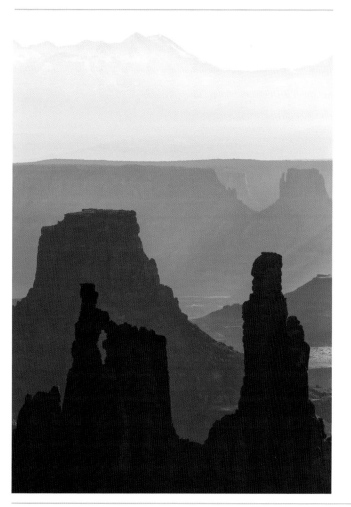

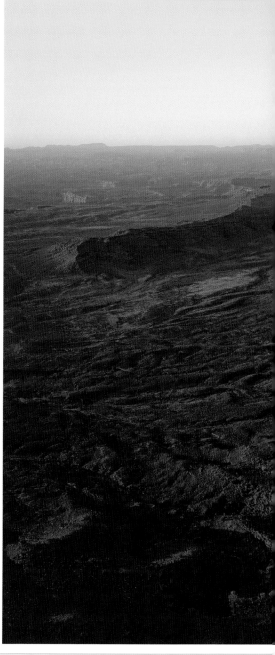

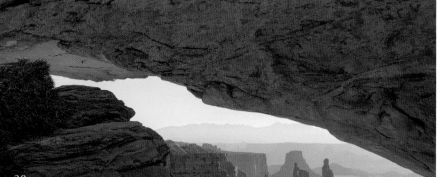

Location: Utah
Nearest city: Moab
Coordinates: 38°10'01"N 109°45'35"W
Area: 337,598 acres (136,621 ha)
Established: September 12, 1964
Visitors in 2015: 634,607

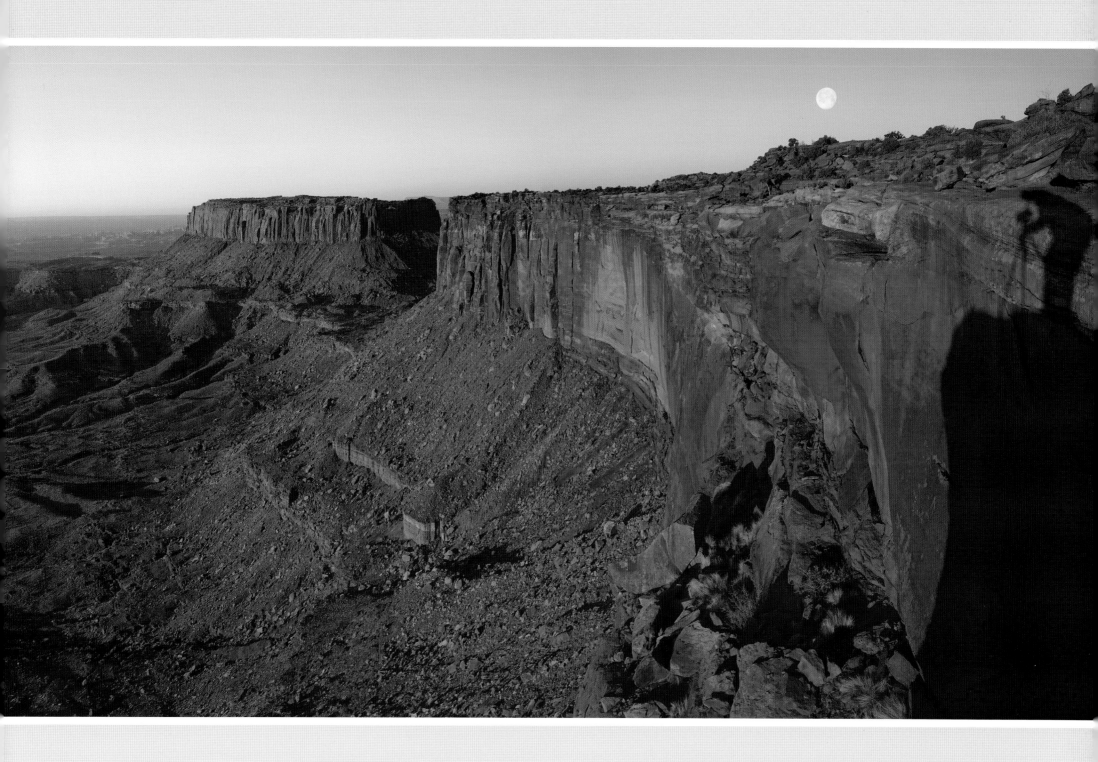

"Driving into the north entrance of Canyonlands National Park, I passed mile after mile of red rock buttes, the light on them constantly changing as the sun filtered through the swiftly passing thunderclouds."

—Erin Hanson, artist, 2016

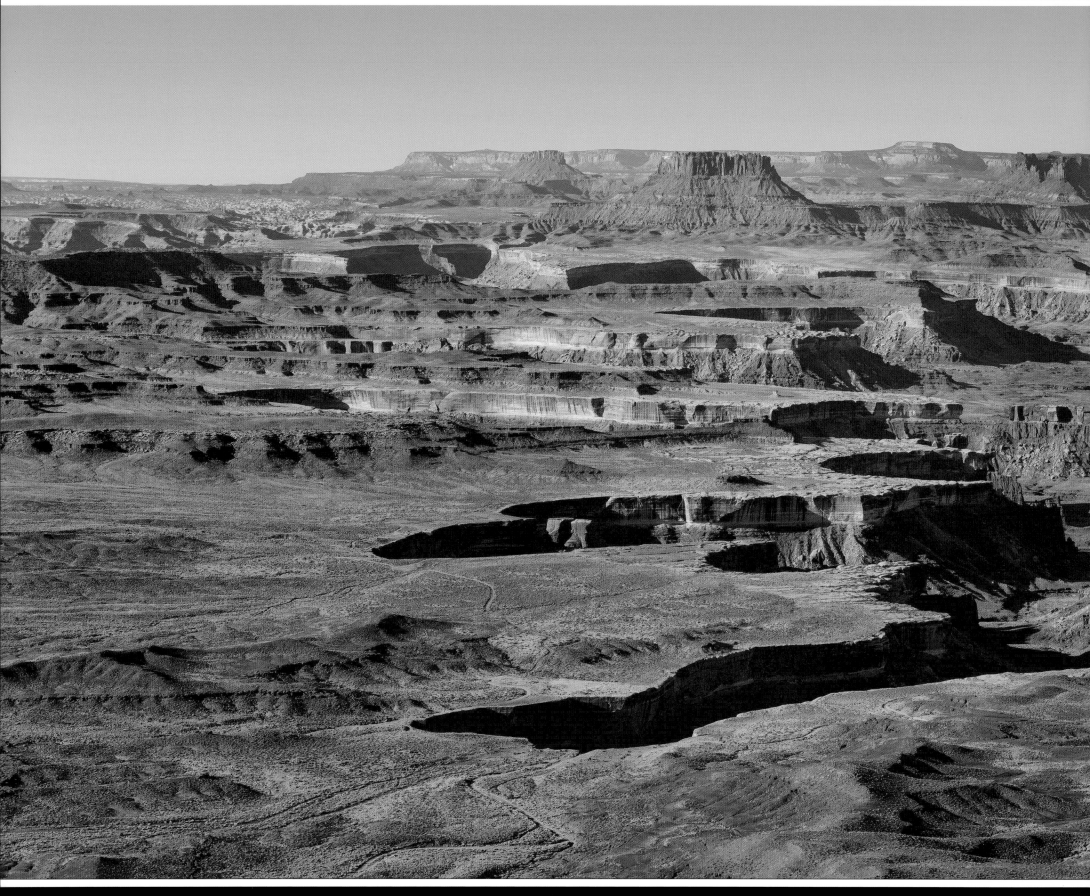

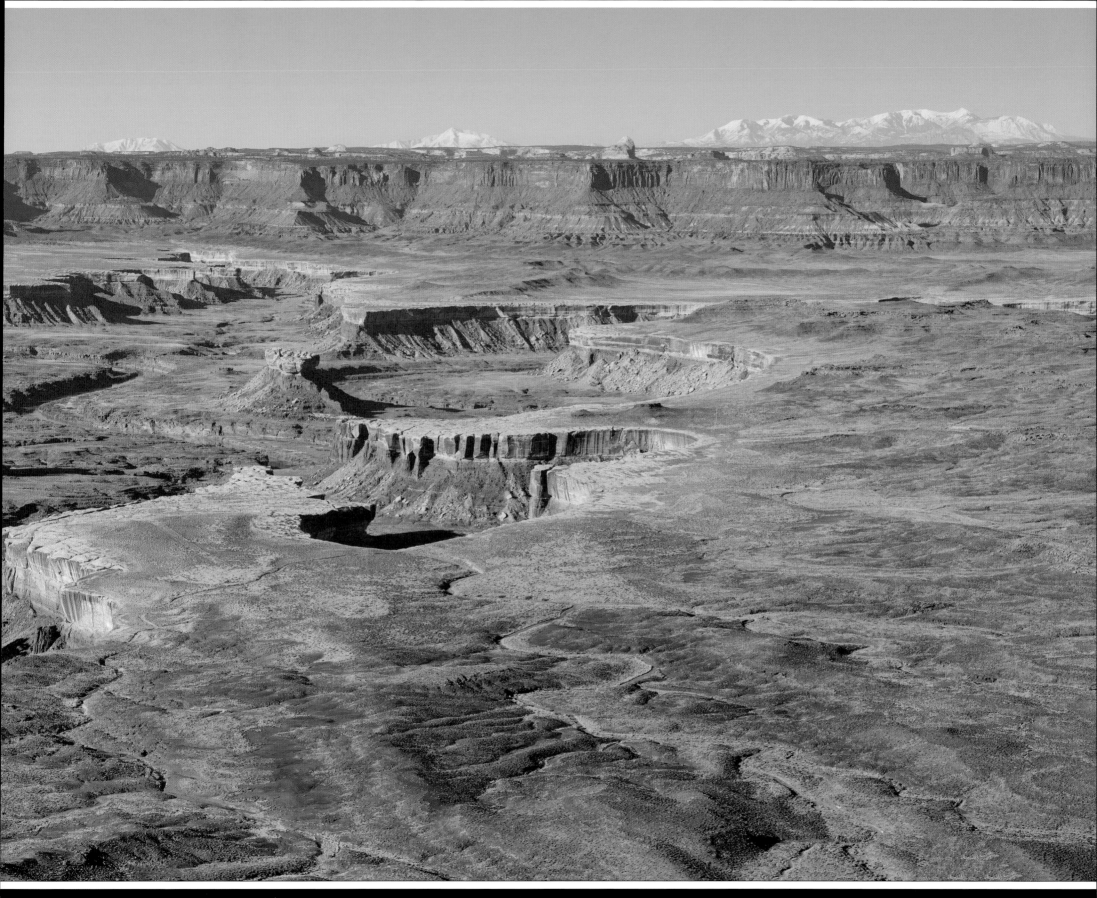

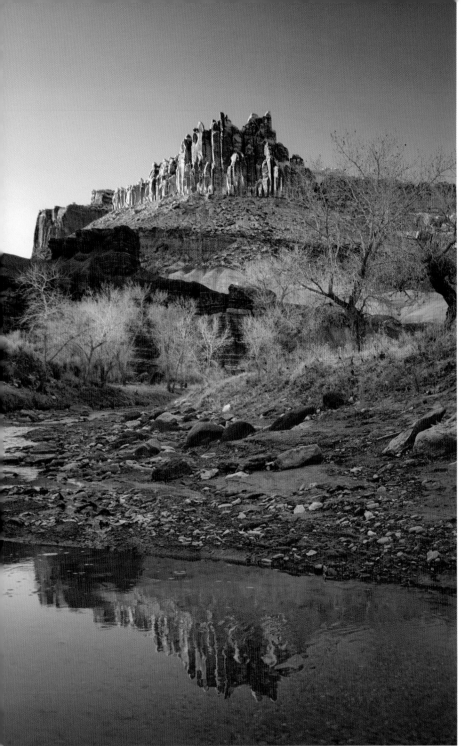

CAPITOL REEF
NATIONAL PARK

Giant Waves of Beauty

Parallel ridges rise from the desert like one hundred miles of giant waves rolling toward shore. Colorful sandstone domes, red cliffs and natural bridges make this park a beautiful and serene place to visit. The layers of stone and earth form a sharp contrast to a blue or stormy sky. You will find petroglyphs on cliff walls along the Fremont River and an abundant fruit orchard planted by Mormons in the 1880s. This park, too, could be the apple of your eye!

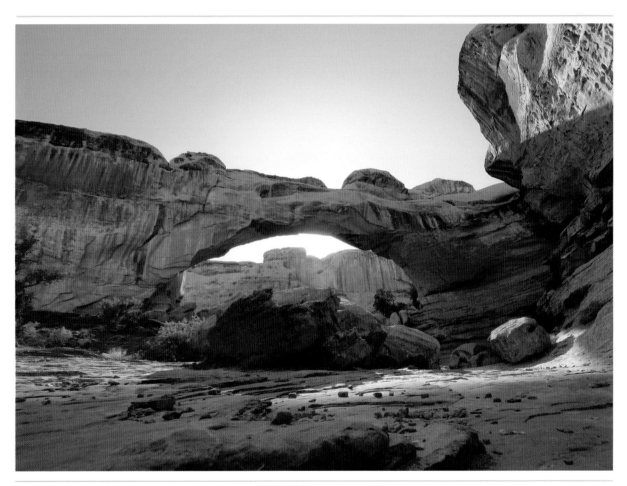

Location: Utah
Nearest city: Torrey
Coordinates: 38°12′0″N 111°10′0″W
Area: 241,904 acres (97,895 ha), 670 acres (270 ha) private
Established: December 18, 1971
Visitors in 2015: 941,029

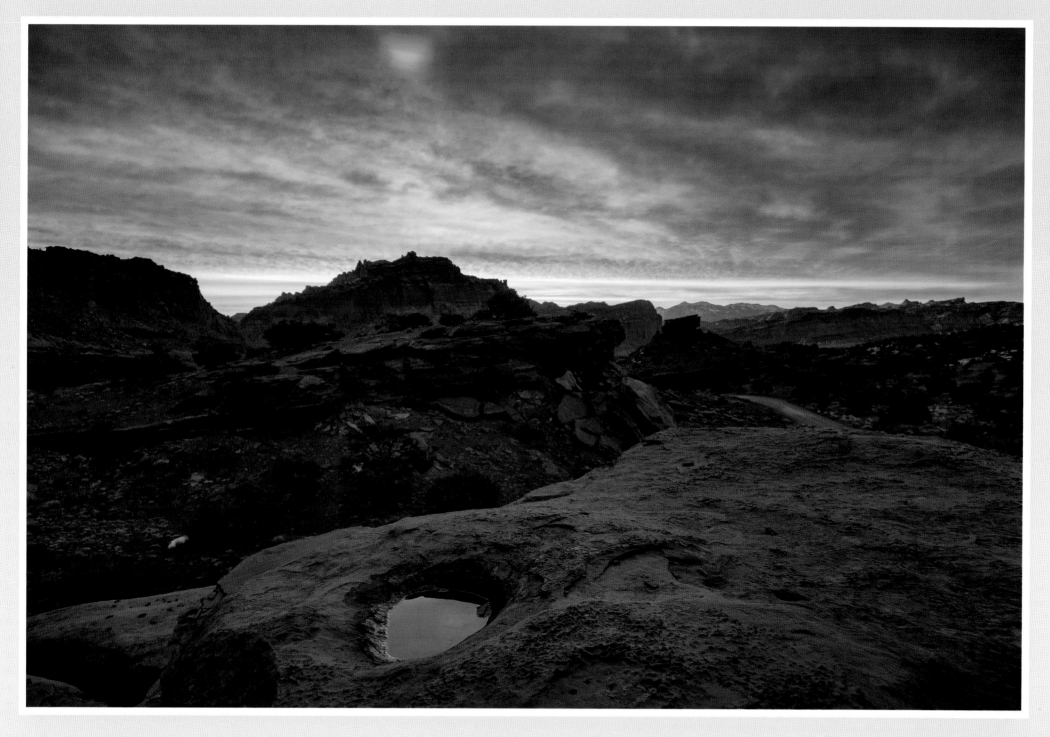

"... make gardens, orchards, and vineyards, and render the earth so pleasant that when you look upon your labors you may do so with pleasure, and that angels may delight to come and visit your beautiful locations."

—*Brigham Young,*
as he sent settlers to remote corners of Utah

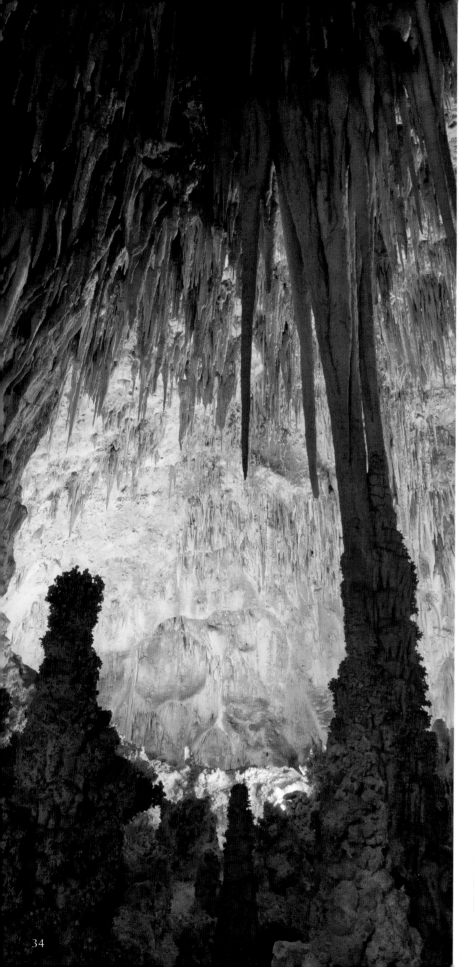

CARLSBAD CAVERNS
NATIONAL PARK

Spend a Day Out–Below!

Hidden below the Chihuahuan Desert floor, in the shadow of the Guadalupe Mountains, are more than 119 known caves. Will Rogers called the area "the Grand Canyon with a roof on it." A sanctuary for these fragile underground sculptures and a home for over 400,000 free-tailed bats, this is one of the deepest, largest and most ornate caverns ever found.

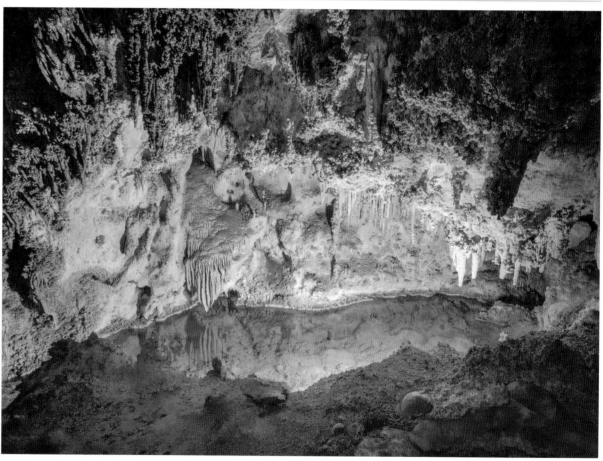

Location: New Mexico
Nearest city: Carlsbad
Coordinates: 32°10′31″N 104°26′38″W
Area: 46,766 acres (18,926 ha), 339 acres (137 ha) private
Established: May 14, 1930
Visitors in 2015: 445,720

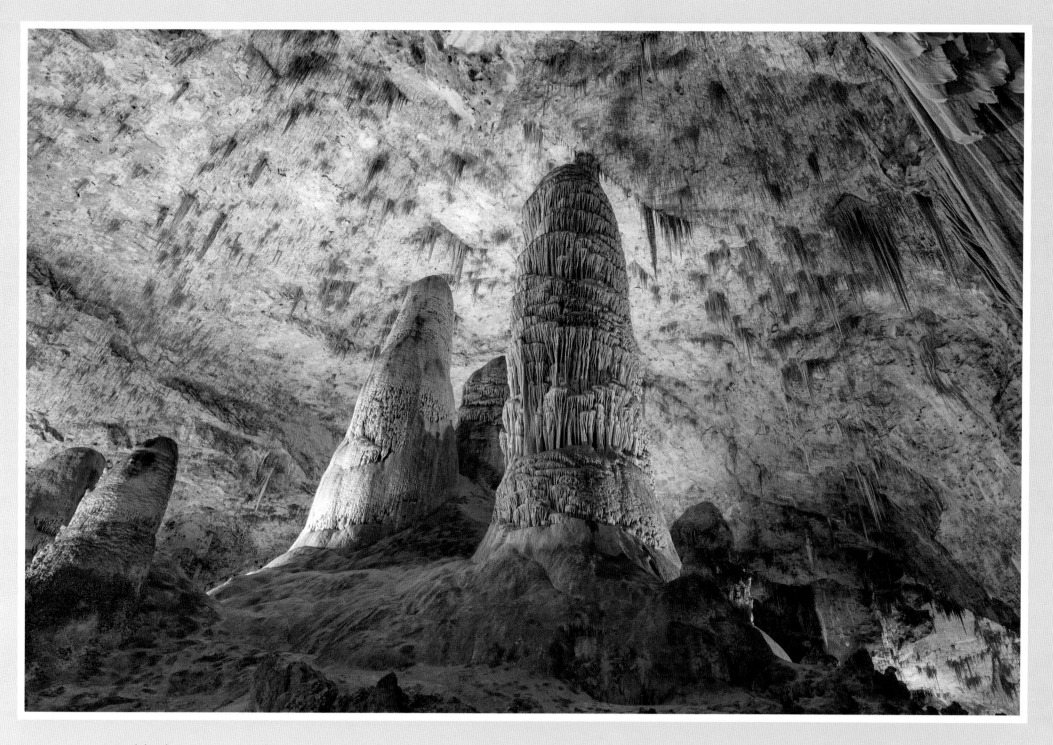

"Carlsbad Cavern . . . is the most spectacular of underground wonders in America. For spacious chambers, for variety and beauty of multitudinous natural decorations, and for general scenic quality, it is king of its kind."

—Willis T. Lee, geologist, 1924

CHANNEL ISLANDS
NATIONAL PARK

A Sanctuary of Solitude
Leave the California coast behind and take a memorable ferry ride to discover any of the five islands that belong to Channel Islands National Park. On and around these remote and beautiful islands you will find rolling hills, eerie sea mists and sea caves. Marine life is abundant and you will most likely see the little island fox or deer mice. Camp under the stars, explore the sea, be adventurous or just embrace the clean air, peace and solitude.

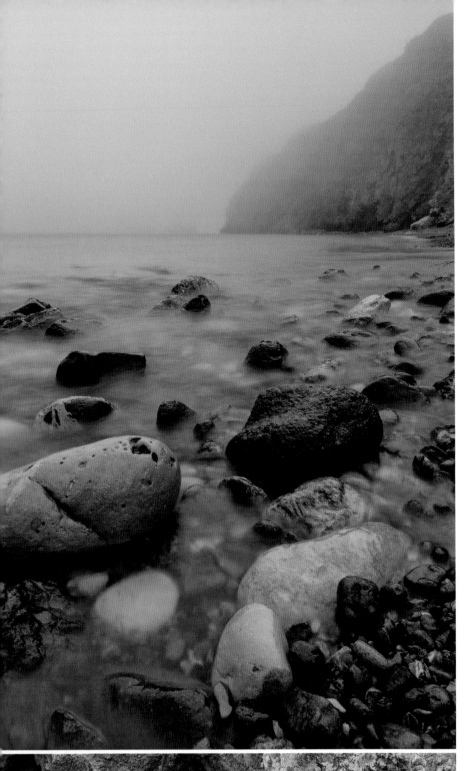

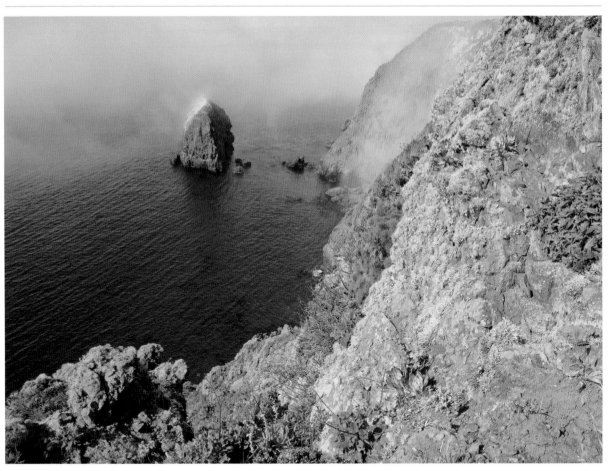

Location: California
Nearest city: Santa Barbara
Coordinates: 34°0'30"N 119°25'0"W
Area: 249,561 acres (100,994 ha)
Established: March 5, 1980
Visitors in 2015: 324,816

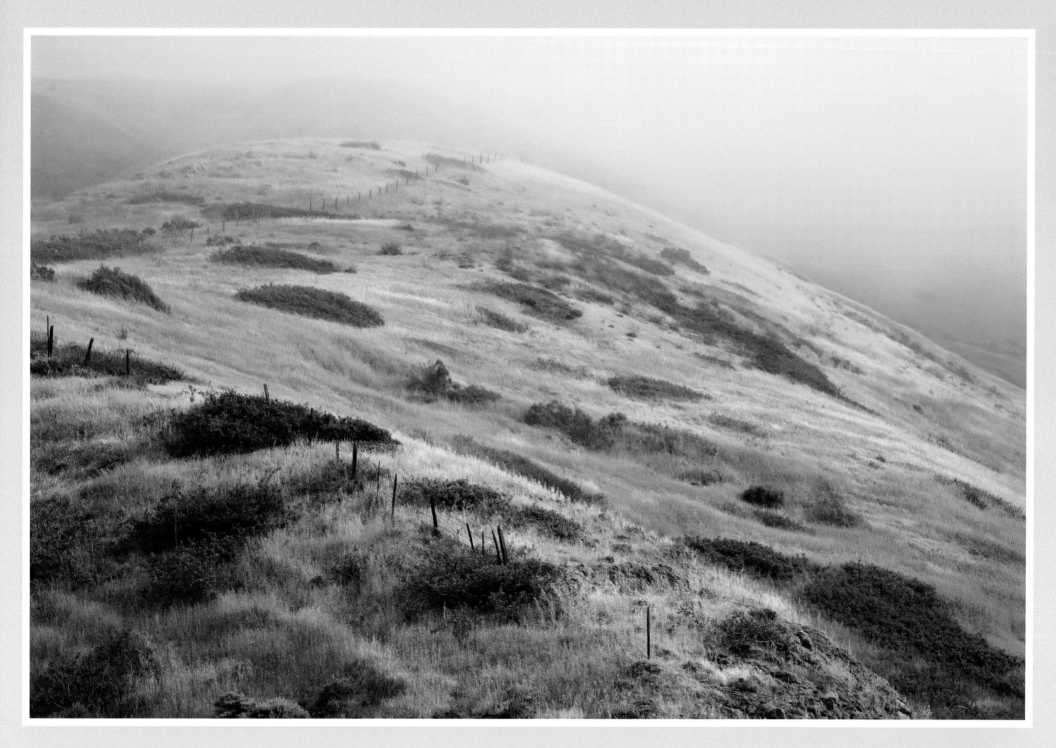

"I have been photographing the Channel Islands for nearly 25 years, and still, when I look out across the waters of the Santa Barbara Channel, the islands tug at my heart to return. Five islands, each with its own unique personality, each with its own beauty, serenity, and solitude. Whether it's the ever-changing vista from Inspiration Point on Anacapa Island, or the rugged, raw, and inhospitable environment of San Miguel Island, the reward of time spent on the islands is not only returning home with another set of photos, but it is also a renewal of my soul."

—Tim Hauf, photographer, 2016

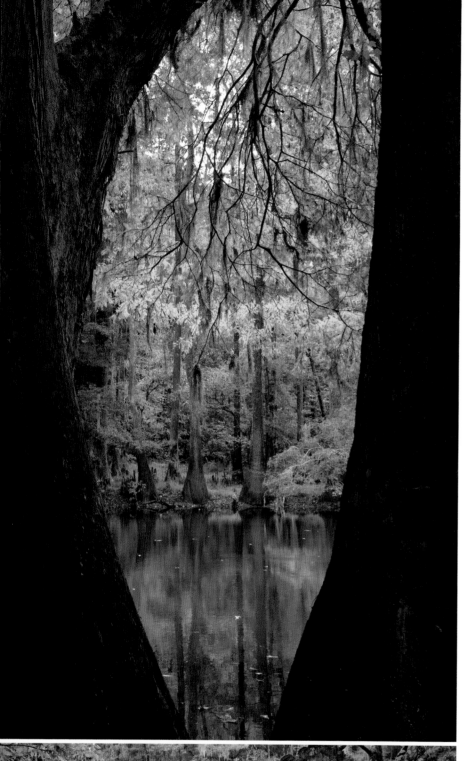

CONGAREE
NATIONAL PARK

The Southern Belle

Congaree is a 26,546 acre hardwood forest, mainly towering, old-growth bald cypresses, growing on a wetland that discouraged the lumber industry. It is technically not a swamp but a floodplain, and this allows visitors to canoe, hike or keep their feet above water by treading the raised boardwalk trail. Under the forest canopy lies the ideal habitat for a diversity of wildlife. A spot of beauty beneath an umbrella of preservation.

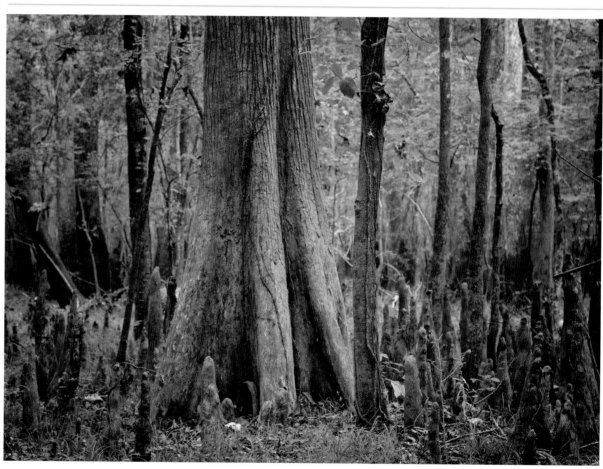

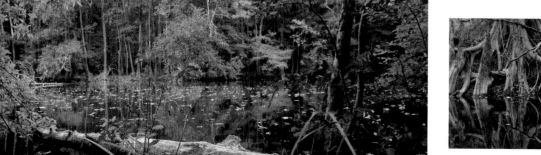

Location: South Carolina
Nearest city: Columbia
Coordinates: 33°47′0″N 80°47′0″W
Area: 26,546 acres (10,743 ha)
Established: November 10, 2003
Visitors in 2015: 87,513

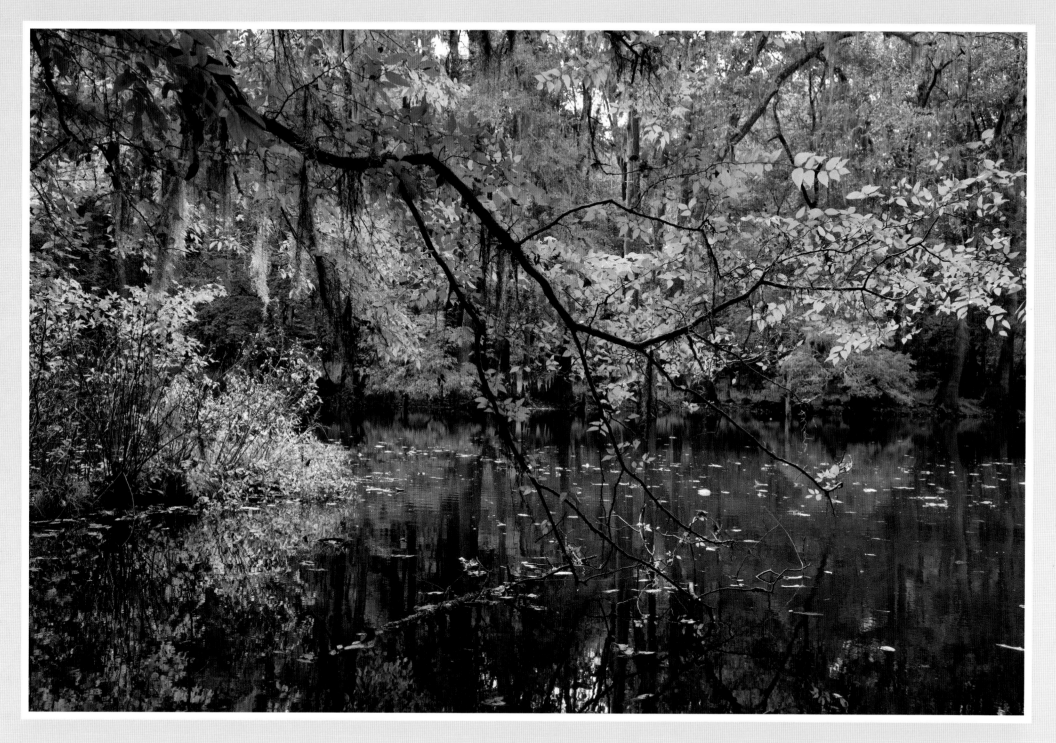

"What is our purpose in preservation, what can be served by hanging onto these pitifully small remnants of virgin forest land? Gentlemen, why are we celebrating a Bicentennial? I hope not to just remind ourselves of past glory . . . So, also, should we celebrate and preserve the Congaree. For it could be, in its pristine wholeness, not only a reminder of the great forests which once existed, but also an inspiration for all of the American people."

—Ed Easton,
Sierra Club regional leader, 1976

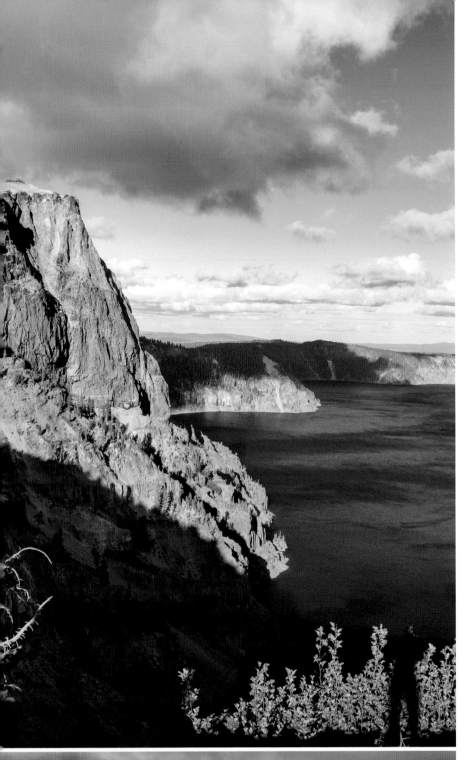

CRATER LAKE
NATIONAL PARK

A Real Showstopper

Within the ancient volcano Mount Mazama lies a lake so deep and blue that the surrounding cliffs and the two small volcanic islands become the supporting act. Whether these cliffs are buried in snow, or bare and showing the beautiful colors of their rugged skin, a more stunning sight is hard to find. A colorful sunrise, a passing storm or a summer sunset warrants a standing ovation for Mother Nature's performance.

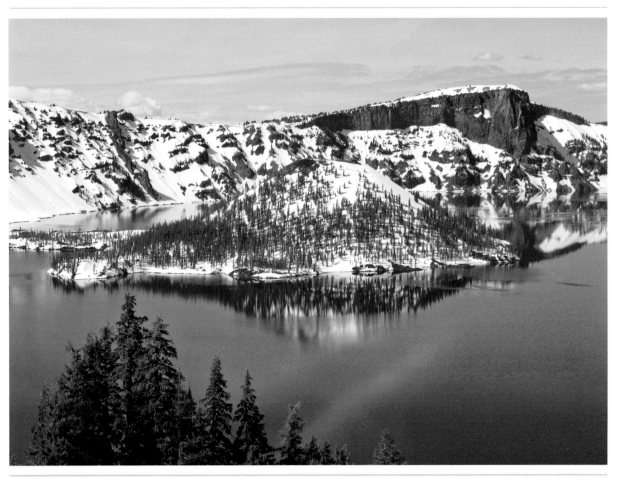

Location: Oregon
Nearest city: Klamath Falls
Coordinates: 42°54'43"N 122°08'53"W
Area: 183,225 acres (74,149 ha)
Established: May 22, 1902
Visitors in 2015: 614,712

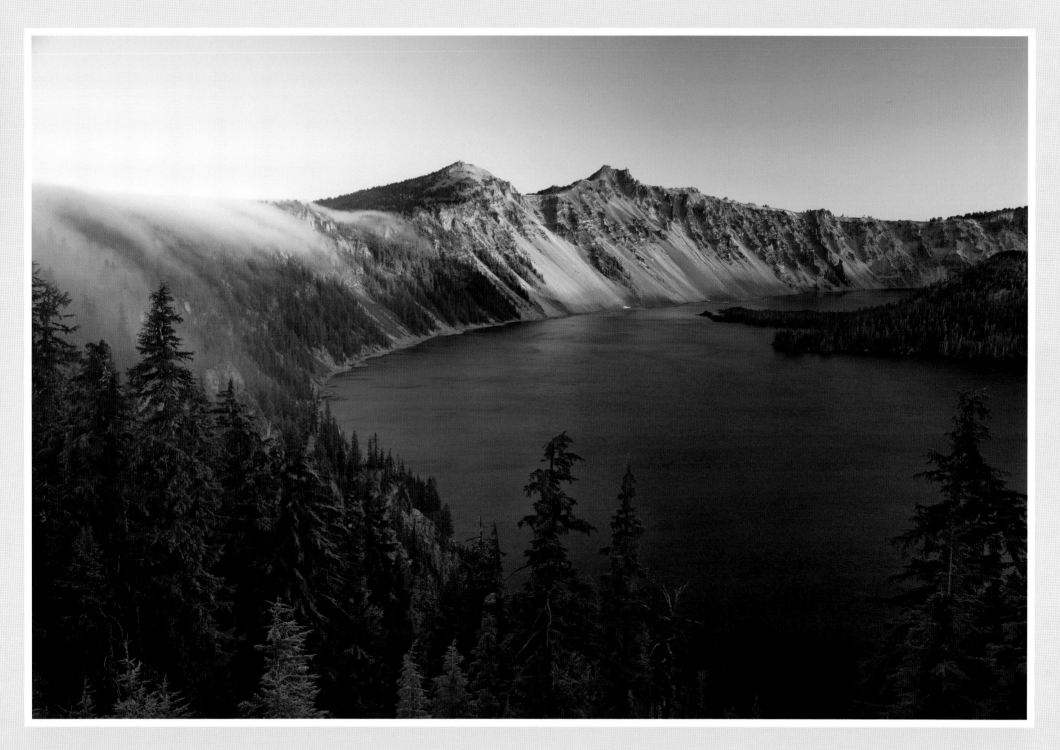

"I thought I had gazed upon everything beautiful in nature as I have spent my years traveling thousands of miles to visit the beauty spots of the earth, but I have reached the climax. Never again can I gaze upon the beauty spots of the earth and enjoy them as being the finest thing I have ever seen. Crater Lake is above them all."

—Jack London, author, 1911

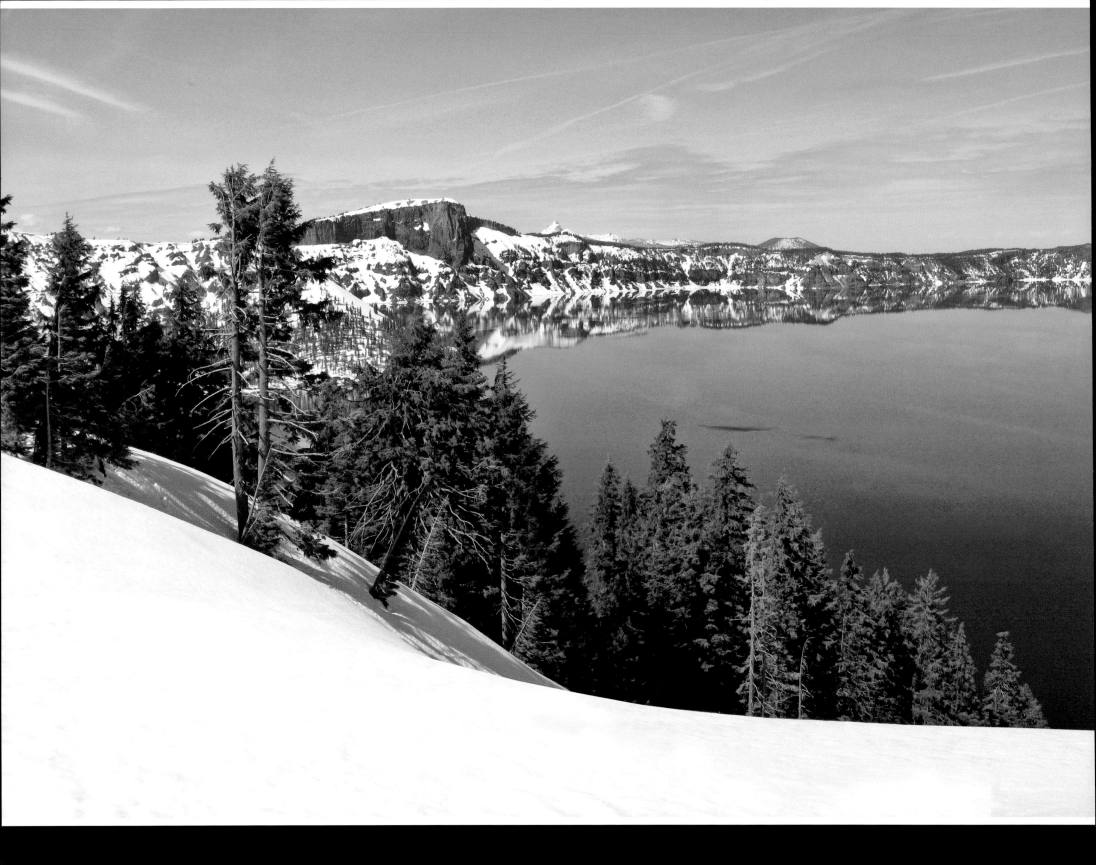

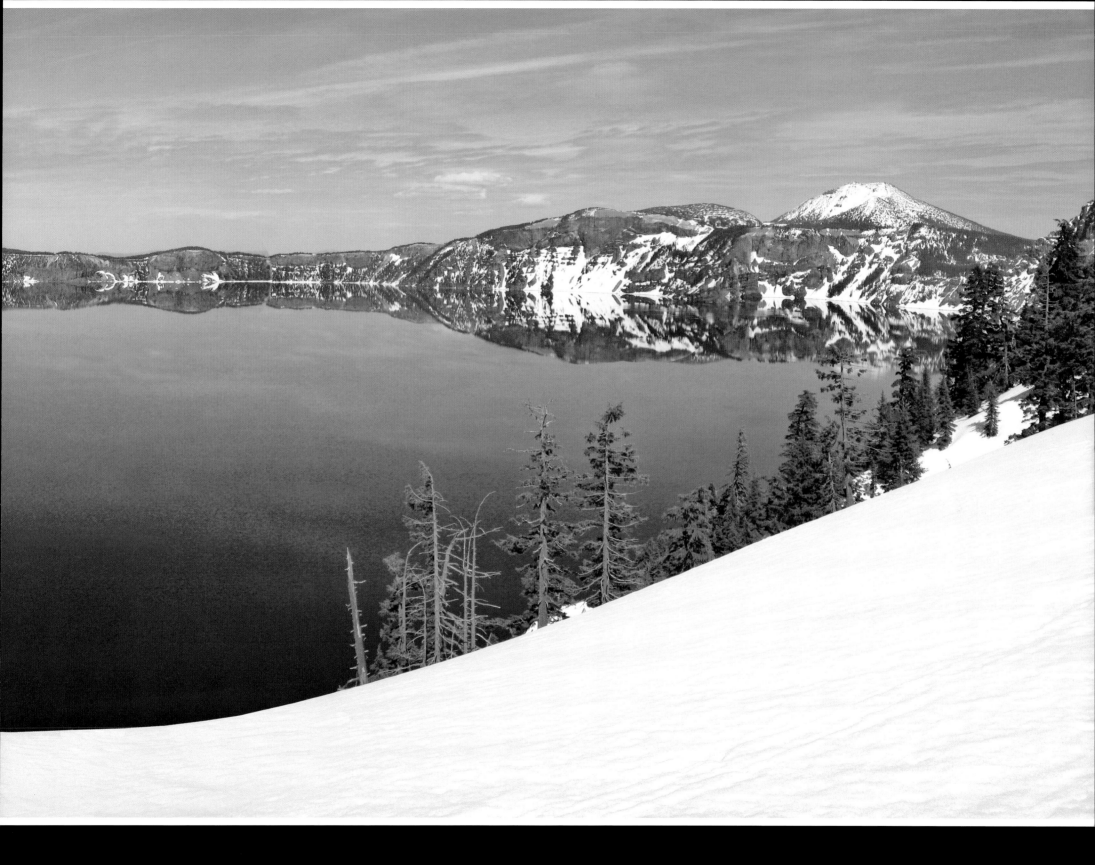

CUYAHOGA VALLEY
NATIONAL PARK

An Urban Oasis

Known as the "crooked river," Cuyahoga has been rescued from a polluted past and now provides recreation and entertainment for many locals and visitors. This is a sanctuary, with its beautiful waterfalls, hills and rugged ledges. The Towpath Trail (historically used by mules to tow canal boats) is widely used today by walkers and cyclists. In such close proximity to urban living, this is a haven for birdlife and birdwatchers alike.

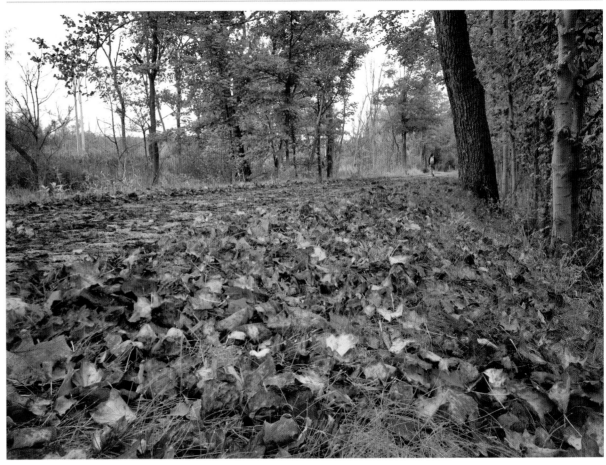

Location: Ohio
Nearest city: Akron
Coordinates: 41°14'30"N 81°32'59"W
Area: 32,832.03 acres (13,286.65 ha)
Established: October 11, 2000
Visitors in 2015: 2,284,612

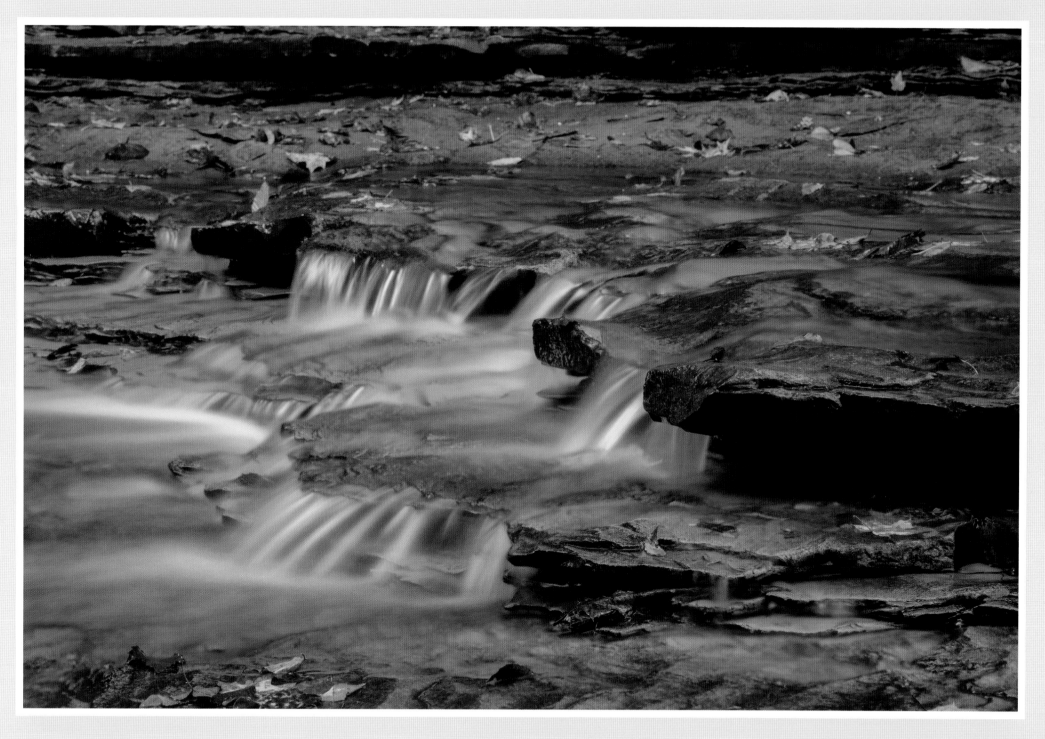

"The Cuyahoga River twists and lingers in the park—it seems as if it's not anxious to emerge into the steel mills and other industrial development farther downstream."

—David Longfellow, photographer, 2015

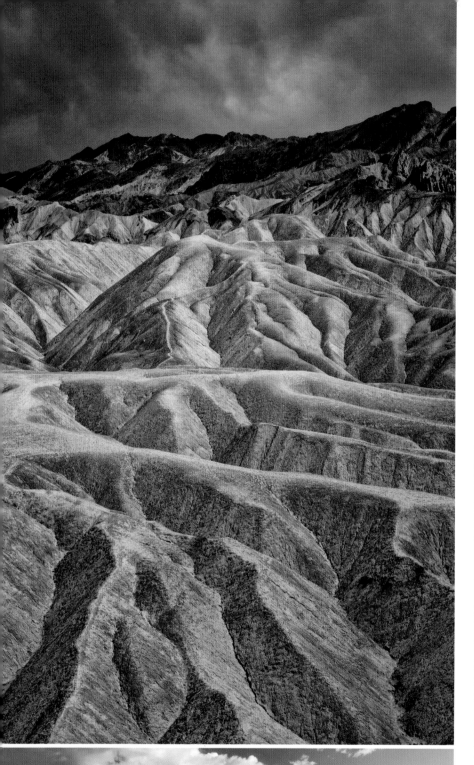

DEATH VALLEY
NATIONAL PARK

A Cauldron of Extremes

Even though Death Valley is America's hottest and driest place, a snowflake survives when it falls on top of the Black Mountains at Dante's View. And though rare, it's not impossible to feel a raindrop when walking across the lowest point in North America, on Badwaters' salt-encrusted basin. The park's reputation for record high temperatures may precede this amazing landscape, but the encompassing desert, canyons and dunes that sustain a diverse range of wildlife are definitely worth a trip into the cauldron.

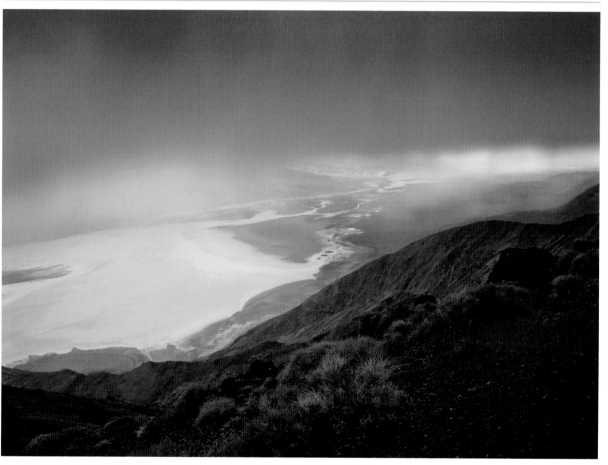

Location: California and Nevada
Nearest city: Lone Pine, California; Beatty, Nevada
Coordinates: 36°14'31"N 116°49'33"W
Area: 3,373,063 acres (1,365,030 ha)
Established: October 31, 1994
Visitors in 2015: 1,154,843

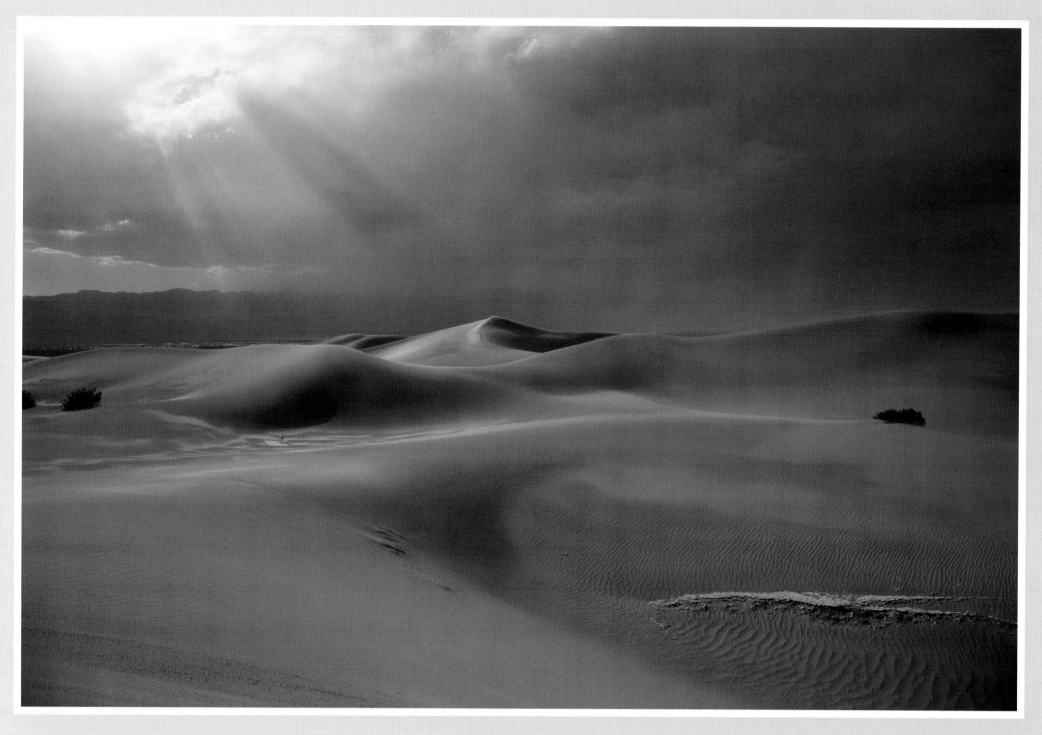

"Death Valley is a microcosm of what I find so amazing about photography, and even the planet in general: the more you look, the more you see. At first glance it might appear to be a barren wasteland, endless in its brown and gold monotony. But once you begin to dig under the surface its wonders unfold before you in a surprising show of the unexpected, the bizarre, and the beautiful. Before you know it the place has grabbed you and pulled you bodily in."

—Joshua Cripps,
Sea to Summit Photography Workshops, 2015

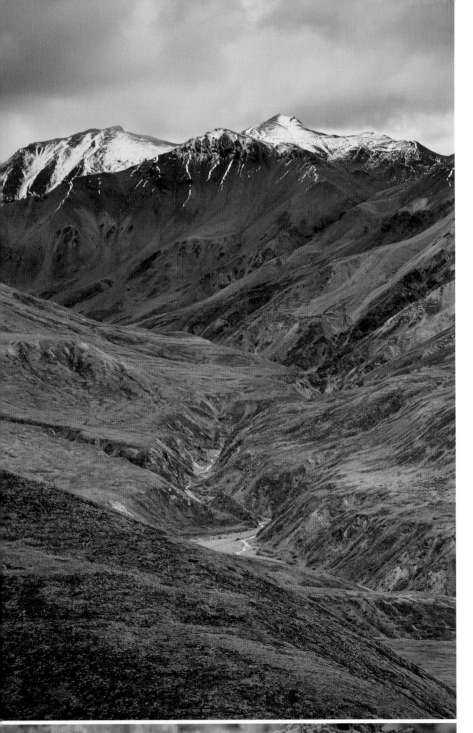

DENALI
NATIONAL PARK AND PRESERVE

One Road to Wonder

Travel the ninety-two miles along a single road within six million acres of wilderness and feel like you have been transported into a land that time forgot. Grizzly bears graze, Dall sheep balance high on the mountains, caribou roam, wolves hunt and moose muscle up for the rut. A golden eagle will soar off the cliffs at colorful Polychrome Pass, and should the clouds clear to reveal the 20,310 feet of the highest mountain in North America, Mount Denali, you will swear you're in heaven.

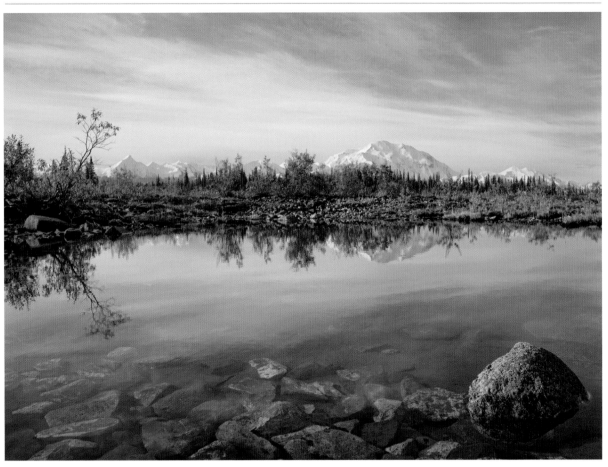

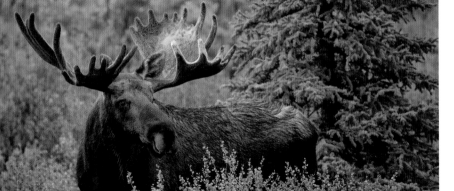

Location: Alaska
Nearest city: Healy
Coordinates: 36°14'31"N 116°49'33"W
Area: 4,740,911 acres (1,918,578 ha) (park) and
 1,304,242 acres (527,808 ha) (preserve)
Established: February 26, 1917
Visitors in 2015: 560,757

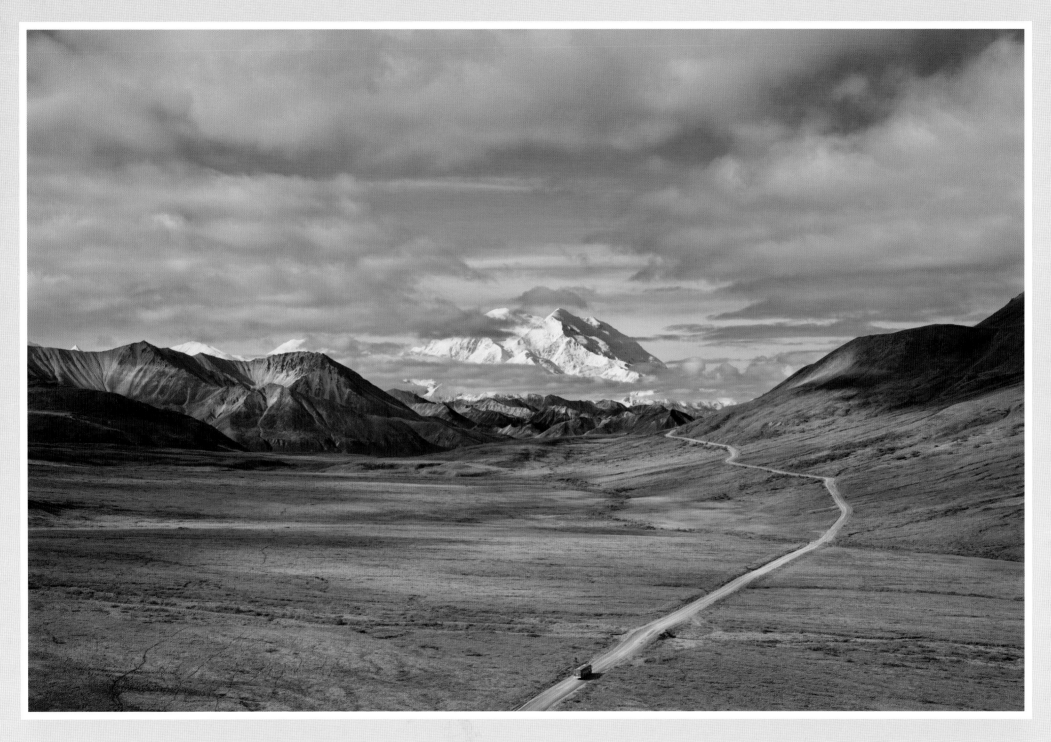

"This forest ought to be withdrawn from disposal and preserved for the use of those who shall come after us to explore the highest and most royal of American mountains."

—James Wickersham,
first white man to attempt to climb Mount Denali, 1903

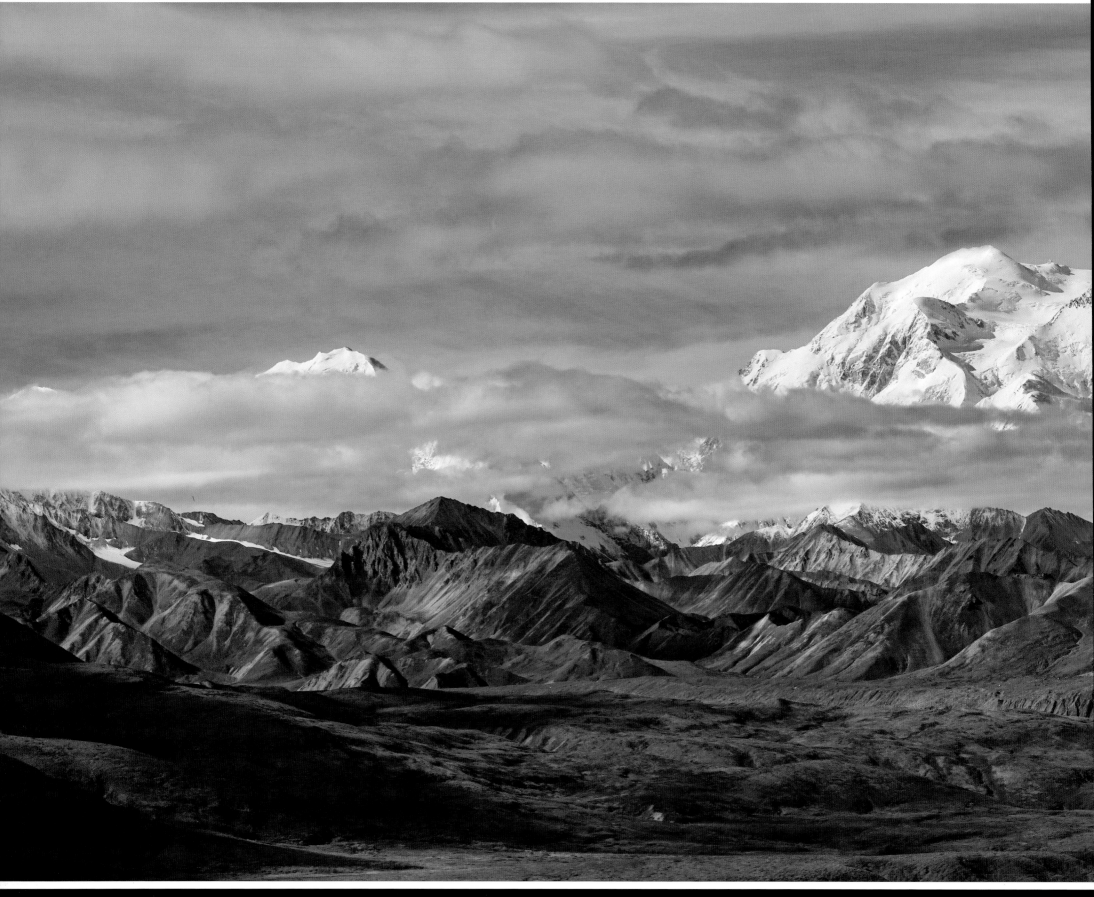

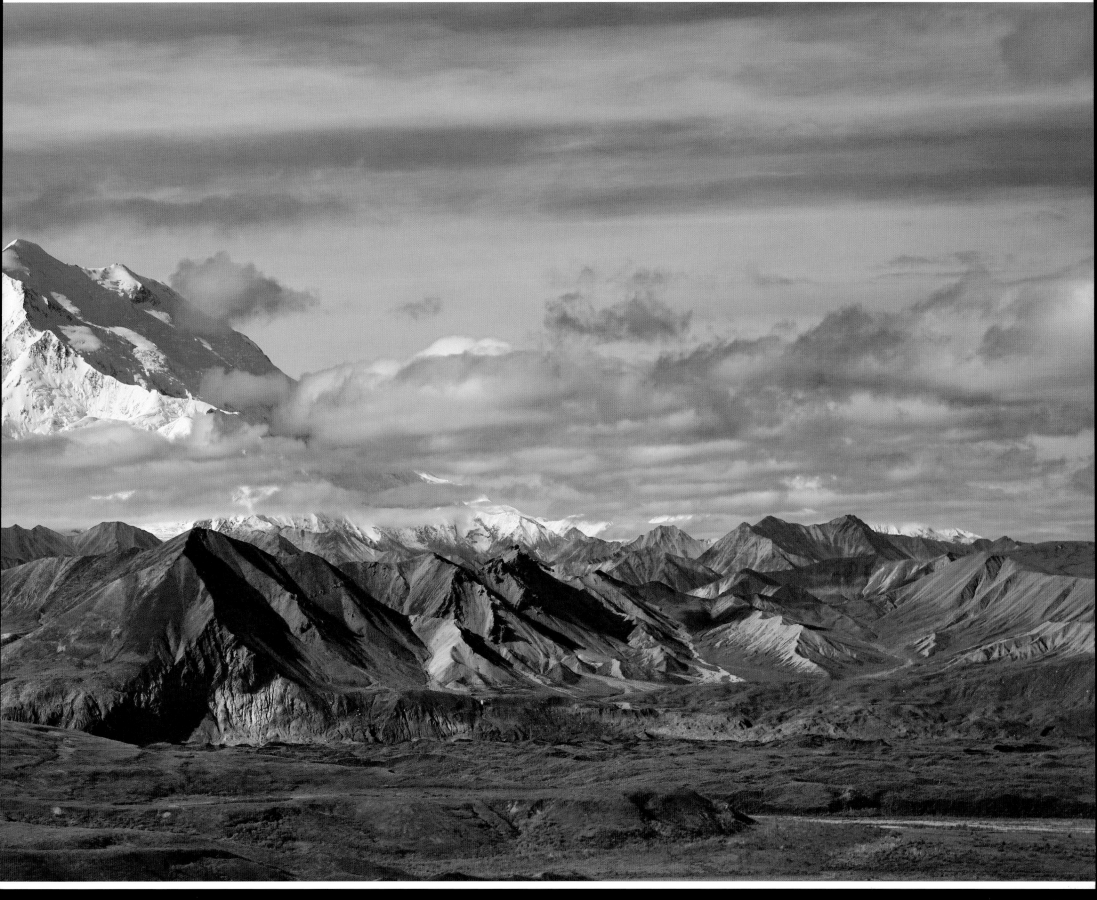

DRY TORTUGAS
NATIONAL PARK

More than Sixteen Million Bricks!
Can you believe it? It took more than sixteen million bricks to build this six-sided fort out in the remote waters of the Gulf of Mexico. Never finished, nor fully armed, a relic of nineteenth-century military strategy, it sits just seventy nautical miles west of Key West, Florida. Surrounded by brilliant blue water, glorious coral reefs and tiny islands with abundant bird and marine life, it is only accessible by boat or plane. Take the family or go alone and discover a beautiful place to be cast ashore.

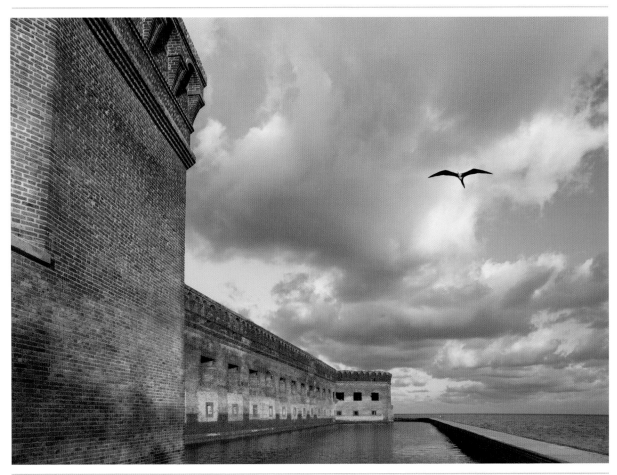

Location: Florida
Nearest city: Key West
Coordinates: 24°37'43"N 82°52'24"W
Area: 64,701 acres (26,184 ha)
Established: October 26, 1992
Visitors in 2015: 70,862

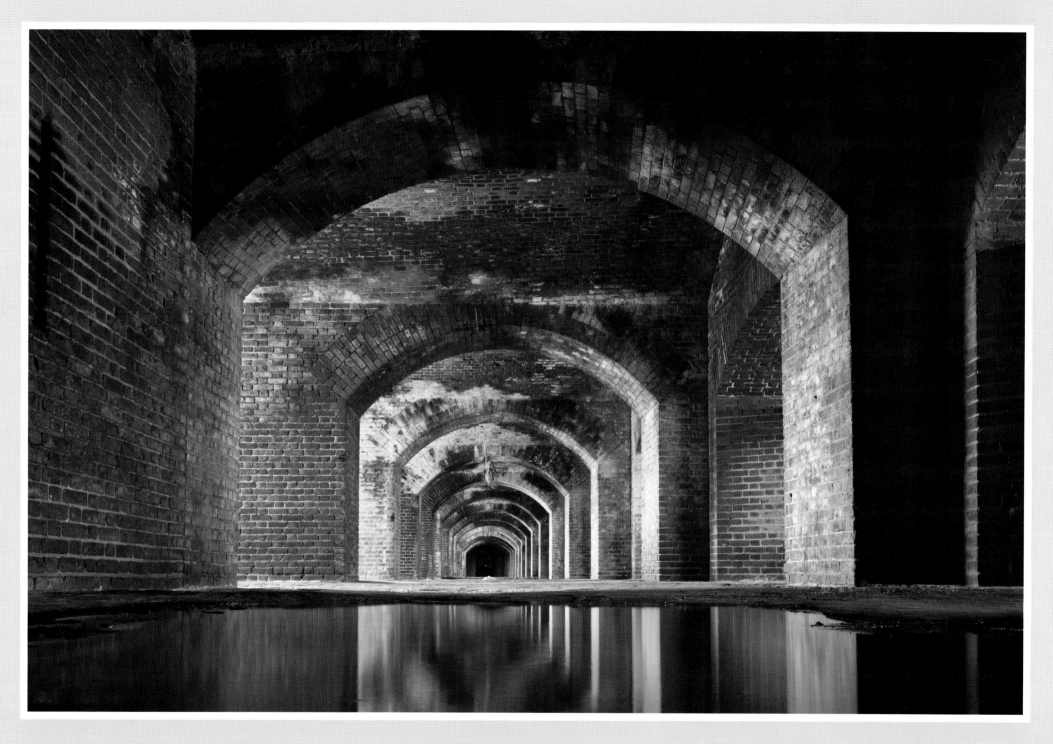

"His stories were what frightened people worst of all. Dreadful stories they were—about hanging, and walking the plank, and storms at sea, and the Dry Tortugas . . . "

—*Robert Louis Stevenson,*
Treasure Island

EVERGLADES
NATIONAL PARK
FLORIDA

More Than Gators!
This large subtropical wilderness, which is virtually flat, is positioned on the edge of a rising ocean. Established to preserve a portion of this vast ecosystem as a wildlife habitat, it also has a fascinating history. You will see plenty of wildlife and, yes, that includes gators!

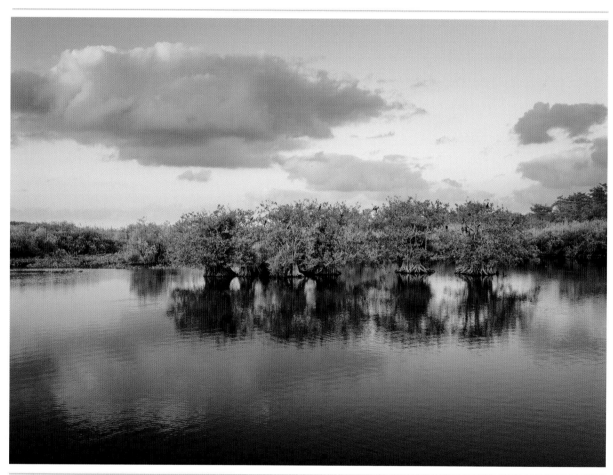

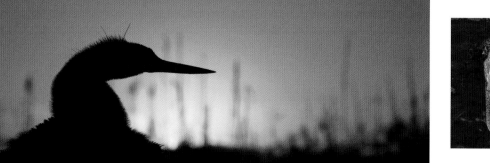

Location: Florida
Nearest city: Florida City
Coordinates: 25°19'0"N 80°56'0"W
Area: 1,508,538 acres (610,484 ha)
Established: December 6, 1947
Visitors in 2015: 1,077,427

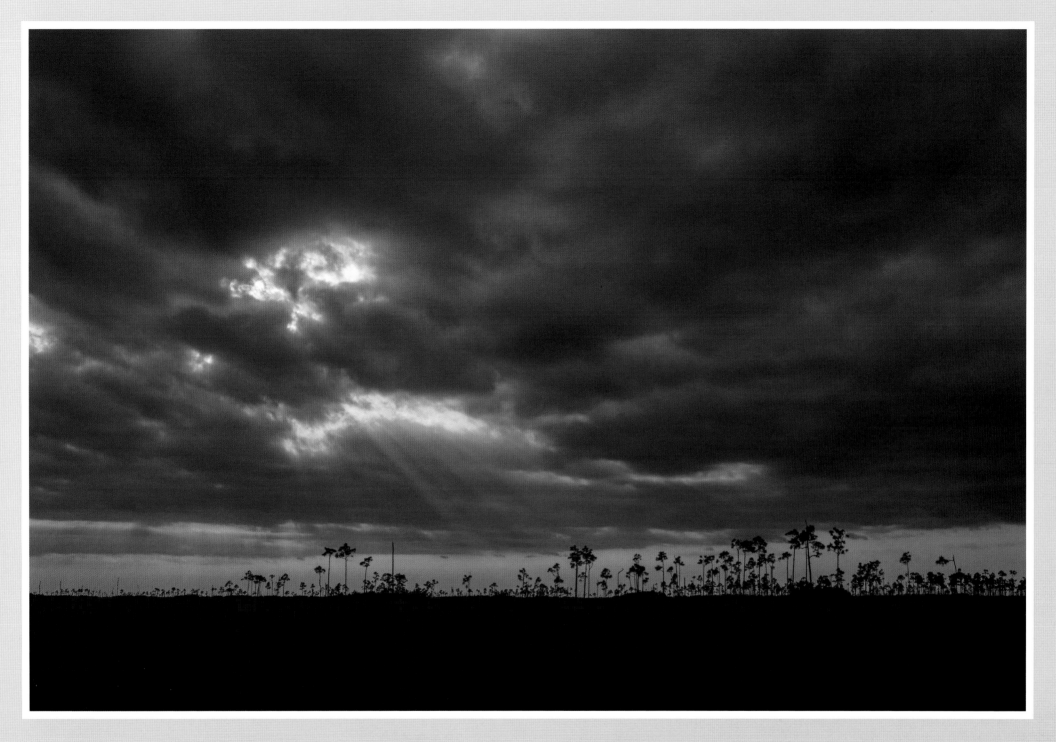

"Here are no lofty peaks seeking the sky, no mighty glaciers or rushing streams wearing away the uplifted land. Here is land, tranquil in its quiet beauty, serving not as the source of water, but as the last receiver of it. To its natural abundance we owe the spectacular plant and animal life that distinguishes this place from all others in our country."

—Harry S. Truman, thirty-third president of the United States,
address at the dedication of Everglades National Park,
December 6, 1947

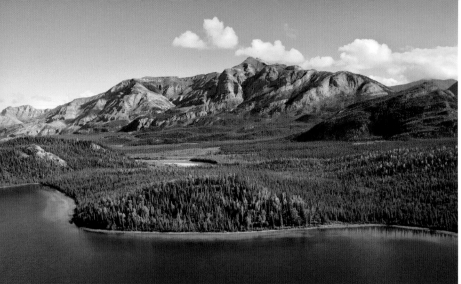

GATES OF THE ARCTIC
NATIONAL PARK AND PRESERVE

Sense-ational Wilderness

You are surrounded by arctic tundra, ancient mountains, long and meandering rivers, and clear lakes. Your feet are wet, submerged in a dense carpet of arctic moss. The environment is practically devoid of human interference, changed only by the forces of nature. Try to find your place within this untamed world of land and animal. If you struggle, just stand still, use all your senses and become one with the wilderness. They say, "leave no trace," but you will leave a piece of your heart!

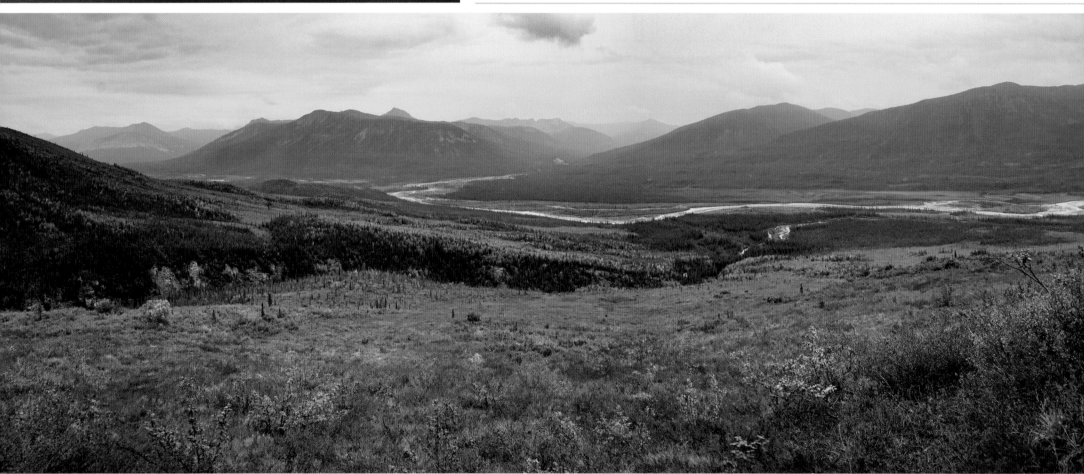

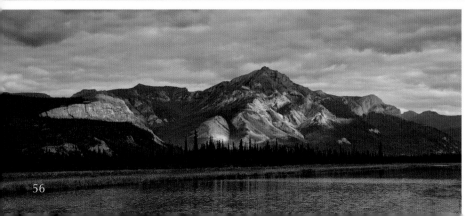

Location: Alaska
Nearest city: Bettles
Coordinates: 67°41'07"N 153°19'31"W
Area: 8,472,506 acres (3,428,702 ha)
Established: December 2, 1980
Visitors in 2015: 10,745

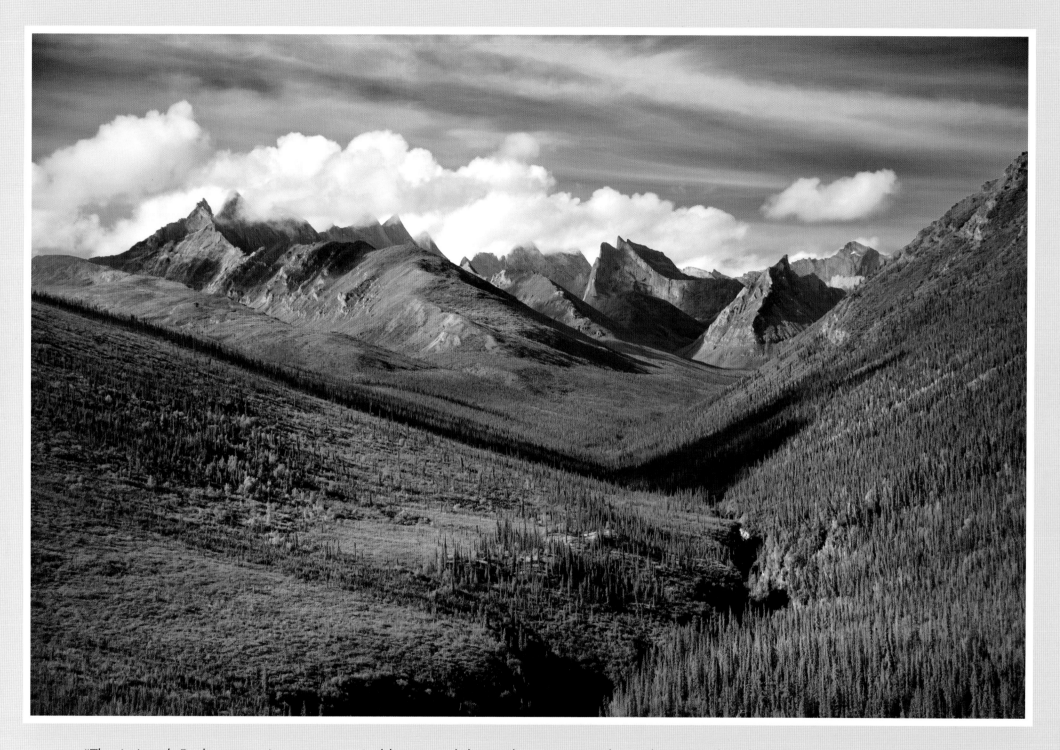

"The Arrigetch Peaks appear in every conceivable way and shape: there are rugged, weather-scarred peaks, lofty minarets, cathedral spires, high towers and rounded domes; with circular knobs, flat tops, sharp edges, serrated ridges and smooth backbones. These fantastic shapes form the summits of bare, perpendicular mountains."

—Naval Lieutenant George Stoney, 1884

GLACIER
NATIONAL PARK

Nature Is Calling

Stunning alpine lakes, with beds of colorful glacial tumbled rocks and stones, mirror the rugged mountain backdrop. Meadows and pristine forests are home to the park's flora and fauna. Mountains are laden with glaciers, so waterfalls adorn rocks and streams. There are miles of trails to lose yourself in, all wrapped in nature's beautiful mantle. There is so much to do and see in this park. I have to go back!

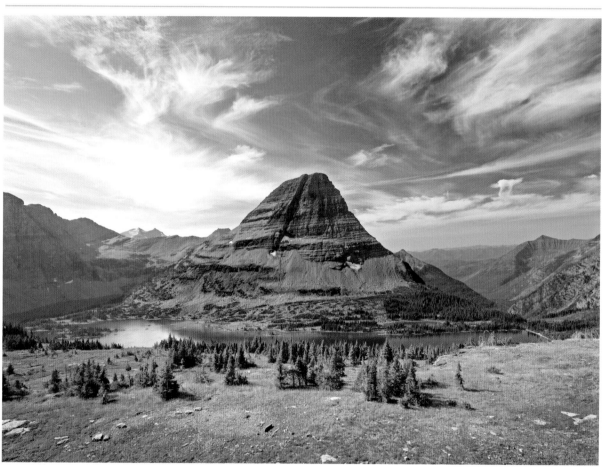

Location: Montana
Nearest city: Kalispell
Coordinates: 48°41'48"N 113°43'6"W
Area: 1,013,322 acres (410,976 ha)
Established: May 11, 1910
Visitors in 2015: 2,366,056

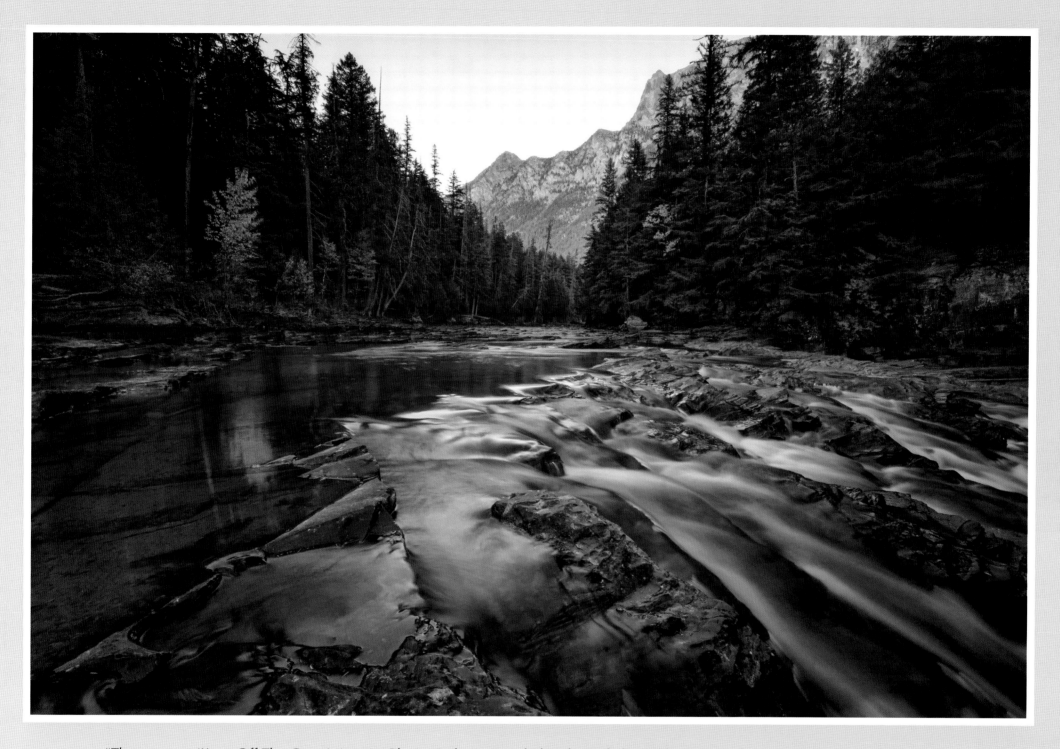

"There are no 'Keep-Off-The-Grass' signs in Glacier Park, no graveled paths and clipped lawns. It is the wildest part of America. If the Government had not preserved it, it would have preserved itself."

—Mary Roberts Rinehart
Through Glacier Park, *1916*

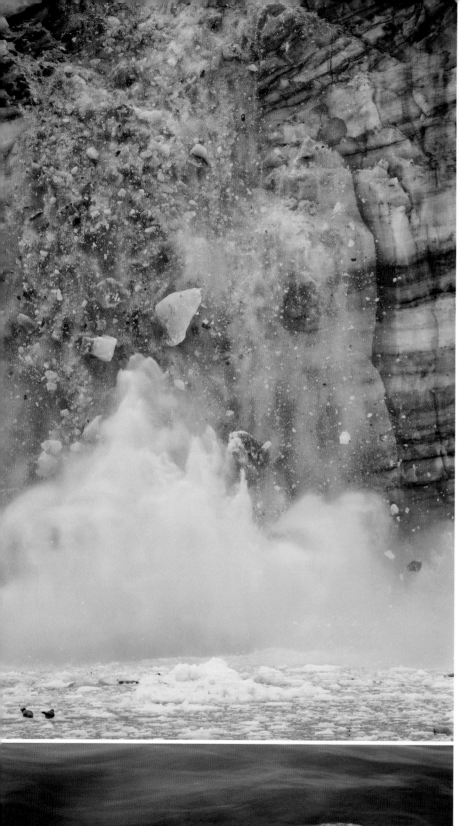

GLACIER BAY
NATIONAL PARK AND PRESERVE

The Reveal of the Centuries

Just over two hundred years ago, this bay was an ice field. Now more than sixty-five miles of the bay are open, allowing access to more of the Alaskan coast than before. From the water, view the Fairweather Range, where the mountains are dotted with wildlife. Approach a seasonal breeding area for harbor seals against the backdrop of a tidewater glacier. Listen for the mighty crack of the ice calving, which is followed by the sight of massive ice blocks falling into the sea. Does it get any better than this?

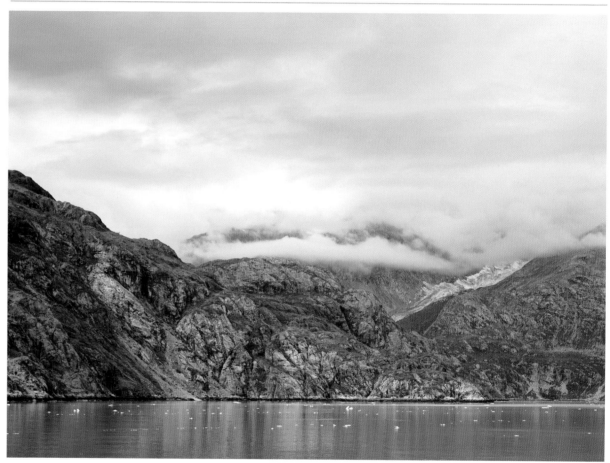

Location: Alaska
Nearest city: Juneau
Coordinates: 48°41'48"N 113°43'6"W
Area: 3,223,384 acres (1,304,457 ha)
Established: December 2, 1980
Visitors in 2015: 551,353

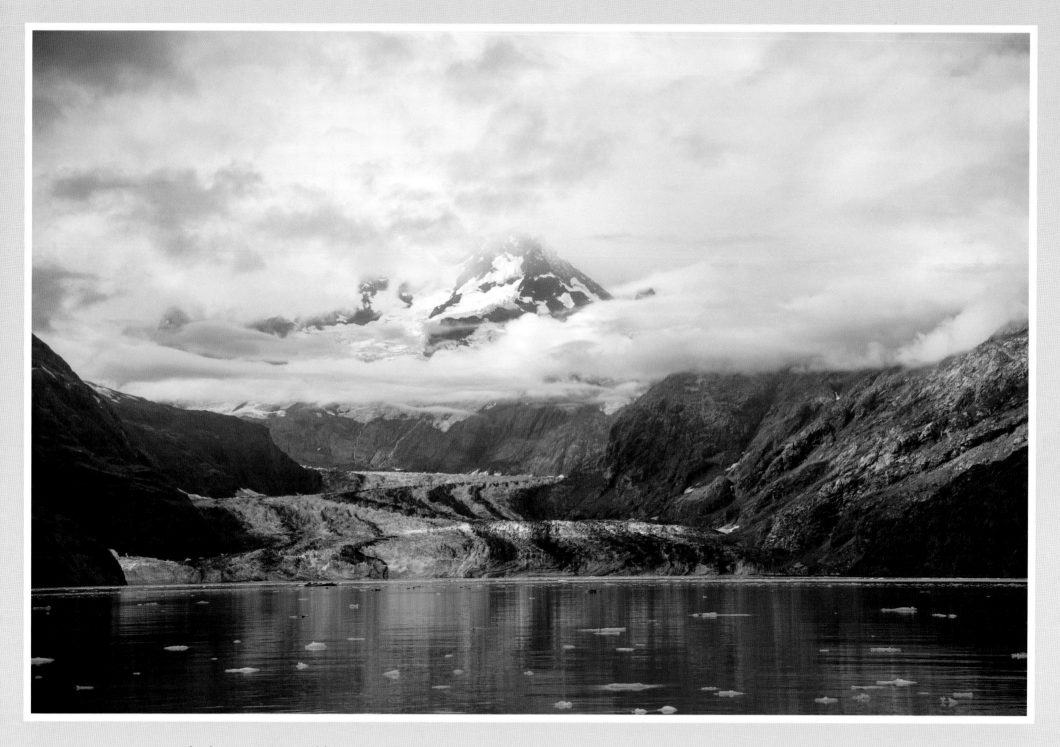

"The bay is terminated by compact and solid mountains of ice, rising perpendicular from the water's edge . . ."

—Captain George Vancouver, 1794

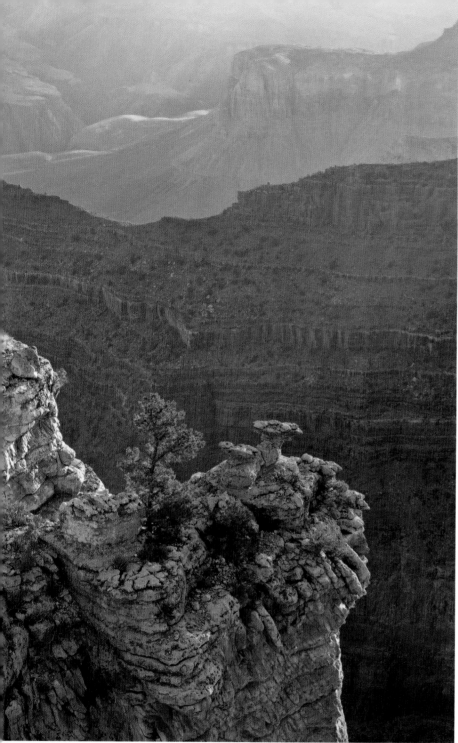

GRAND CANYON
NATIONAL PARK

She's a Grand Old Lady!

If you arrive at the Grand Canyon on a cloudy day, with her ancient rock totally obscured from view, be happy and be patient. There is nothing that compares with the awe and joy experienced when she decides to lift her veil. A slow and teasing reveal, coupled with the sound of gasps and cheers from fellow onlookers, creates an unforgettable experience. Up to eighteen miles wide, a mile deep and 277 river miles long, she commands respect. The weather is her cloak, wrapping around her rises and curves and dominating the extreme temperatures from rim to river.

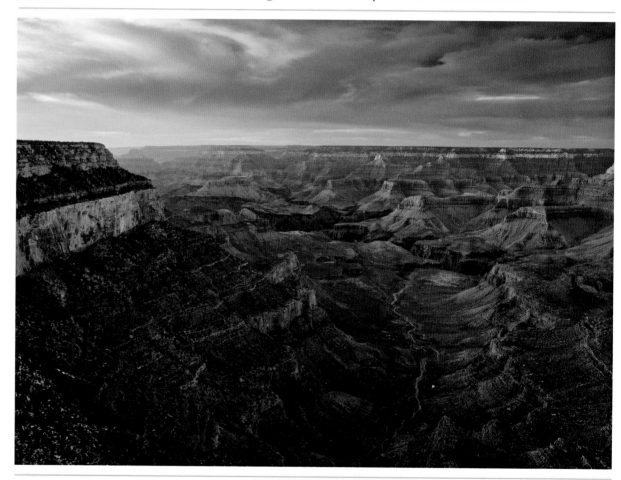

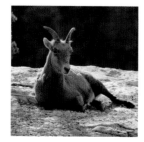

Location: Arizona
Nearest city: Fredonia (North Rim), Tusayan (South Rim)
Coordinates: 36°03'19"N 112°07'19"W
Area: 1,217,262 acres (492,608 ha)
Established: February 26, 1919
Visitors in 2015: 5,520,736

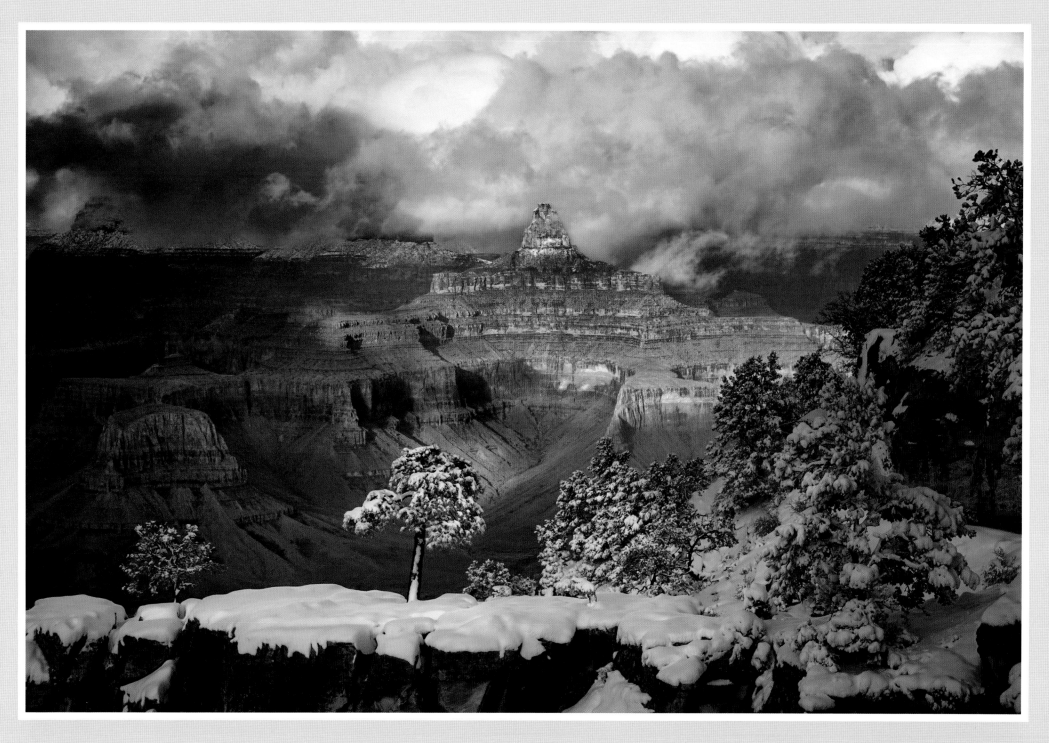

"You cannot see the Grand Canyon in one view, as if it were a changeless spectacle from which a curtain might be lifted, but to see it, you have to toil from month to month through its labyrinths."

—John Wesley Powell, Powell Geographic Expedition,
first known passage through the Grand Canyon
by Europeans, 1869

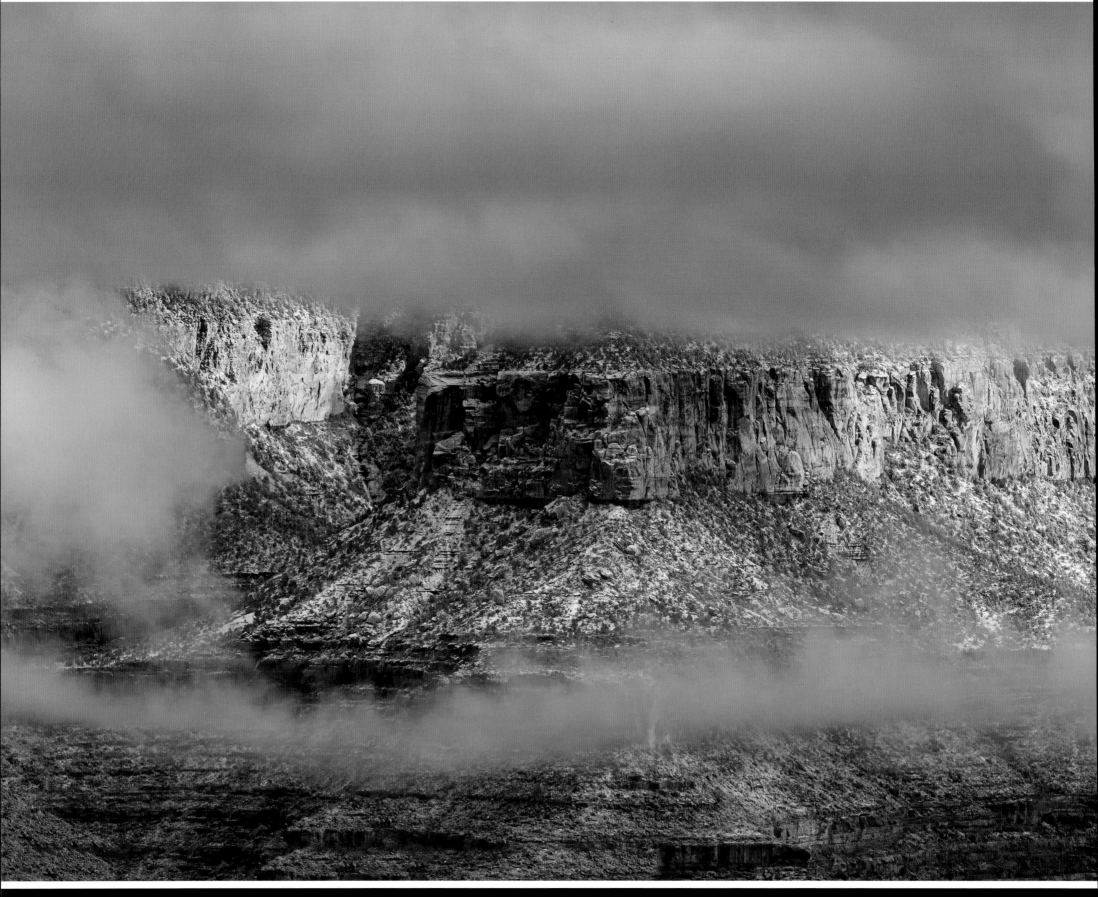

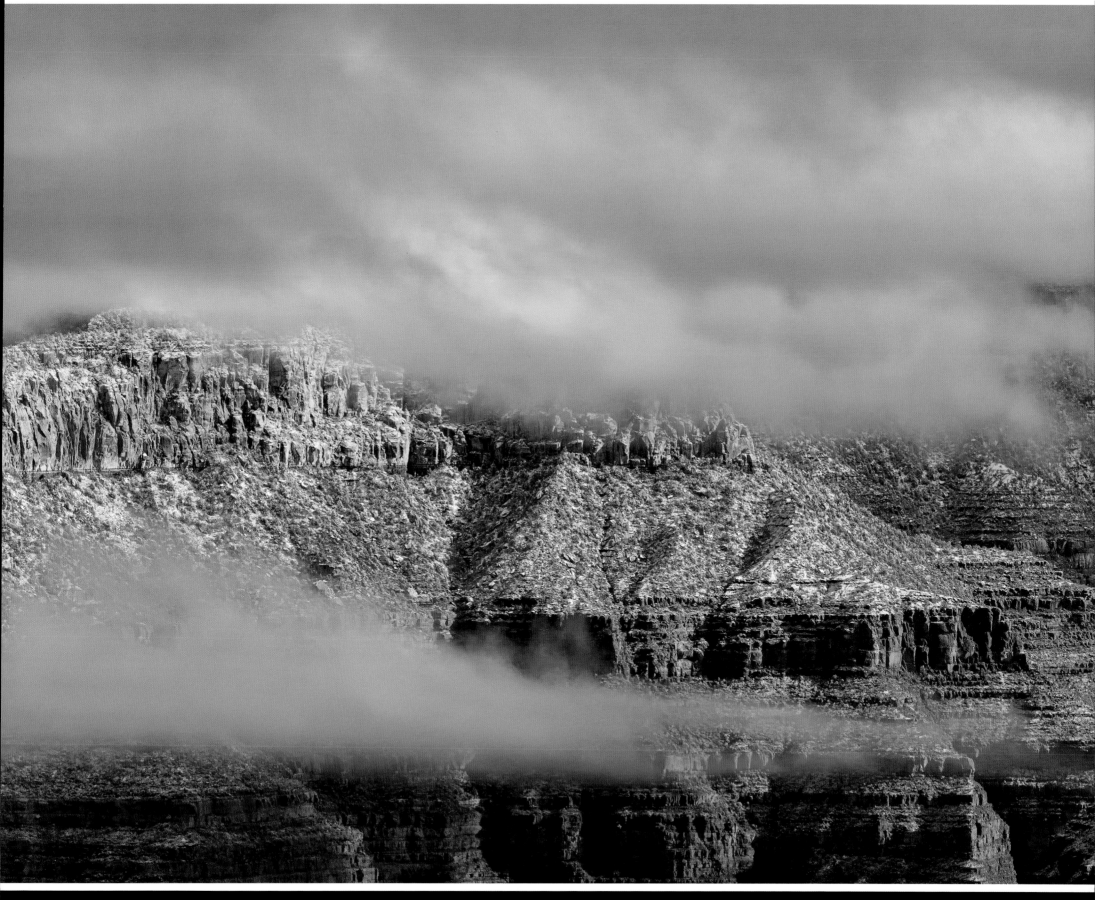

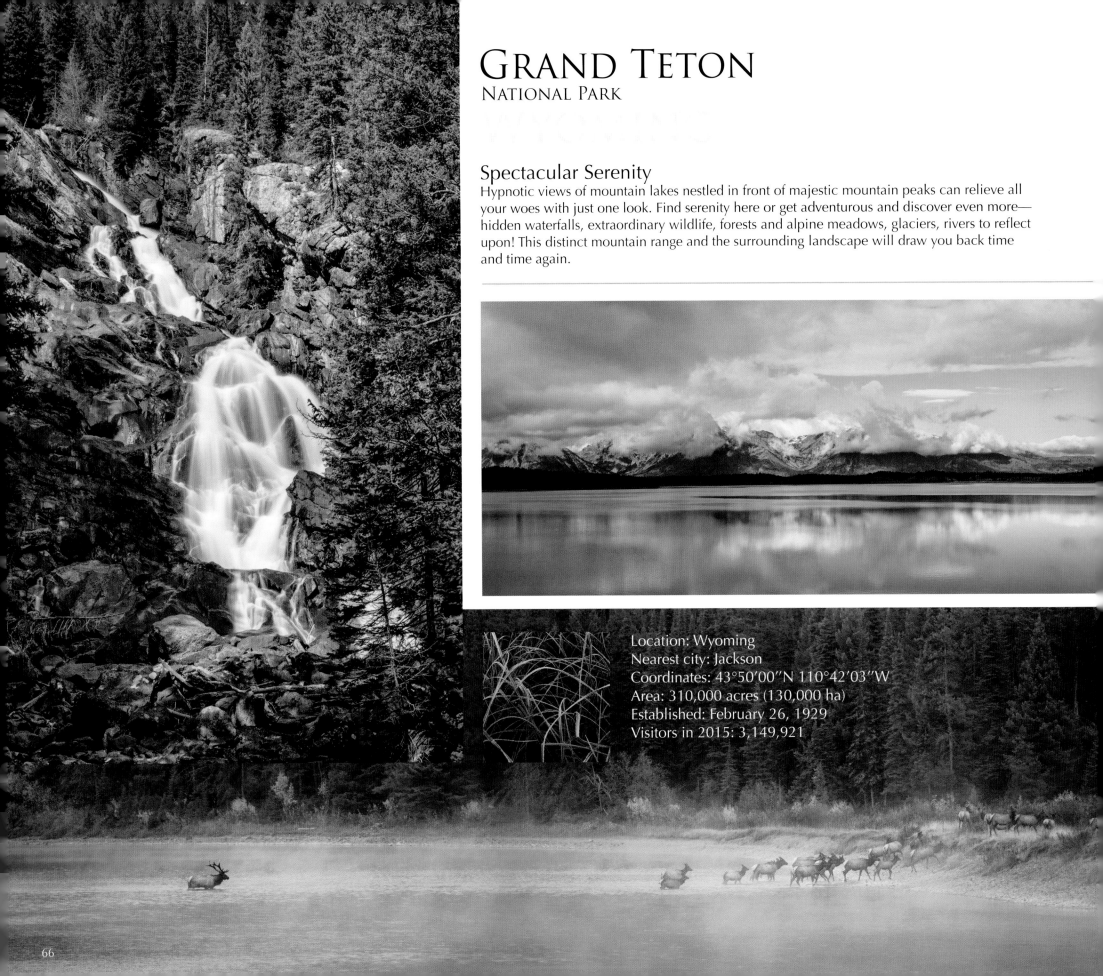

GRAND TETON
NATIONAL PARK

Spectacular Serenity

Hypnotic views of mountain lakes nestled in front of majestic mountain peaks can relieve all your woes with just one look. Find serenity here or get adventurous and discover even more—hidden waterfalls, extraordinary wildlife, forests and alpine meadows, glaciers, rivers to reflect upon! This distinct mountain range and the surrounding landscape will draw you back time and time again.

Location: Wyoming
Nearest city: Jackson
Coordinates: 43°50'00"N 110°42'03"W
Area: 310,000 acres (130,000 ha)
Established: February 26, 1929
Visitors in 2015: 3,149,921

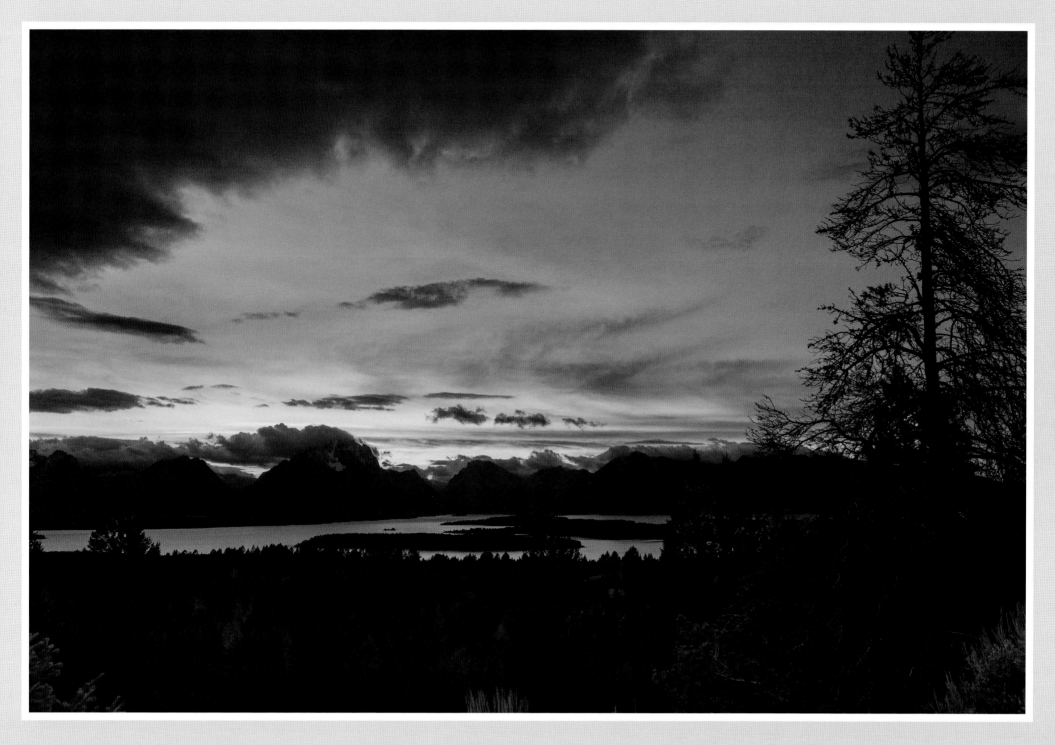

"There are few spots in the Western mountain lands about which there hangs so much frontier romance with the quite exceptional natural beauty of the spot."

—*William Baillie-Grohman, English mountaineer,1882*

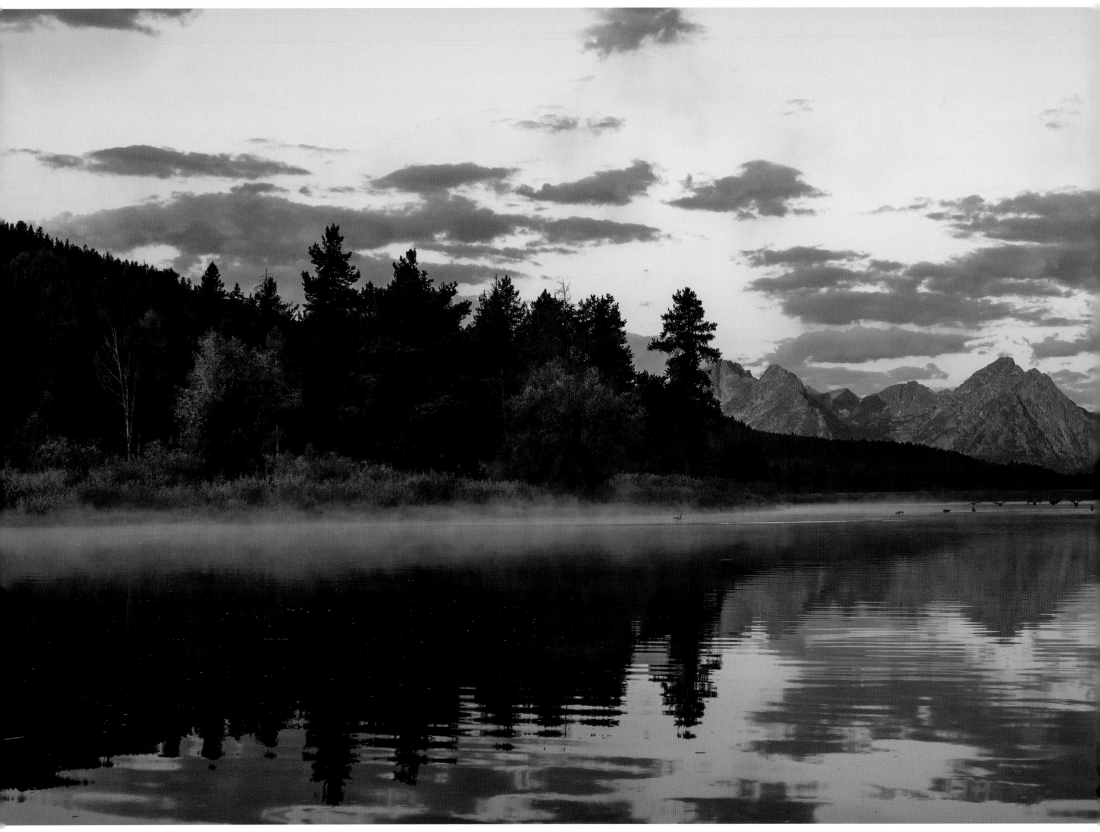

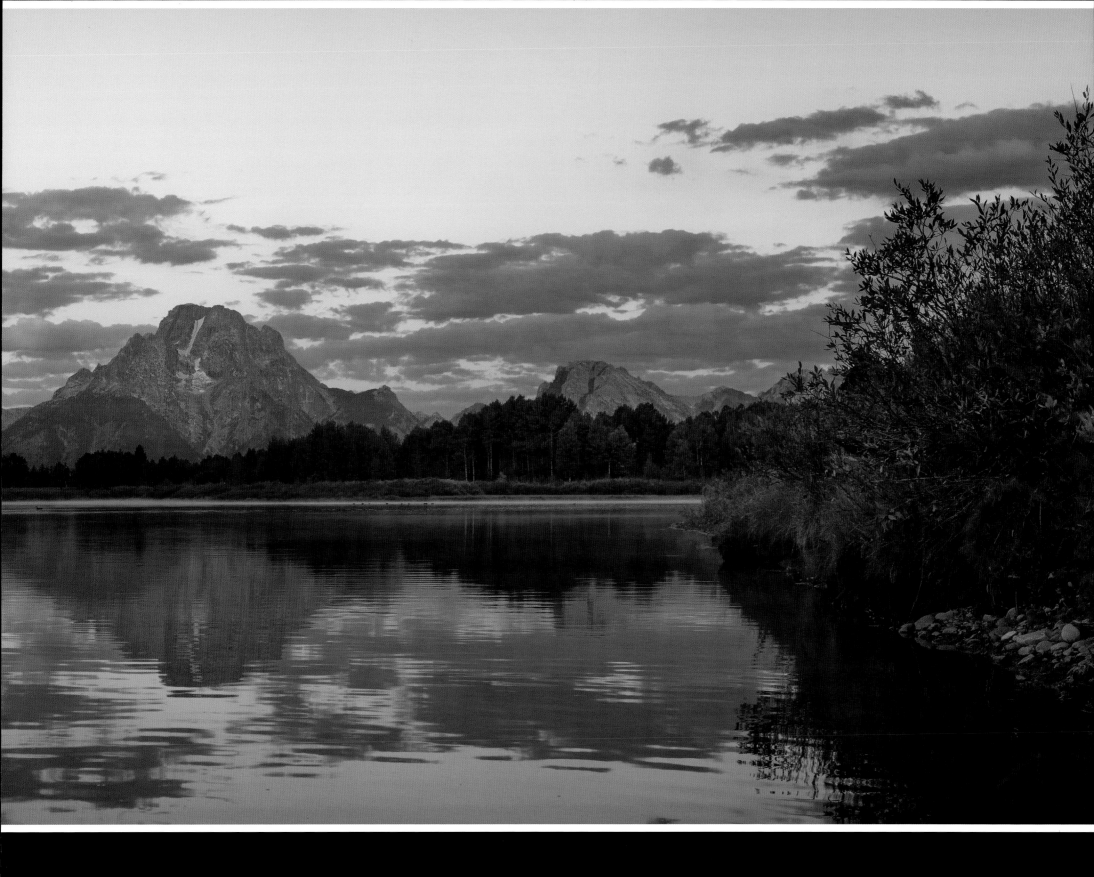

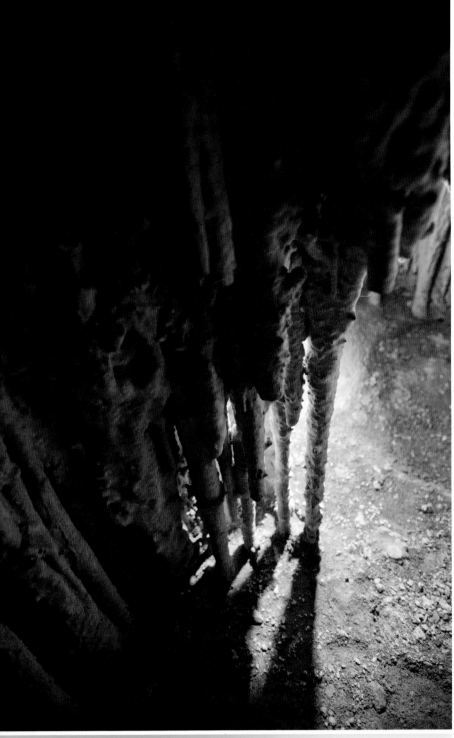

GREAT BASIN
NATIONAL PARK

Life in the Desert

If Wheeler Peak at 13,063 feet high doesn't impress from a distance, hike its rocky glacial moraines and trails, pausing to contemplate the age of the bristlecone pine trees, some as old as five thousand years. Enjoy a walk through the underground passages of Lehman Caves, which showcase over three hundred rare shield formations, or admire the grand sweeping views of the basin where all rivers flow inland, not to any ocean.

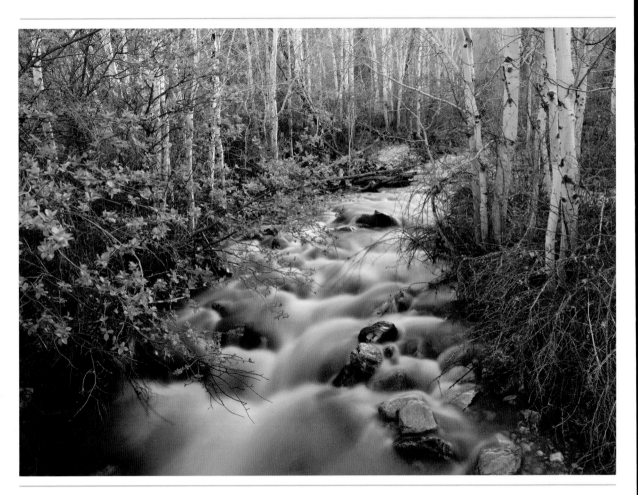

Location: Nevada
Nearest city: Ely
Coordinates: 39°00'21"N 114°13'11"W
Area: 77,180 acres (31,230 ha)
Established: October 27, 1986
Visitors in 2015: 116,123

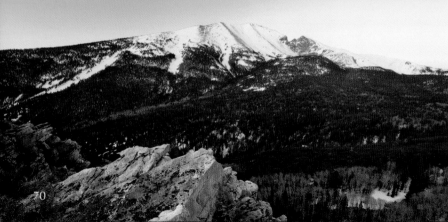

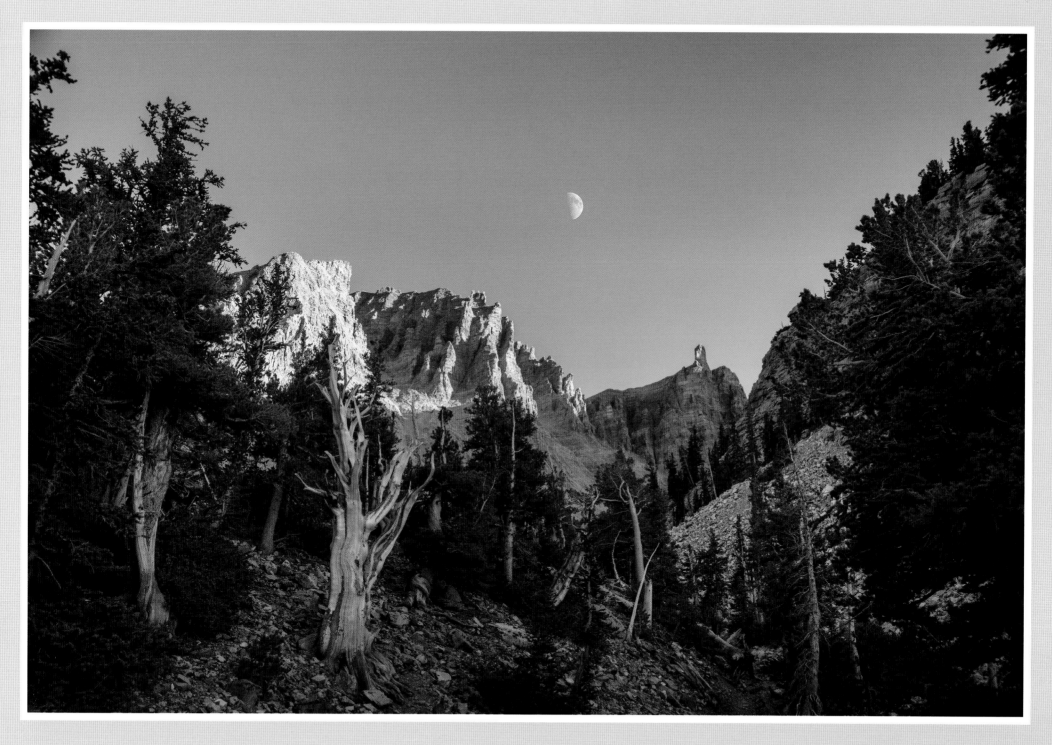

"Mountains are always beautiful, and here they are ever in sight, wearing every variety of shape and form . . . There is a rich exhilaration, especially in the fresh evening air, dry, clear and strengthening, that no eastern mountain or ocean breeze can rival."

—Samuel Bowles,
editor of the Springfield Republican, 1865

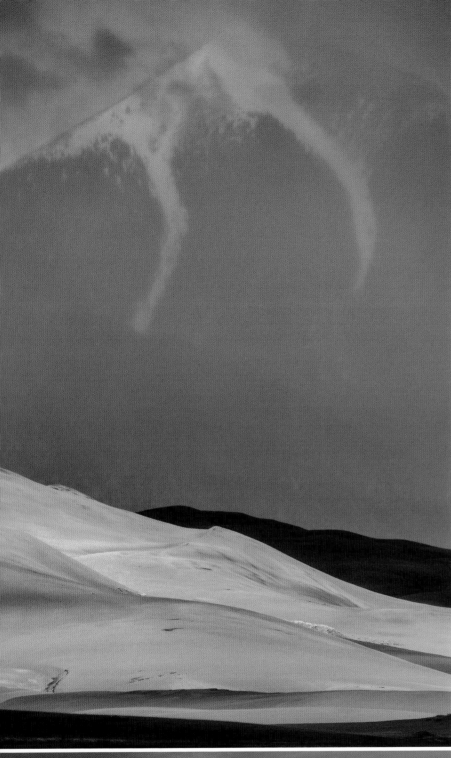

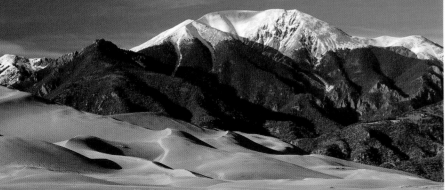

GREAT SAND DUNES
NATIONAL PARK AND PRESERVE
COLORADO

A Playground For Young and Old
Imagine your surprise when you first see the focal point of this park, sand dunes up to 750 feet tall, resting against snow-capped mountains within a landscape of grasslands and forests. This park, with its thirteen-thousand-foot mountains, alpine lakes, and the pulsating Medano Creek, is a giant playground, begging you to come explore.

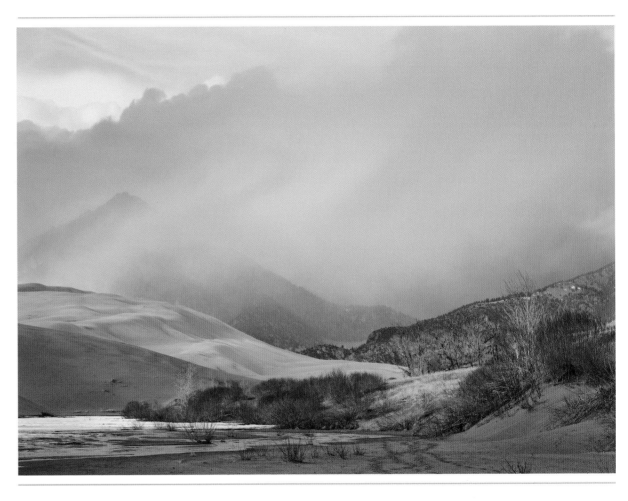

Location: Colorado
Nearest city: Alamosa
Coordinates: 37°43'58"N 105°30'44"W
Area: 77,180 acres (31,230 ha)
Established: September 13, 2004
Visitors in 2015: 299,513

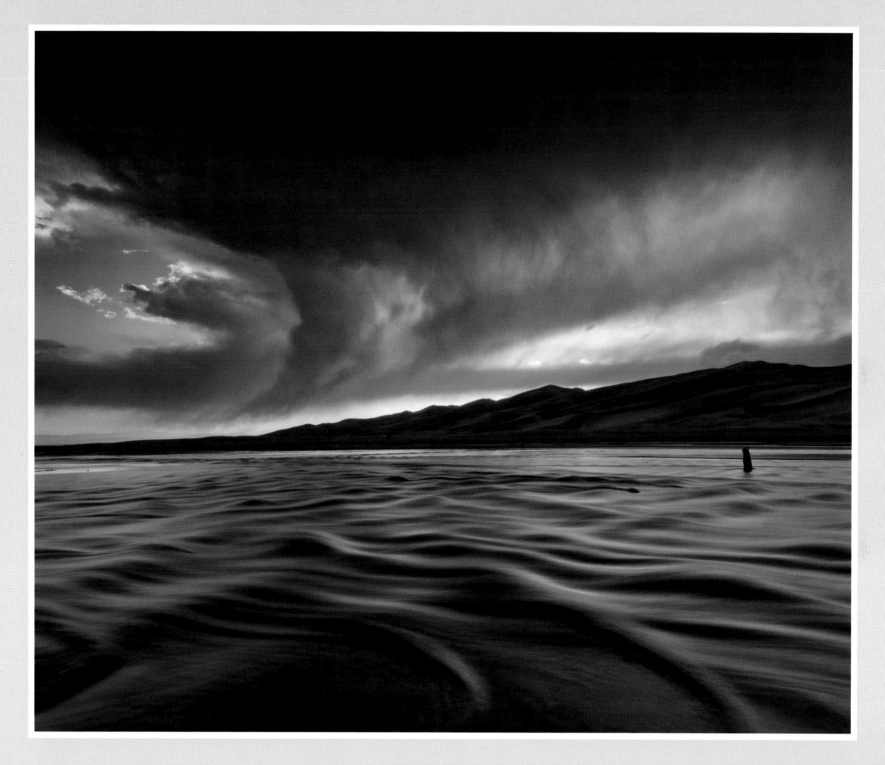

"After marching some miles, we discovered . . . at the foot of the White Mountains [today's Sangre de Cristos] which we were then descending, sandy hills . . . The sand-hills extended up and down the foot of the White Mountains about 15 miles, and appeared to be about 5 miles in width. Their appearance was exactly that of the sea in a storm, except as to color, not the least sign of vegetation existing thereon."

—Army Lieutenant Zebulon Pike, 1807

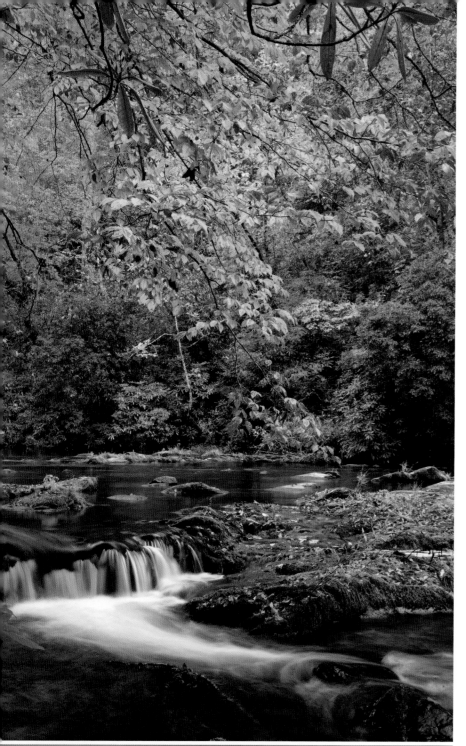

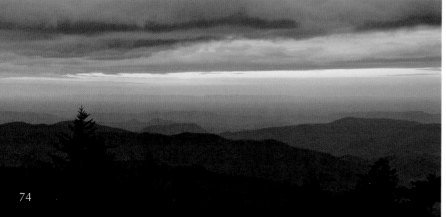

GREAT SMOKY MOUNTAINS
NATIONAL PARK

Take a Walk in the Woods

In the fall, a spectacular colored patchwork of foliage covers the ridges of the Appalachian Mountains. However, you can pick up a trail any time of year to hike to the park's waterfalls, explore forested rivers and ridges, visit historic structures or walk part of the Appalachian Trail, and it will be worth every step. A drive through Cades Cove is also beautiful in any season.

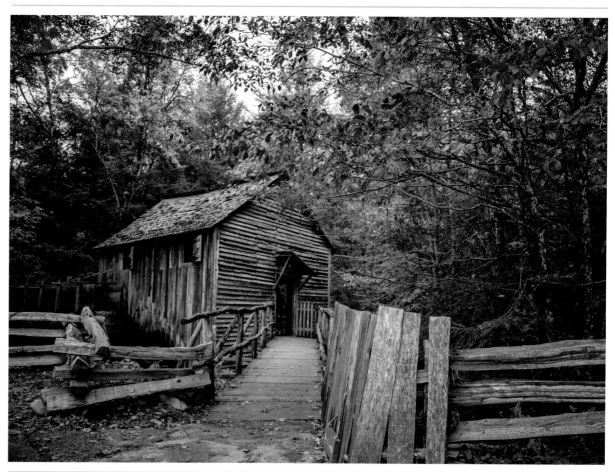

Location: North Carolina and Tennessee
Nearest city: Cherokee, North Carolina, and Gatlinburg, Tennessee
Coordinates: 35°41'0"N 83°32'0"W
Area: 522,419 acres (211,415 ha)
Established: June 15, 1934
Visitors in 2015: 10,712,674

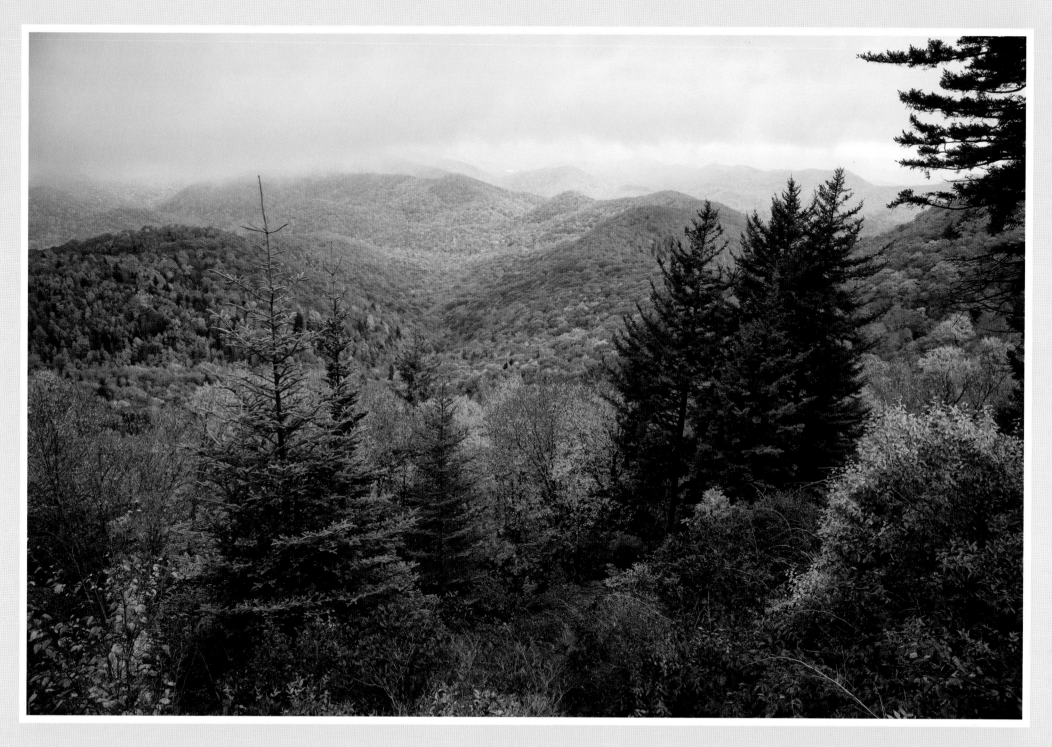

"I have been recognized as the person who originated the idea for the creation of a National Park in the Great Smoky Mountains, as the birth of the idea occurred while my late husband W.P. Davis and myself were on a visit to Yellowstone National Park in June of 1923. Why can't we have a national park in the Great Smoky Mountains? They are just as beautiful as these mountains."

—Anne May Davis, 1923

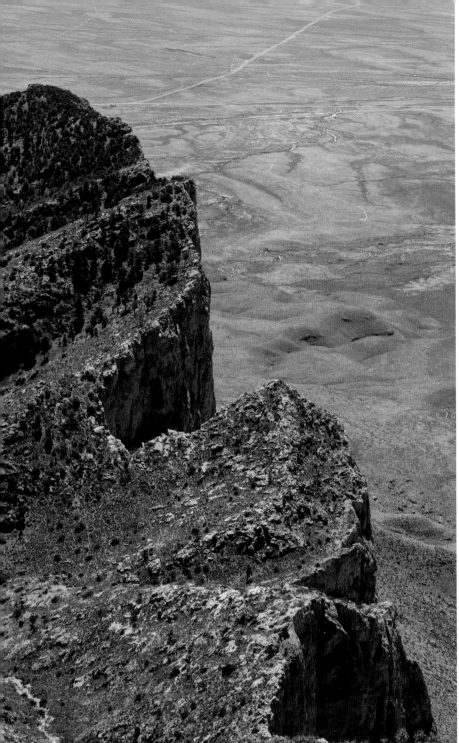

GUADALUPE MOUNTAINS
NATIONAL PARK

The Top of Texas

This park boasts Guadalupe Peak, at 8,749 feet, the highest point in Texas. From the top, look west and view sand dunes, deposits left by an ancient Permian sea. Hike the mountain peak or scenic McKittrick Canyon, immerse yourself in the park's history, search out the abundant wildlife and birds and camp under the stars. You won't be disappointed.

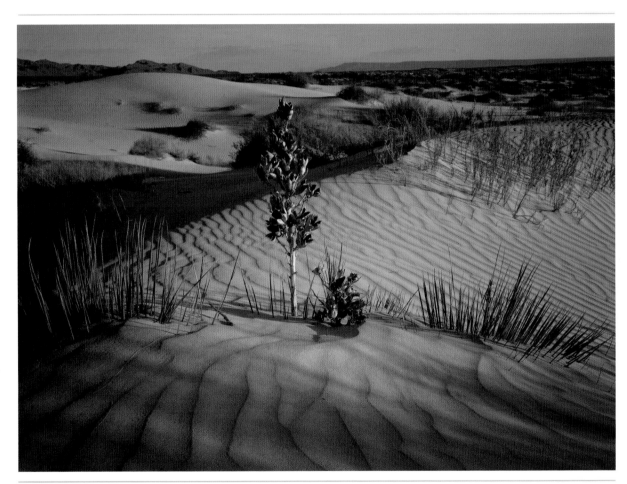

Location: Texas
Nearest city: Carlsbad, New Mexico
Coordinates: 31°55'0"N 104°52'0"W
Area: 86,367 acres (34,951 ha)
Established: September 30, 1972
Visitors in 2015: 169,535

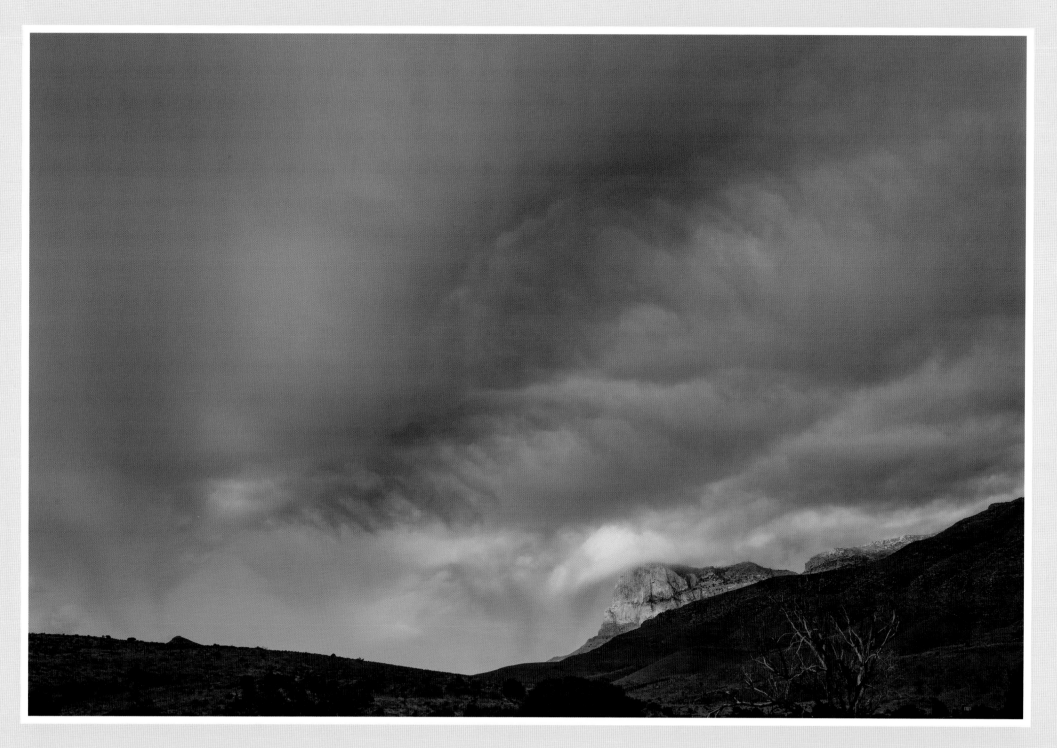

"Guadalupe Mountains National Park protects one of world's best examples of a fossil reef and invites visitors to explore a wilderness environment that varies from cactus-studded hills and lowlands to steep, shady canyons and highcountry conifer forests. Diverse cultures have interacted with this landscape for thousands of years and people continue to use El Capitan as a landmark to guide them to a place where one can discover nature's primeval beauty. Whether one is looking for adventure or peace and quiet, opportunities for both are easily found in this remote corner of the Southwest."

—Michael Haynie, park ranger, 2016

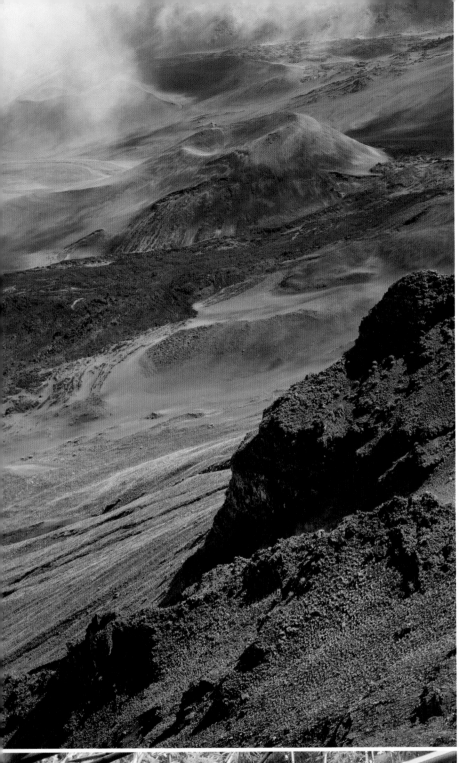

HALEAKALA
NATIONAL PARK

Moonscape and Rainforest

Is it worth the effort of an early rise to sit in near-freezing temperatures to catch sunrise at the ten-thousand-foot summit of this volcano? Absolutely! The stark volcanic landscape here is breathtaking and warrants a walk at least partway down into the crater. And just as worthy is visiting the coastal 'Ohe'o Gulch to view abundant waterfalls and the massive bamboo forest. This volcanic tropical environment is out of this world.

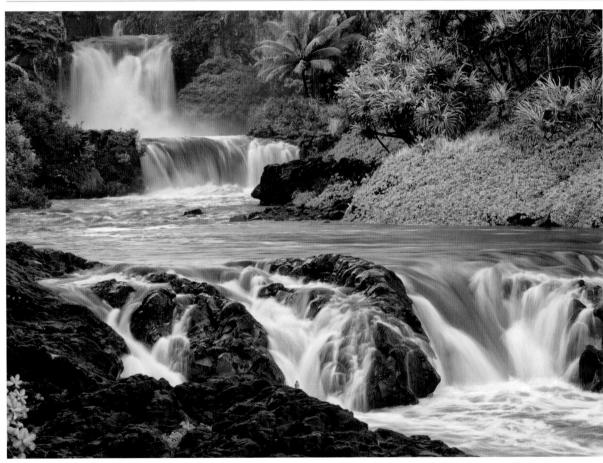

Location: Maui, Hawaii
Nearest city: Pukalani
Coordinates: 20°43'0''N 156°10'0''W
Area: 33,265 acres (13,462 ha)
Established: July 1, 1961
Visitors in 2015: 1,216,772

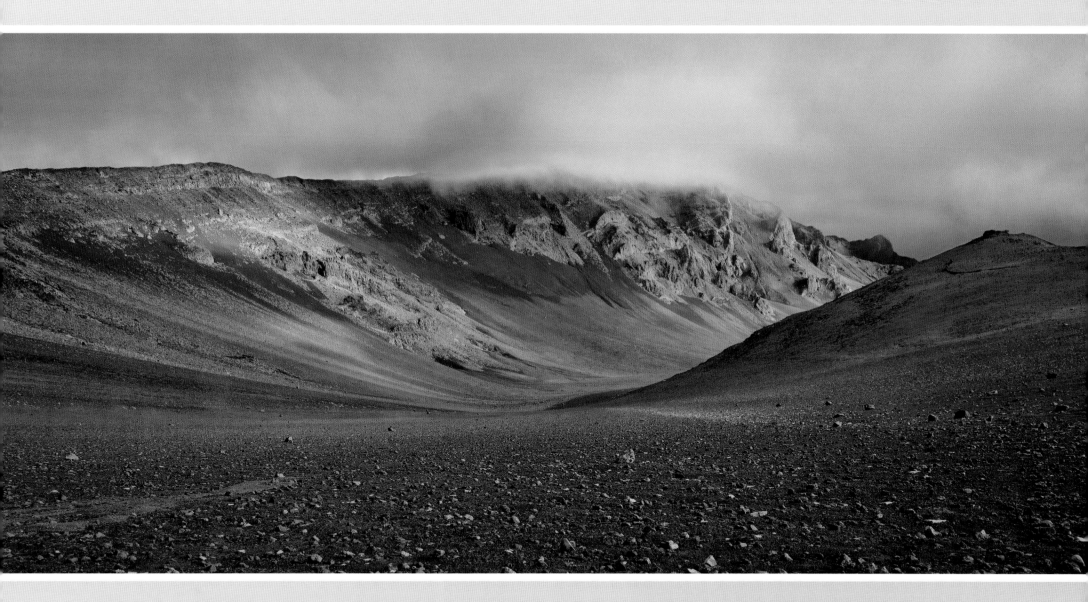

"But the chief pride of Maui is her dead volcano of Haleakala—which means, translated, 'the house of the sun.' We climbed a thousand feet up the side of this isolated colossus one afternoon; then camped, and next day climbed the remaining nine thousand feet, and anchored on the summit, where we built a fire and froze and roasted by turns, all night. With the first pallor of dawn we got up and saw things that were new to us. Mounted on a commanding pinnacle, we watched Nature work her silent wonders."

—Mark Twain, 1866

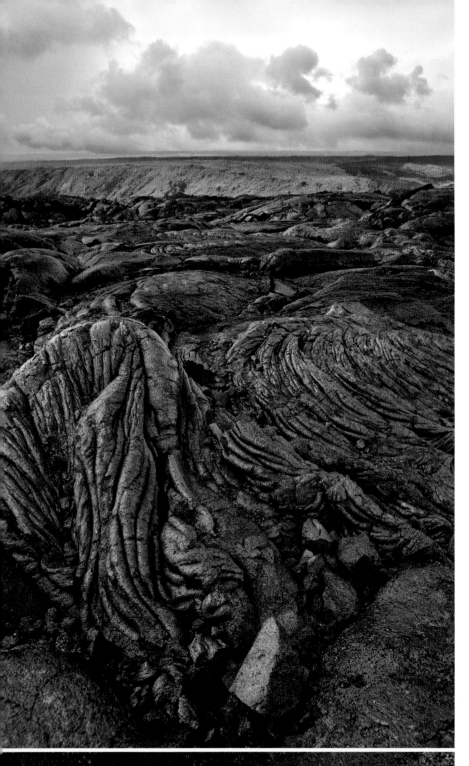

HAWAI'I VOLCANOES
NATIONAL PARK

A Destructive Beauty

Once-vibrant and yellow-hot magma has hardened and ambitious plant life has reinvented itself, juxtaposed perfectly against the rust- or black-colored crust of past lava flows. Mother Nature's formidable power is so evident in Volcanoes National Park. Kilauea and Mauna Loa are two of the world's most active volcanoes and continue to add new land to the Big Island of Hawaii. In this extraordinary park, life and death can be seen together in the closest of quarters.

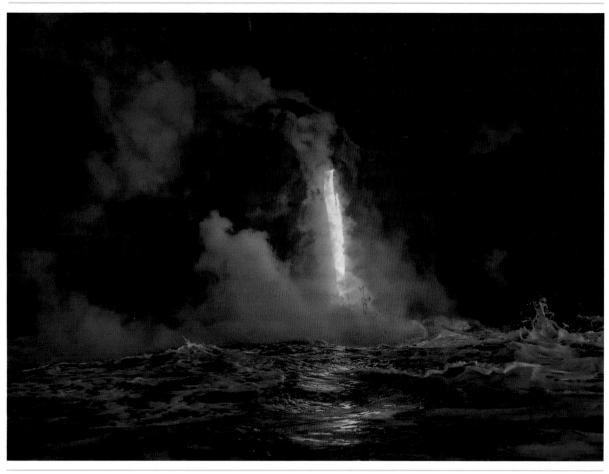

Location: Big Island, Hawaii
Nearest city: Hilo
Coordinates: 19°23'0"N 155°12'0"W
Area: 323,431 acres (130,888 ha)
Established: August 1, 1916
Visitors in 2015: 1,832,660

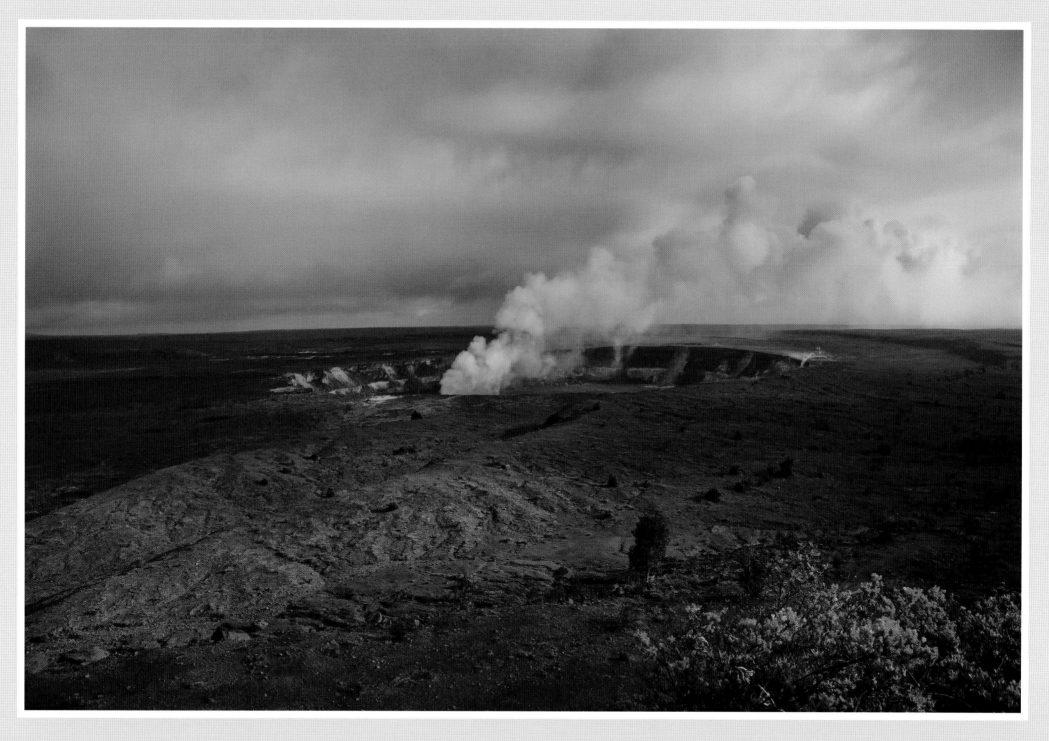

"This sight is more glorious than any I had ever beheld, and the sight of it alone would have repaid for the trouble of coming thus far."

—Lieutenant Charles Wilkes, United States Exploring Expedition, 1841

Hot Springs
National Park

Healing Waters

You'll find this smallest of the national parks, and oldest federally designated recreation area, sitting within a town built around natural hot springs that flow from the Ouachita Mountains. Bathhouse Row, the heart of this unique national park, has a fascinating history as well as exhibiting preserved nineteenth-century architecture. People have long used the mineral-rich waters of the hot springs for healing or just relaxation.

Location: Arkansas
Nearest city: Hot Springs
Coordinates: 34°30′49″N 93°03′13″W
Area: 5,550 acres (2,250 ha)
Established: March 4, 1921
Visitors in 2015: 1,418,162

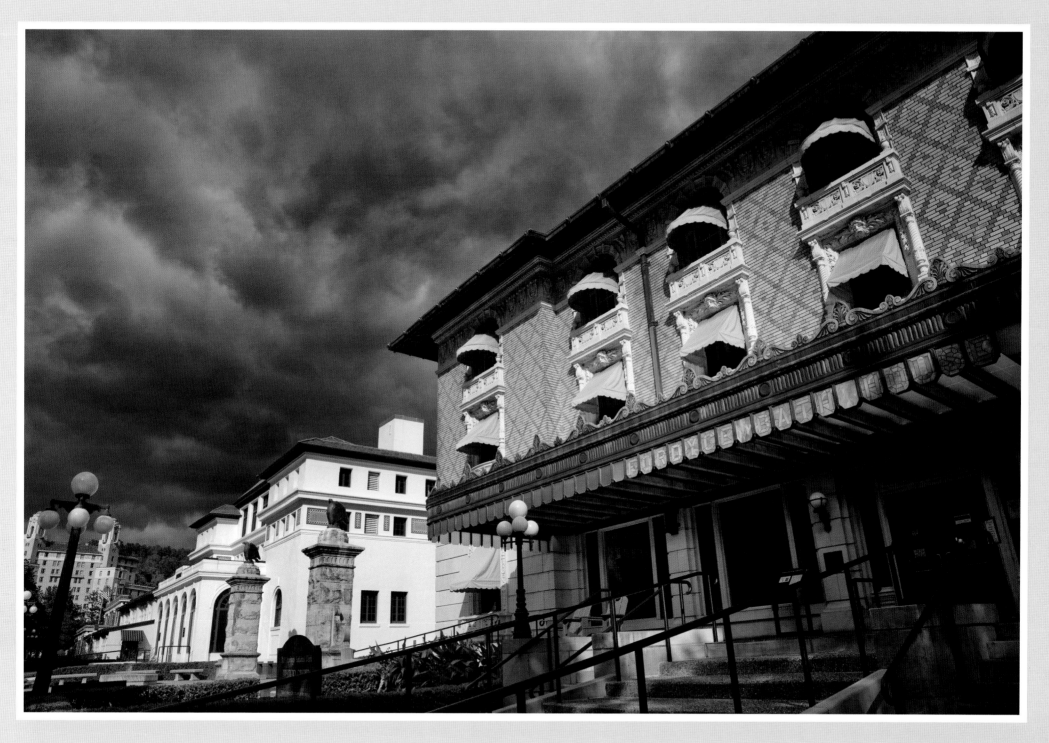

"I went down to Hot Springs, Arkansas, to boil out and try to pare myself down to what I figured was my best playing weight, 220 pounds."

—Babe Ruth, 1920s

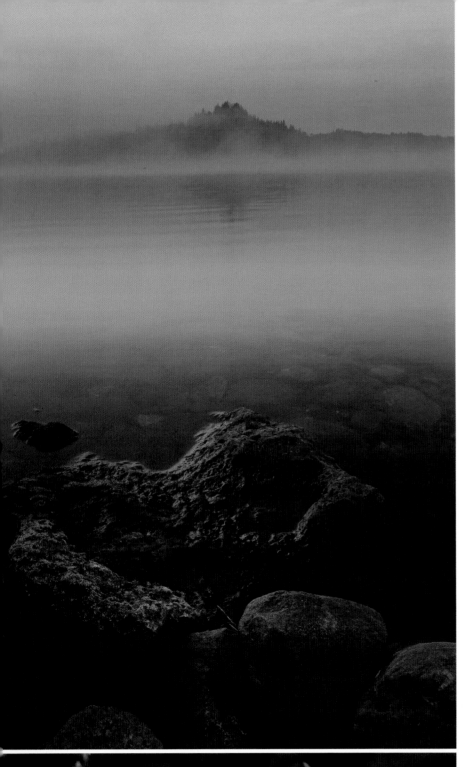

ISLE ROYALE
NATIONAL PARK

Lake Superior's Secret

Make time to remove yourself from modern-day living, get back to nature and feel more alive than ever before. Spend a few days on Isle Royale, the largest island in Lake Superior, and acknowledge the solitude and adventure. You will leave with unforgettable memories, but may also comprehend why a small population of immigrant wolves and moose have made this place their sanctuary.

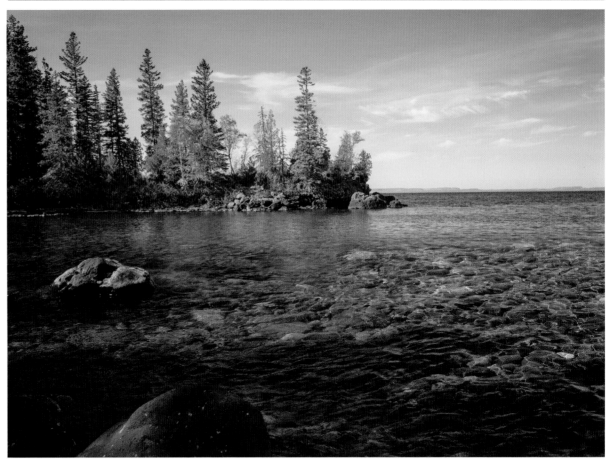

Location: Michigan
Nearest city: Copper Harbor
Coordinates: 48°06'00"N 88°33'0"W
Area: 571,790 acres (231,400 ha)
Established: April 3, 1940
Visitors in 2015: 18,684

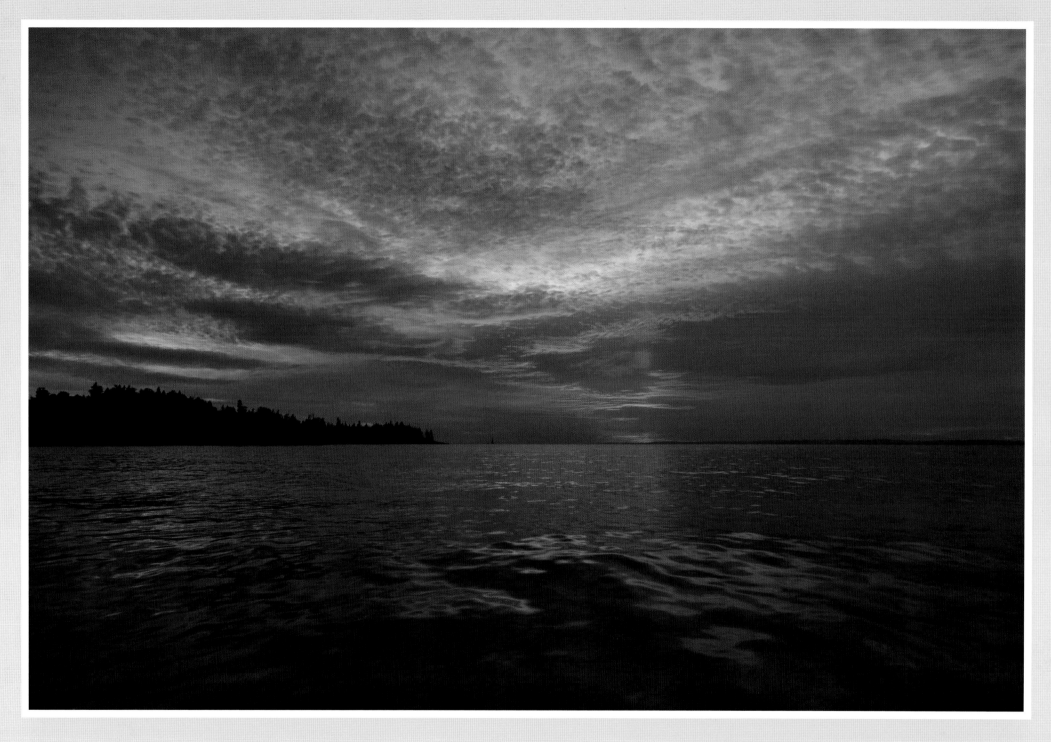

"I don't believe I will go home, kids; I am home. Any other spot on earth has merely been an interval in my life, a place to earn a living, a place to raise you kids, to survive, to exist. But this is home. And didn't they say that's where your heart is? And that my pals is Isle Royale from my point of view."

Betty Sivertson Strom,
Isle Royale . . . From My Point of View, *2010*

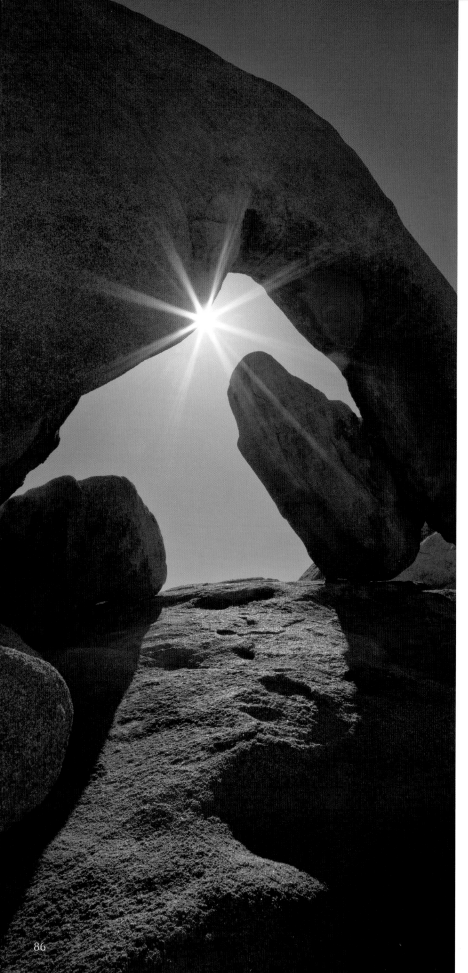

JOSHUA TREE
NATIONAL PARK

Pretty and Prickly

With its diversity of plants and animals, this popular desert park provides a virtual playground of rocks, canyons and rugged mountains. The famous Joshua trees are found throughout the park and, surprisingly, a prickly garden of cholla cactus springs up as if out of nowhere. Climb, hike and drive your way through this fun park—but keep your shoes on!

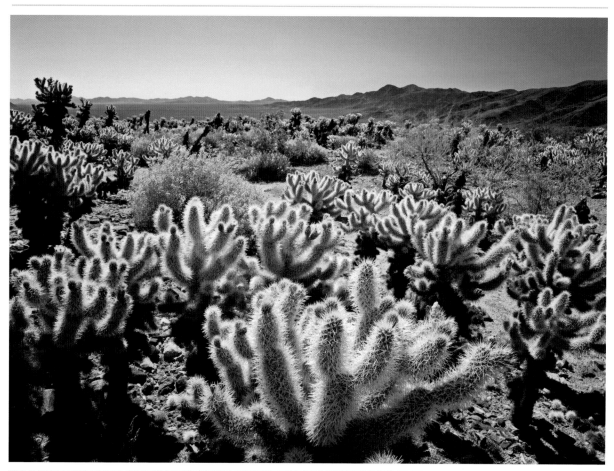

Location: California
Nearest city: Twentynine Palms
Coordinates: 33°47′18″N 115°53′54″W
Area: 790,636 acres (319,959 ha)
Established: October 31, 1994
Visitors in 2015: 2,025,756

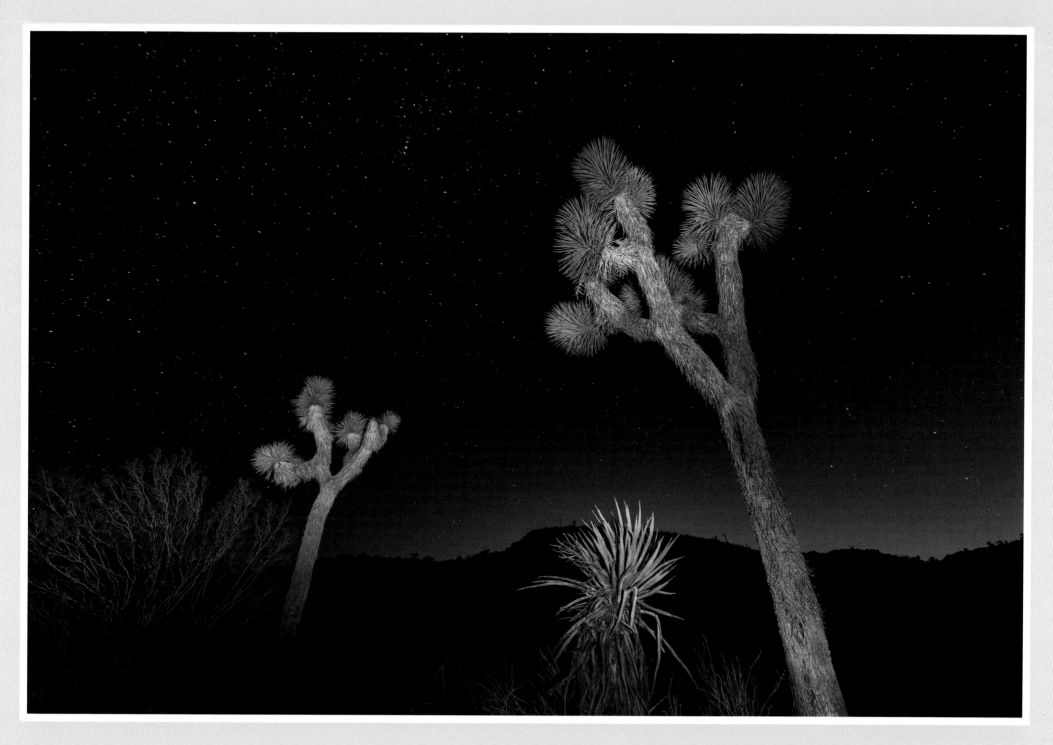

"What a thrill of adventure it is to arise early some golden desert morning, eat breakfast in the cool, snappy air, and begin packing for a day's work in the open!"

—Elizabeth Campbell, archeologist, 1931

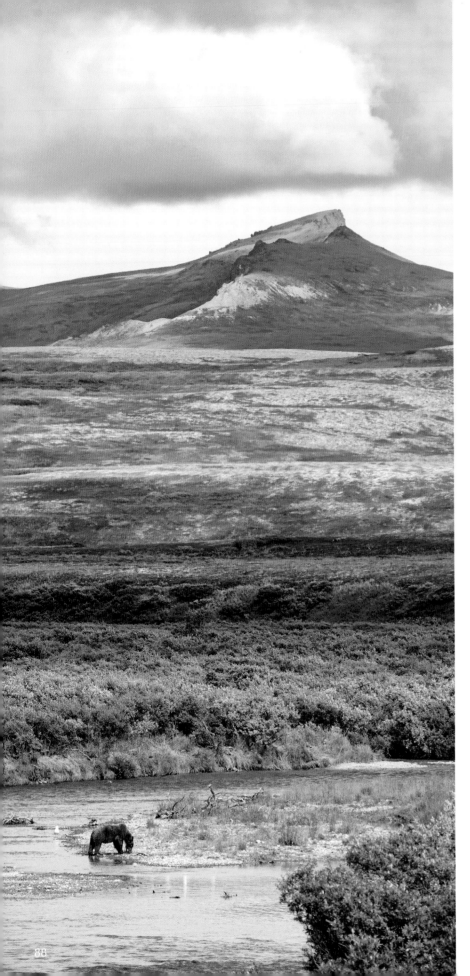

KATMAI
NATIONAL PARK AND PRESERVE

Smokin' Bears

Flying over the Valley of Ten Thousand Smokes and looking down over the most beautiful of landscapes, you will be reminded of the 1912 eruption of Novarupta, which devastated this region and left a massive ash flow. The park also protects the lower elevations where over two thousand grizzly bears come each year to catch spawning salmon. Stunning scenery, powerful history, inspiring solitude.

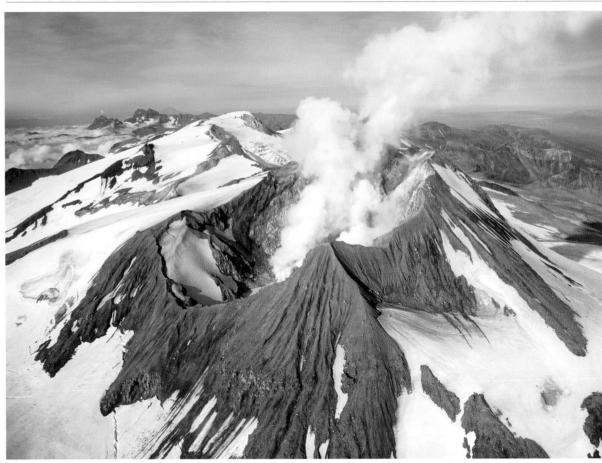

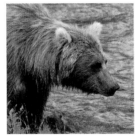

Location: Alaska
Nearest city: King Salmon
Coordinates: 58°30'00"N 155°00'00"W
Area: 4,093,977 acres (1,656,409 ha)
Established: December 2, 1980
Visitors in 2015: 37,818

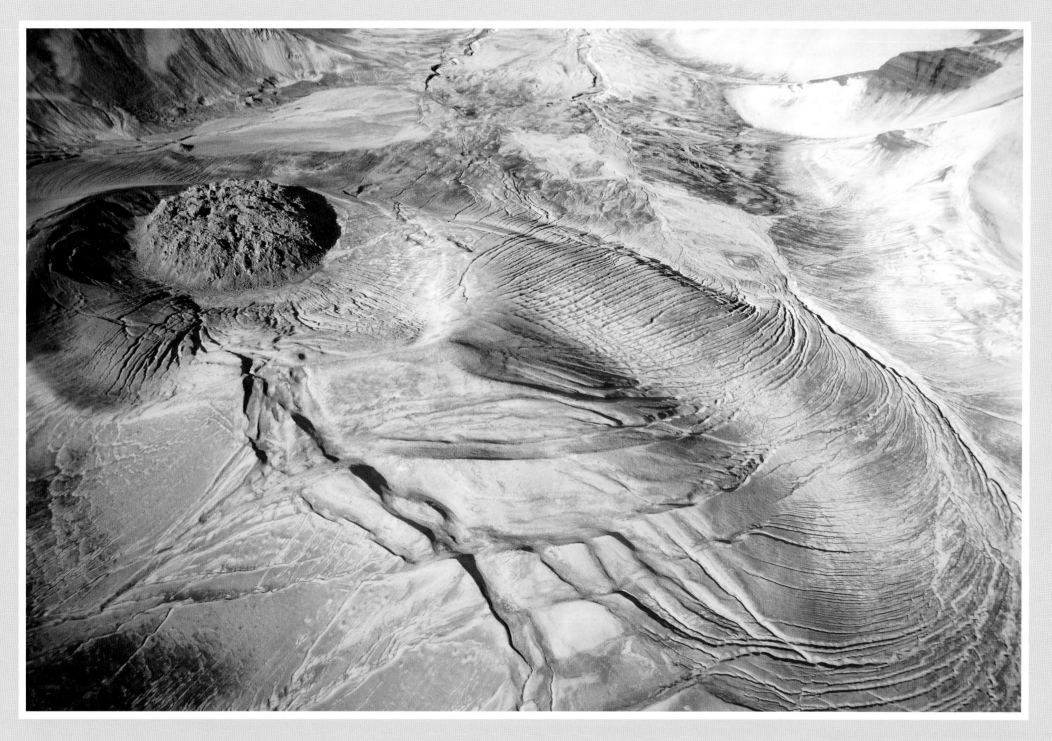

"The whole valley as far as the eye could reach was full of hundreds, no thousands—literally, tens of thousands—of smokes curling up . . . we knew many of them must be gigantic. Some were sending up columns of steam which rose a thousand feet before dissolving."

—Robert F. Griggs, explorer of Katmai country, 1916

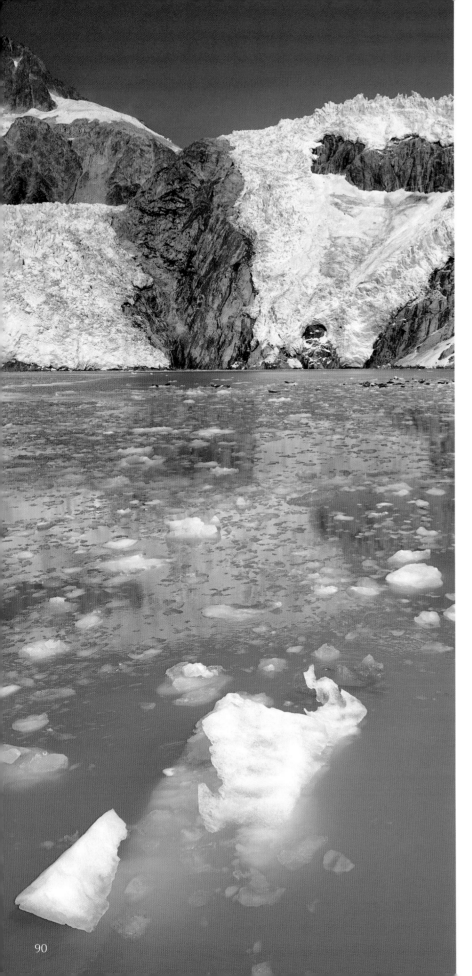

KENAI FJORDS
NATIONAL PARK

Where Mountains, Ice and Ocean Meet

If fitness allows, hike the stunningly beautiful trail that leads along the park's Exit Glacier, to the top of the Harding Icefield. On reaching the top, you will find even more breathtaking scenery of ice and mountains. Down at sea level, a boat tour cruises through the icy waters to the fjords, a surreal environment of abundant wildlife, with seals floating on icebergs that have broken free from the many glaciers.

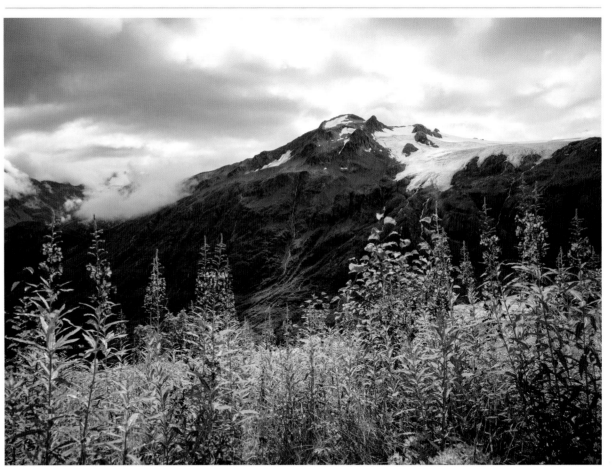

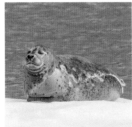

Location: Alaska
Nearest city: Seward
Coordinates: 59°55'04"N 149°59'15"W
Area: 669,984 acres (271,133 ha)
Established: December 2, 1980
Visitors in 2015: 296,697

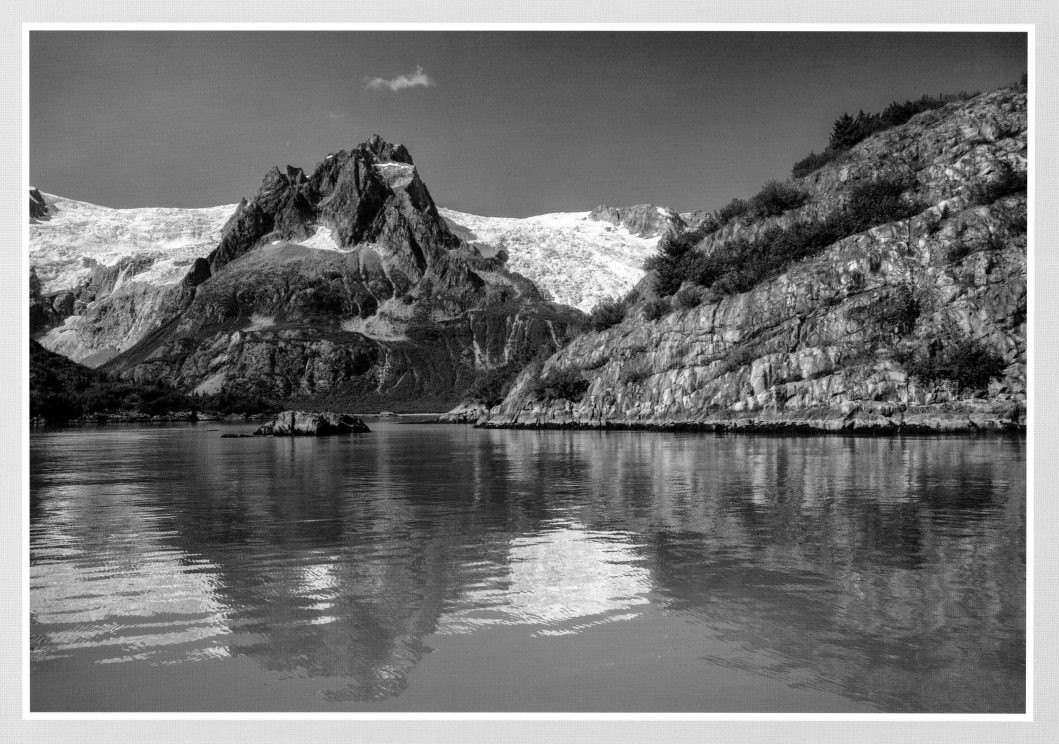

"None of it compared to the view from the end of the trail. Ice covers everything past the edge of the lookout point. An almost infinite expanse of ice stretches off into the distance. It felt as if the 'edge of the world' and the 'top of the world' had joined, and became the same place. It stays with me year to year, and keeps me coming back."

—Don Stanko, park ranger, 2015

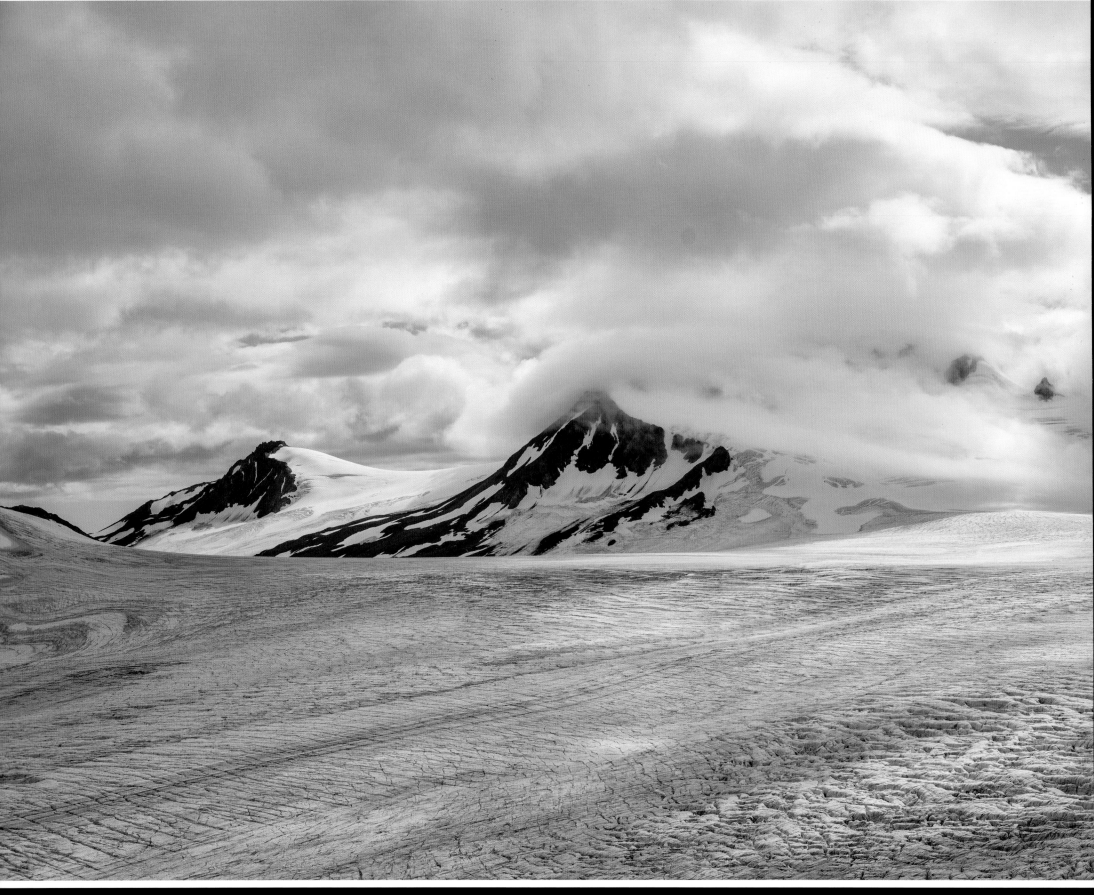

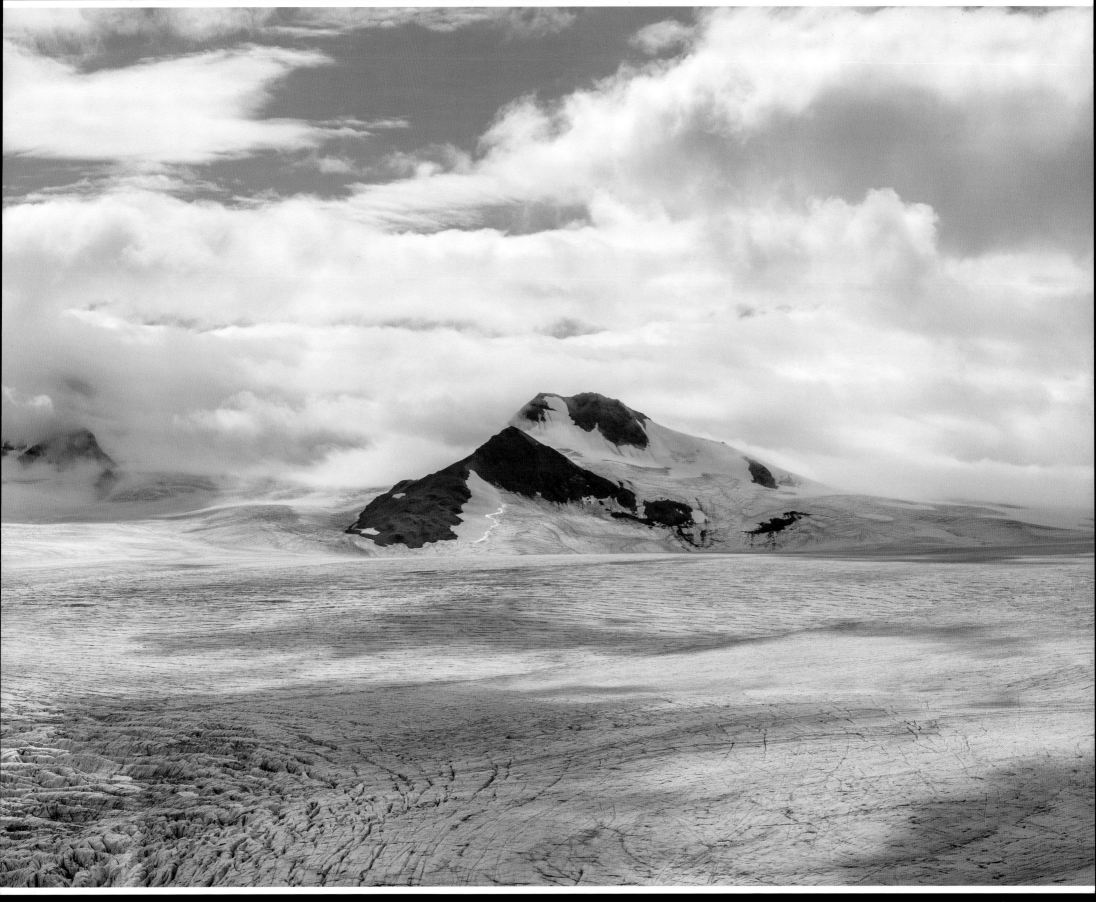

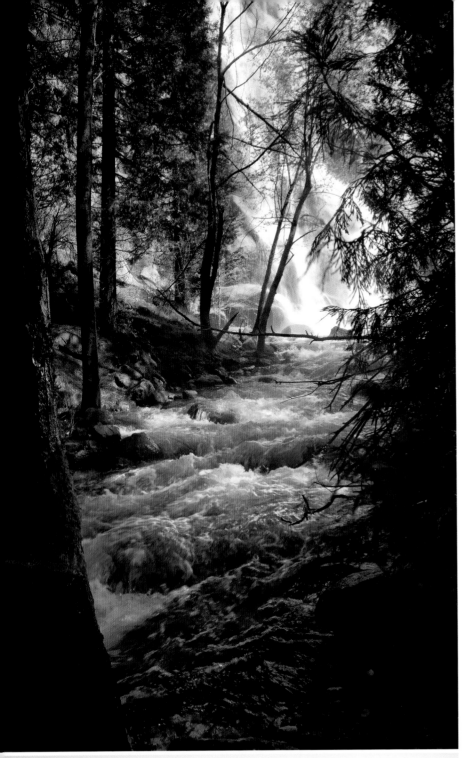

KINGS CANYON
NATIONAL PARK

Nature Is King
Giant sequoia groves, deep canyons, soaring mountains, rugged foothills and much more are found here, not to mention the third-largest tree in the world, the 267-foot-tall General Grant. Waterfalls and meadows also adorn the landscape, carved by the south and middle forks of the Kings River and the south fork of the San Joaquin River. Established in 1890 as General Grant National Park to protect the giant sequoias, it was enlarged in 1940 and renamed Kings Canyon National Park.

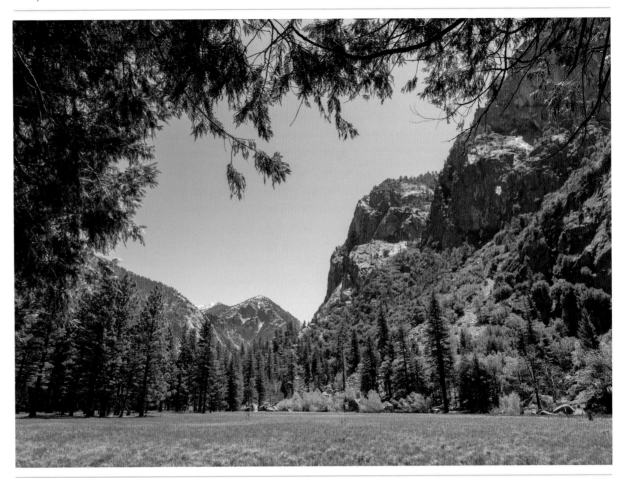

Location: California
Nearest city: Fresno
Coordinates: 36°47'21"N 118°40'22"W
Area: 461,901 acres (186,925 ha)
Established: March 4, 1940
Visitors in 2015: 468,106

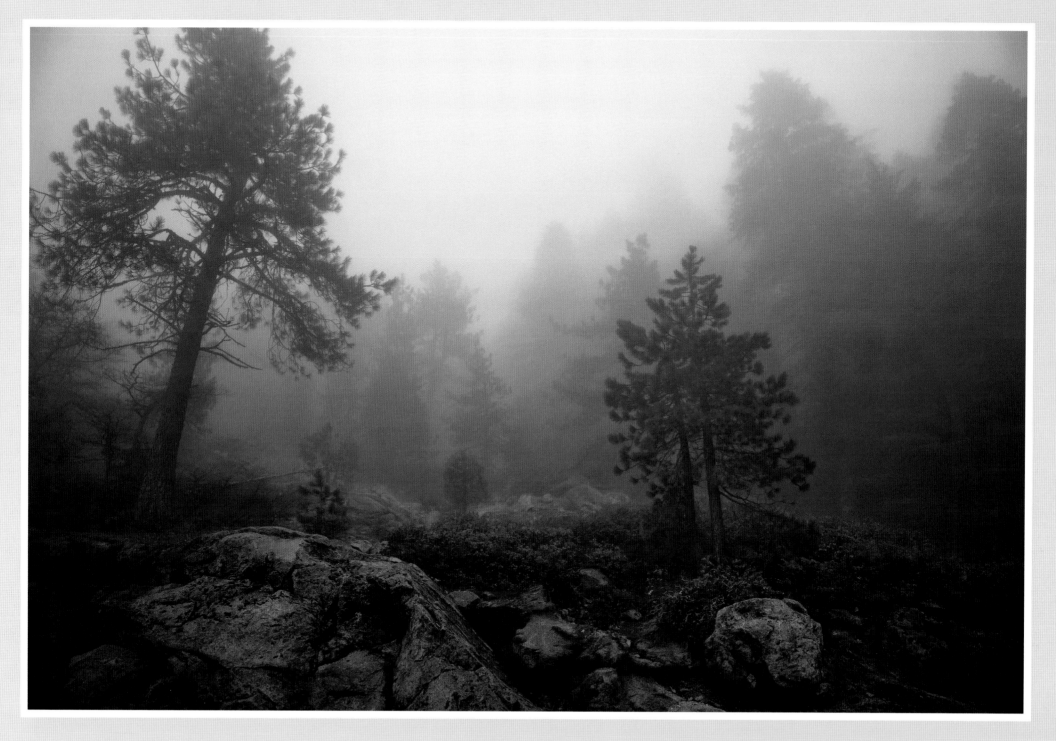

"What makes Sequoia and Kings Canyon National Parks special? There is a certain rawness to the country that you can only get when less people visit those places. You feel quite removed, especially in Kings Canyon, from everything and everybody else."

—Anna's Blog,
Sequoia Parks Foundation website, 2011

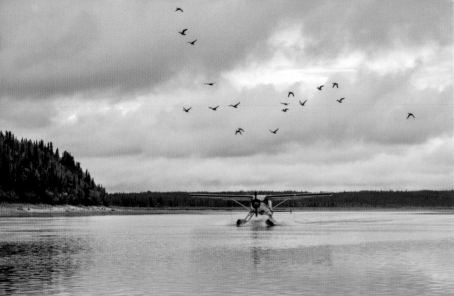

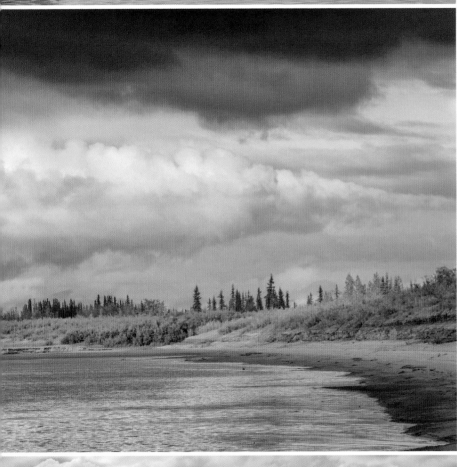

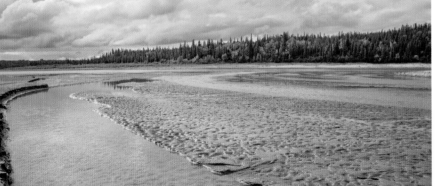

KOBUK VALLEY
NATIONAL PARK

Wilderness Adventure

A bull moose feeds on the grasses in an elbow of a winding river. The largest dunes in the Arctic lie between mountains and wetlands. Footprints of wolf, bear and moose dot the sandy banks of the Kobuk River. A dense wilderness of moss, shrubs and spruce hamper your every step. This land belongs to the wild; we leave with memories of total solitude.

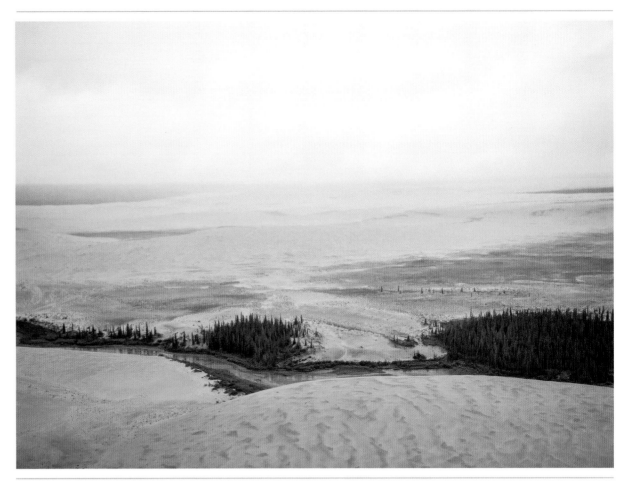

Location: Alaska
Nearest city: Kotzebue
Coordinates: 67°33′0″N 159°17′0″W
Area: 1,750,716 acres (708,490 ha)
Established: December 2, 1980
Visitors in 2013: 16,875

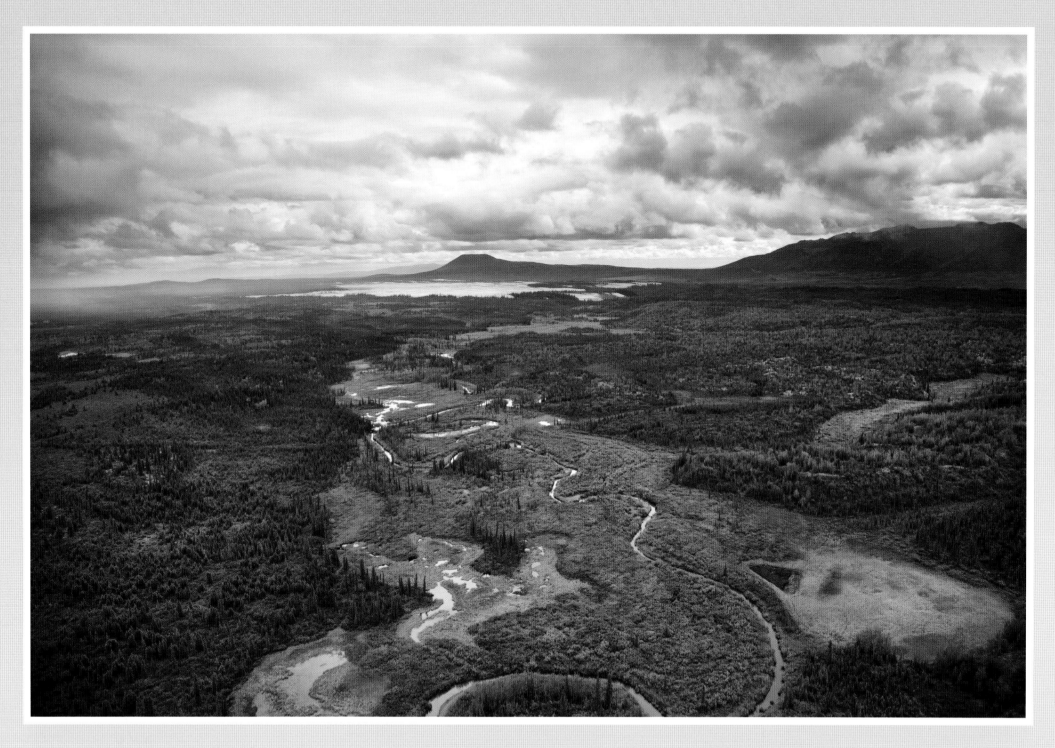

"It won't be long before the land freezes again, but for now I make way toward the creek where I forage for food. The river is low, exposing deep river bluffs which creates an easy path for me to amble over the soft, silted sand. I sniff the air . . . a few more paces . . . I am not alone. I slink into the river and swim to free myself from the intrusion. Across the river I disappear into the haven of birch and spruce in my wild untamed land."

—The Black Bear of Kobuk on a human encounter

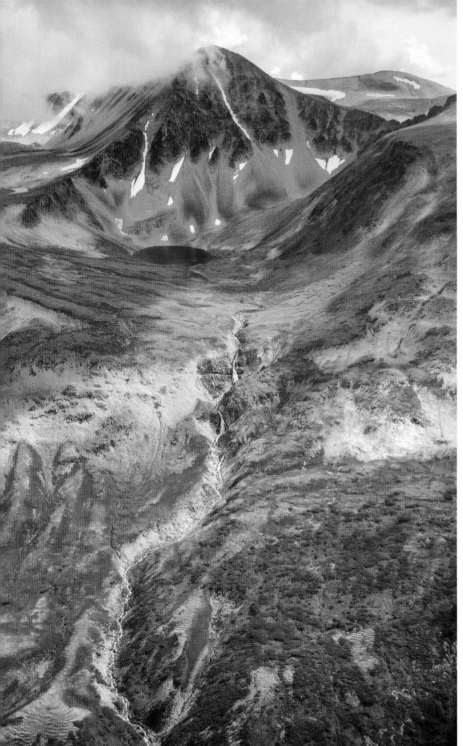

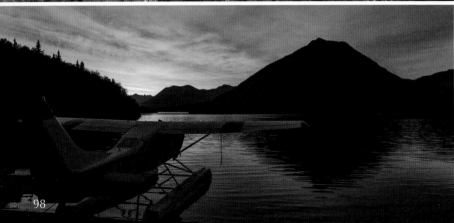

LAKE CLARK
NATIONAL PARK AND PRESERVE
ALASKA

Stunning Wilderness
Another park with a volcanic history has resulted in a beautiful turquoise lake, Lake Clark. There is even more to inspire visitors, though, with waterfalls, wild rivers, abundant fish and distinctive Alaskan wildlife, all braided through temperate rainforests, tundra and glacially clad mountains.

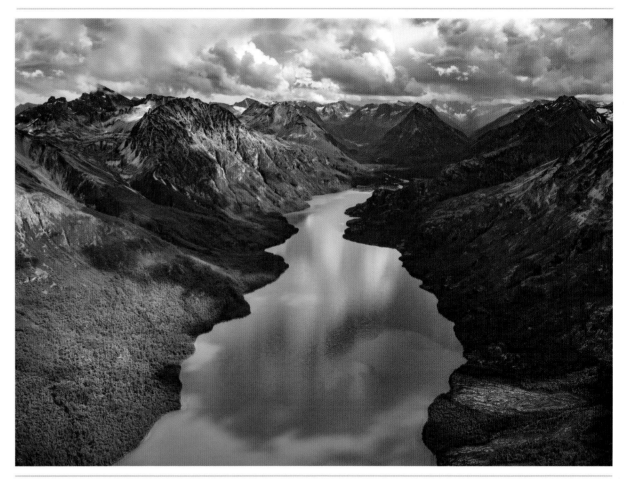

Location: Alaska
Nearest city: Port Alsworth
Coordinates: 60°58'0"N 153°25'00"W
Area: 4,030,015 acres (1,630,889 ha)
Established: December 2, 1980
Visitors in 2015: 17,818

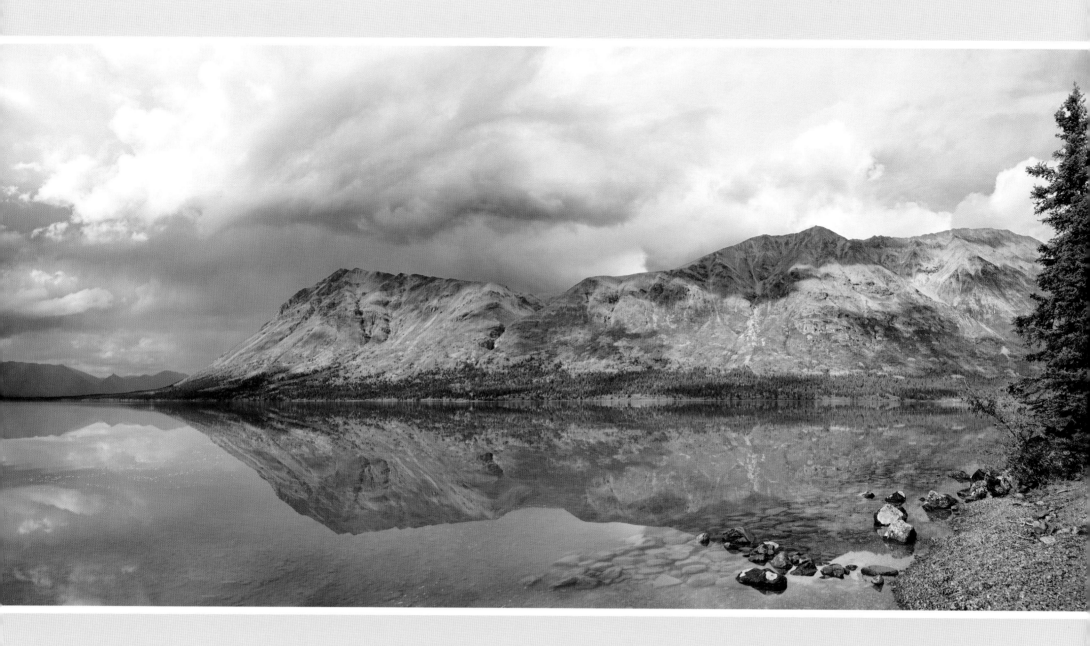

"In Lake Clark we felt constantly the forces of nature, watched powerful and surprisingly agile grizzly bears running after sockeye salmon spawning in the rivers, flew over majestic mountains with reflections in shimmering turquoise lakes, a place of peace and supreme beauty."

—Susi Ma, photographer, London, 2016

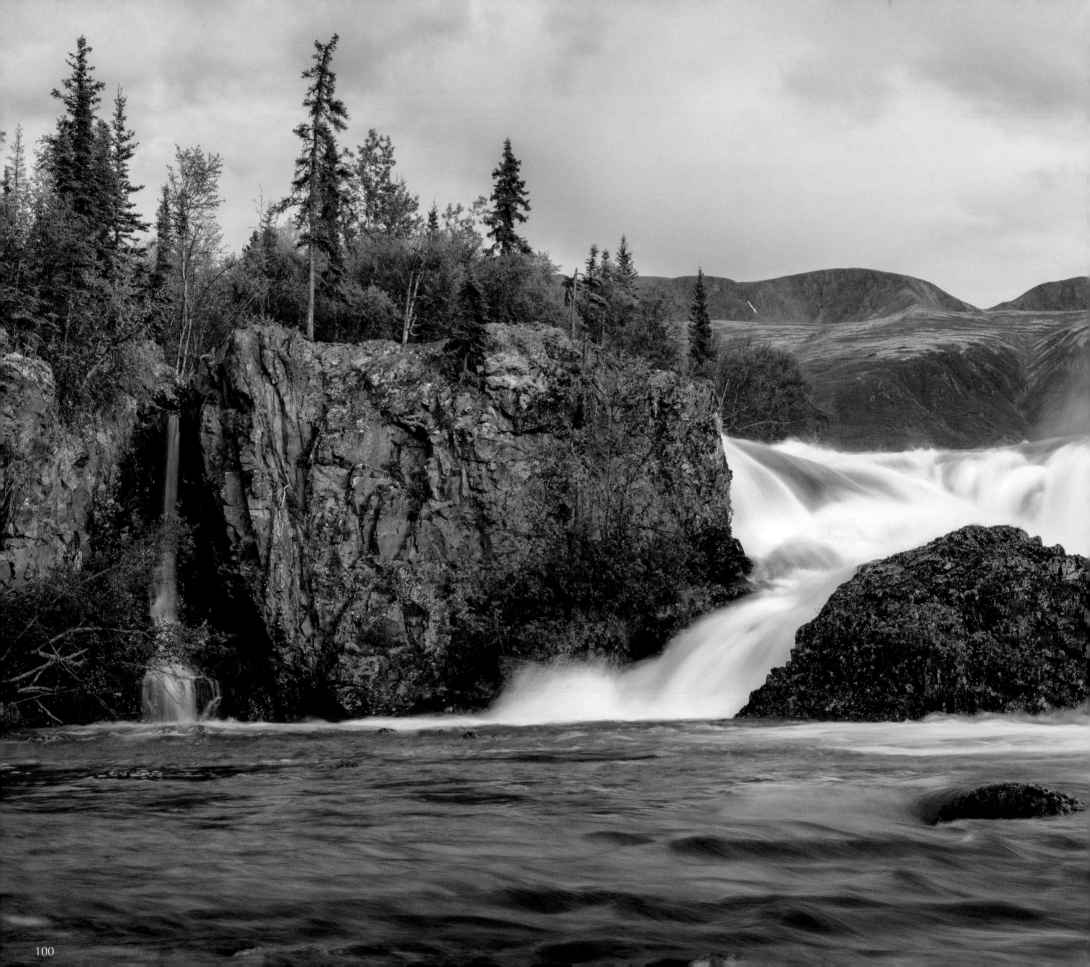

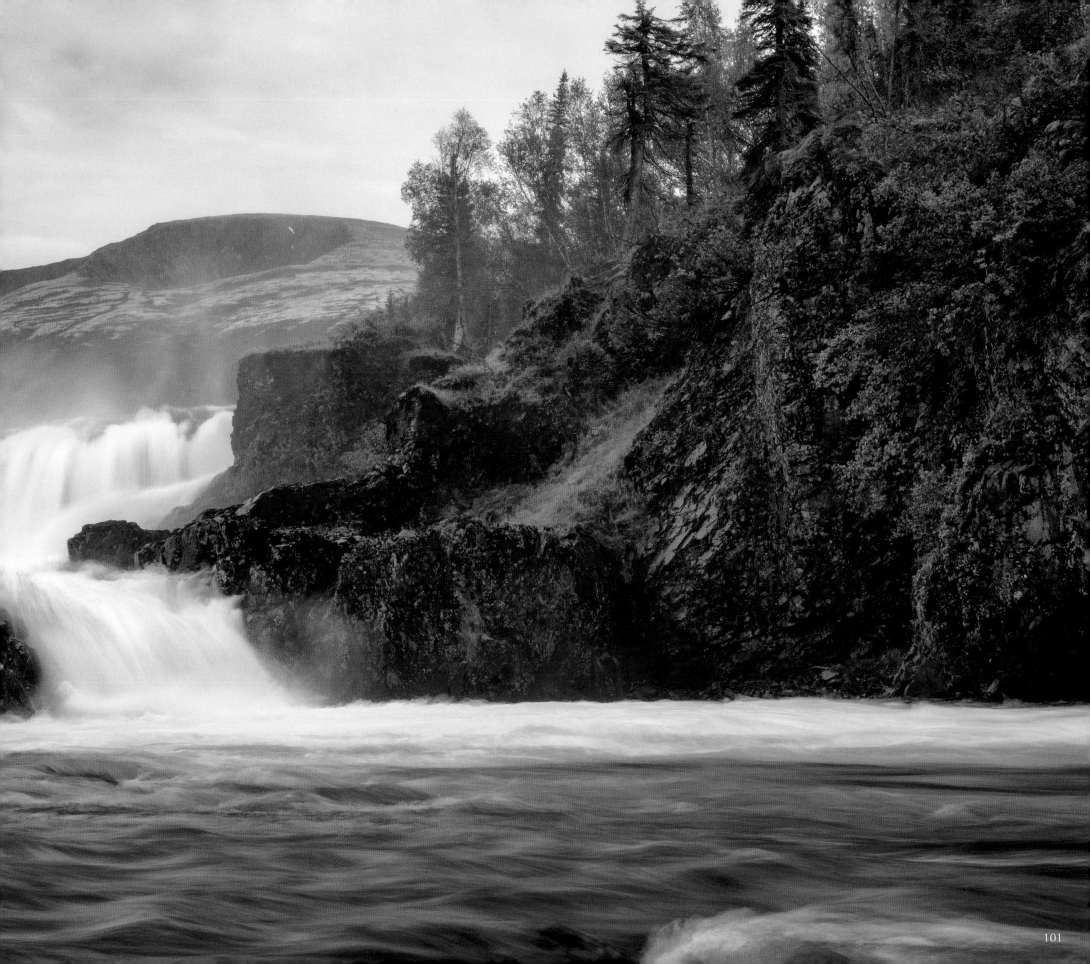

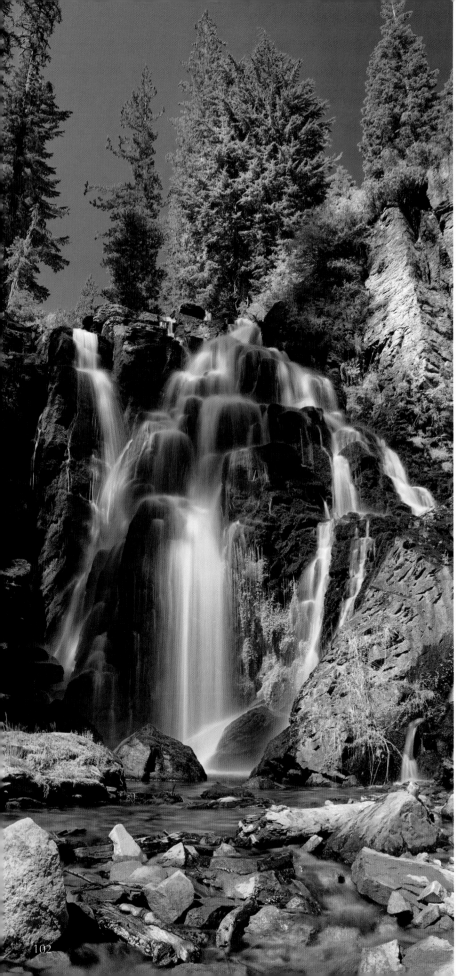

LASSEN VOLCANIC
NATIONAL PARK

A Blast from the Past
The evidence of volcanic activity, past and present, is all around this park. From the road you will see steaming fumaroles; hike a little and find bubbling mud pots and waterfalls. A little more effort will take you to the rim of a cinder cone that overlooks multicolored pumice fields, or to Lassen Peak, the largest plug dome volcano in the world. All this and more creates an exciting park in a volcanic area that is still continuously active.

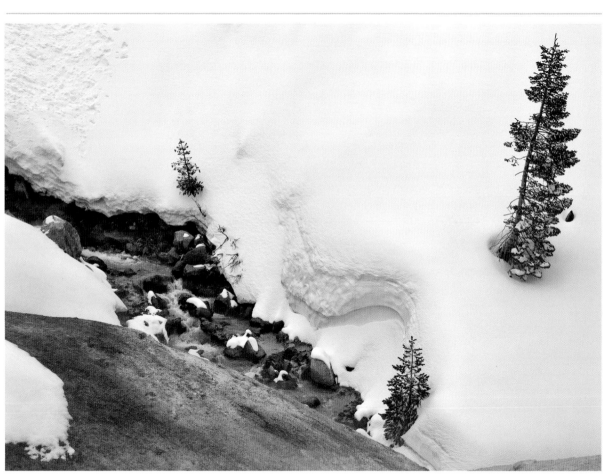

Location: California
Nearest city: Redding, Susanville
Coordinates: 40°29′16″N 121°30′18″W
Area: 106,452 acres (43,080 ha)
Established: August 9, 1916
Visitors in 2015: 468,092

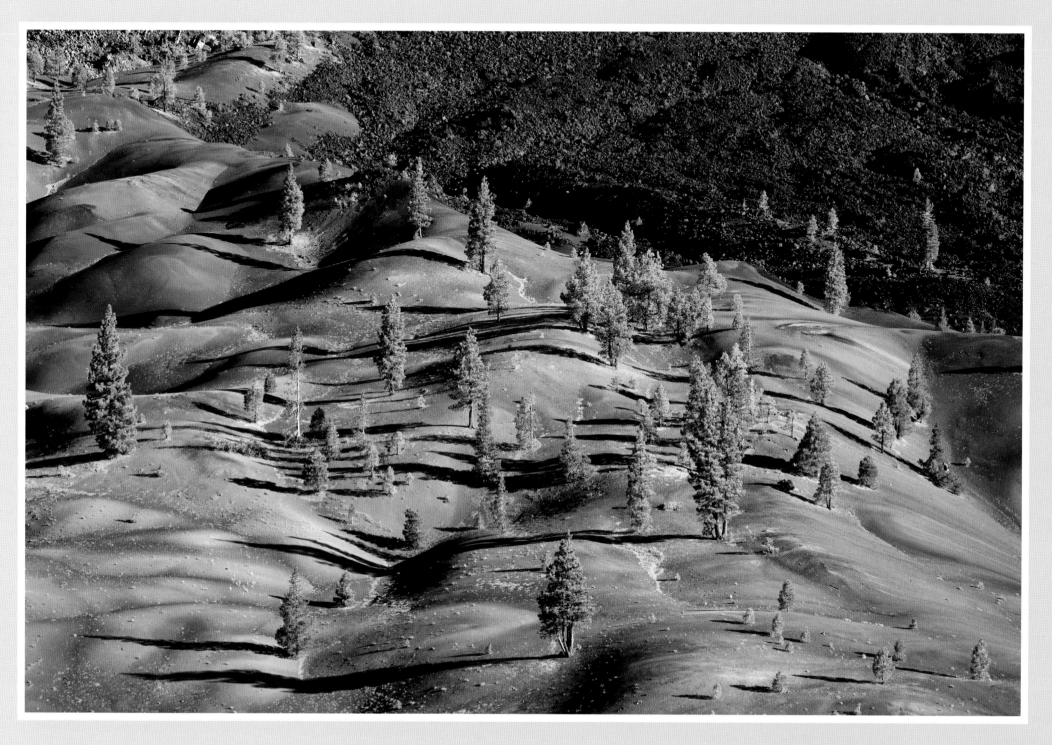

"Terrific eruption. Incomparable with any former eruption . . . column of steam reached 30,000 feet."

—*Joseph Diller, geologist,*
"The Volcanic History of Lassen Peak," 1918

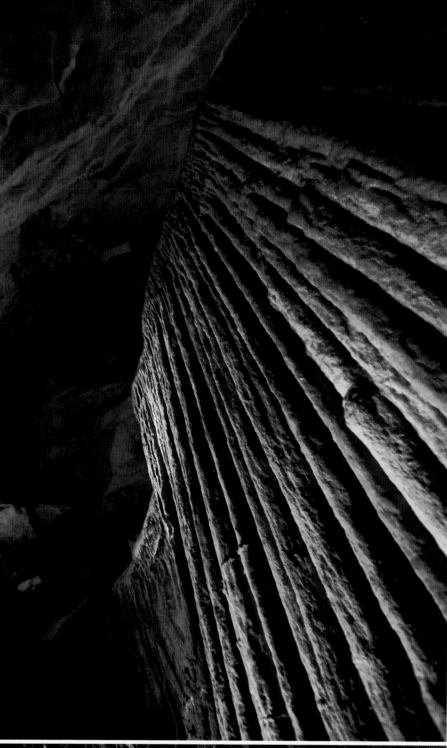

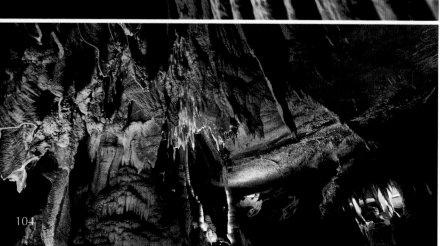

MAMMOTH CAVE
NATIONAL PARK

The World's Longest Known Cave System
Beneath the Kentucky hills lies a silent sleeping giant with more than four hundred miles of explored cave systems. You will learn both the natural and cultural history of the caves during any of the various cave tours. If you prefer, you can be entertained on the surface above, where the Green River runs through the park. Either way, whether you are a curious child, an adventurous adult or a more serious spelunker, you will be accommodated.

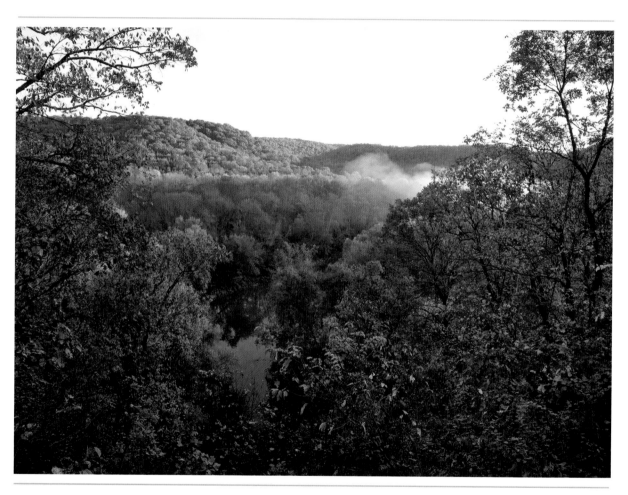

Location: Kentucky
Nearest city: Brownsville
Coordinates: 37°11'13"N 86°06'01"W
Area: 52,830 acres (21,380 ha)
Established: July 1, 1941
Visitors in 2015: 566,895

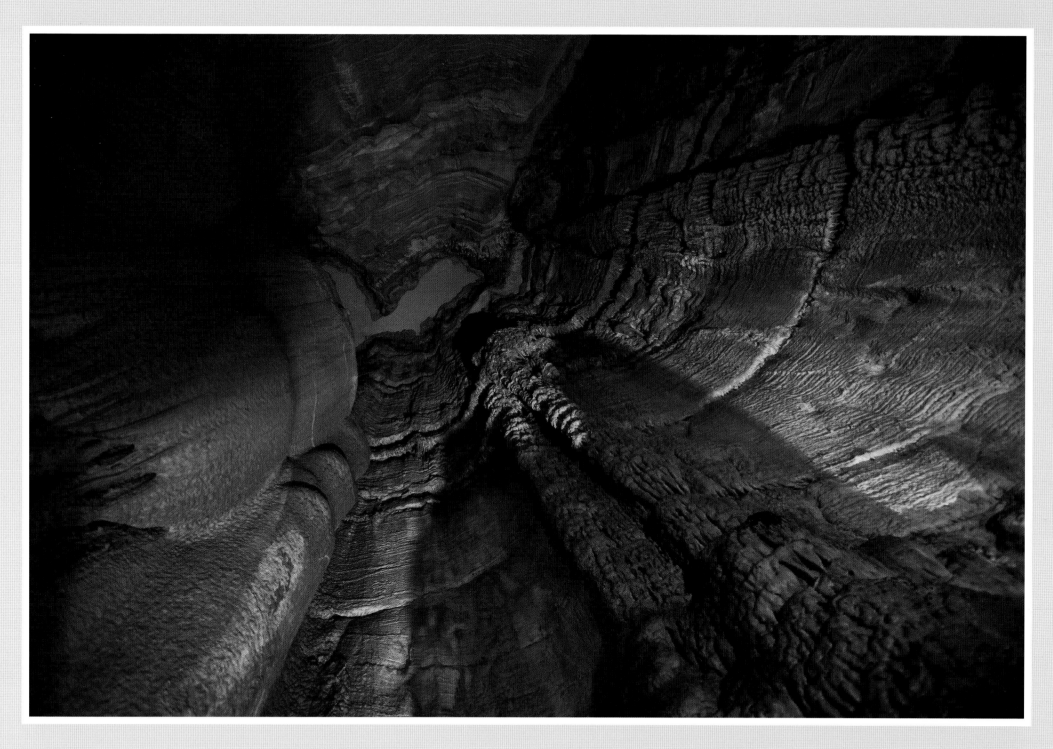

*"The proper costume for a gentleman consists of a jacket, heavy boots, a cloth cap and woollen pants.
The Bloomer or Turkish dress is the proper costume for a lady. It may be plain, or fancifully trimmed to suit the wearer."*

—*Charles W. Wright,*
A Guide Manual to the Mammoth Cave of Kentucky, *1860*

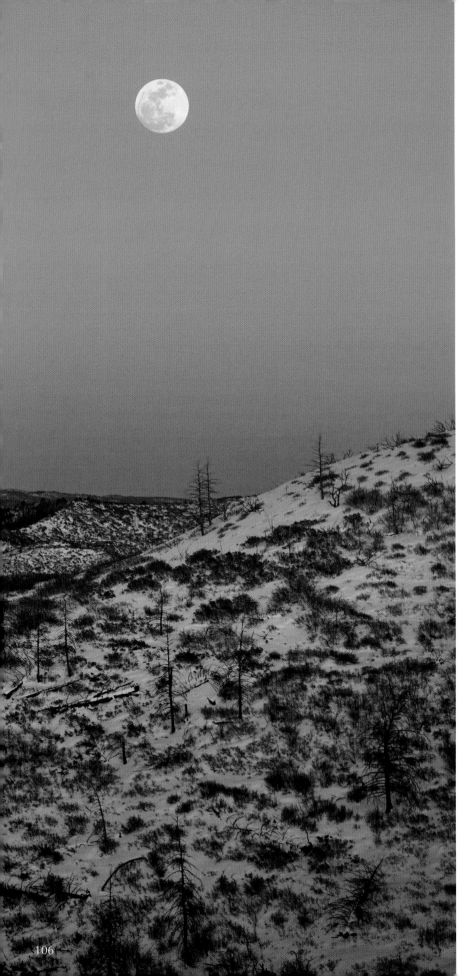

MESA VERDE
NATIONAL PARK
COLORADO

Why Is It So?
A twenty-mile drive along a winding road gives no clue as to what you are about to experience. It does, however, offer spectacular scenery and overlooks so you can continue your contemplations on the way back out. But when you see the ancient dwellings within, your imagination goes wild. Why did the Ancestral Pueblo people build their homes in the cliffs, and why did they leave? They made this their home for over seven hundred years, from AD 600 to 1300. This park protects nearly five thousand known archeological sites, including six hundred cliff dwellings.

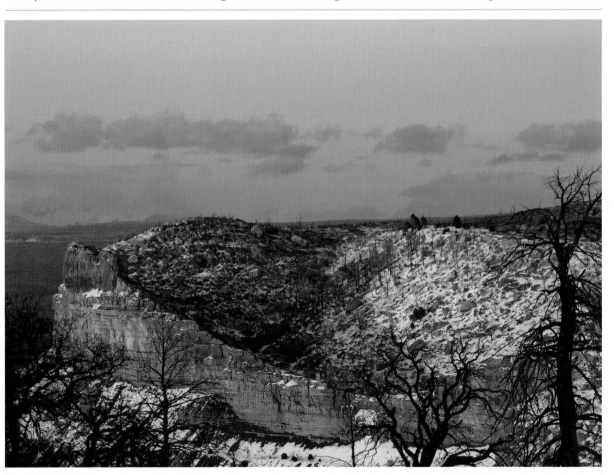

Location: Colorado
Nearest city: Cortez
Coordinates: 37°11'02"N 108°29'19"W
Area: 52,485 acres (21,240 ha)
Established: June 29, 1906
Visitors in 2015: 547,325

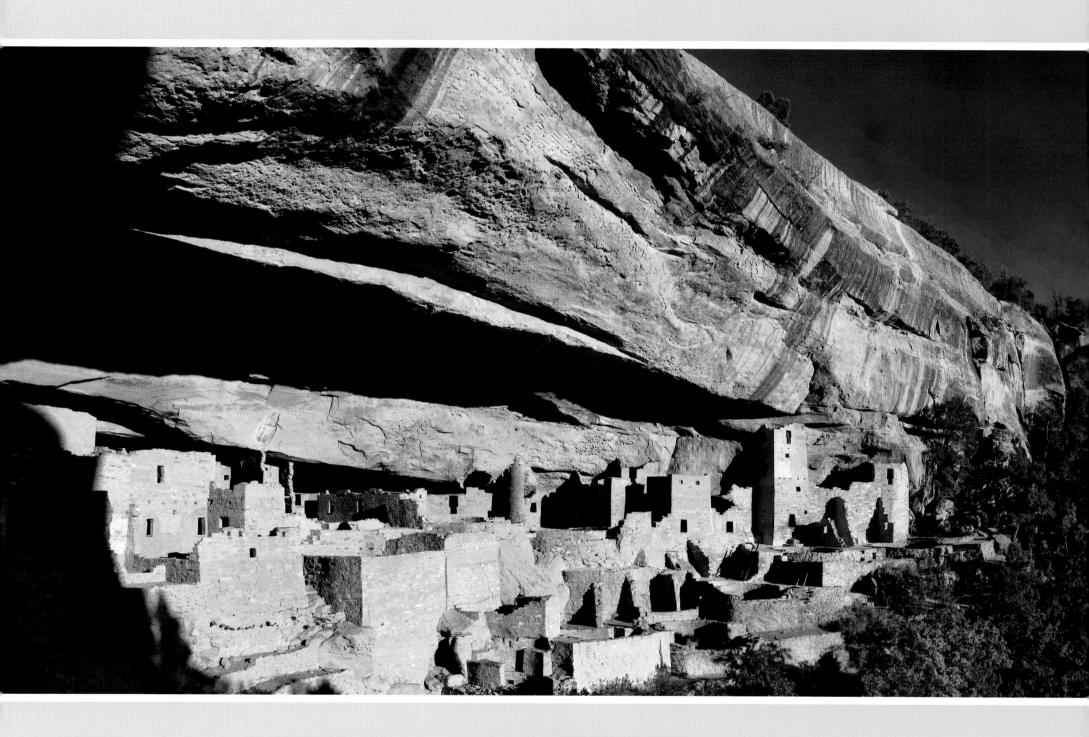

"Deep in that canyon and near its head are many houses of the old people—the Ancient Ones. One of those houses, high, high in the rocks, is bigger than all the others. Utes never go there, it is a sacred place."

—Ute Indian Acowitz, speaking to rancher Richard Wetherill, 1881

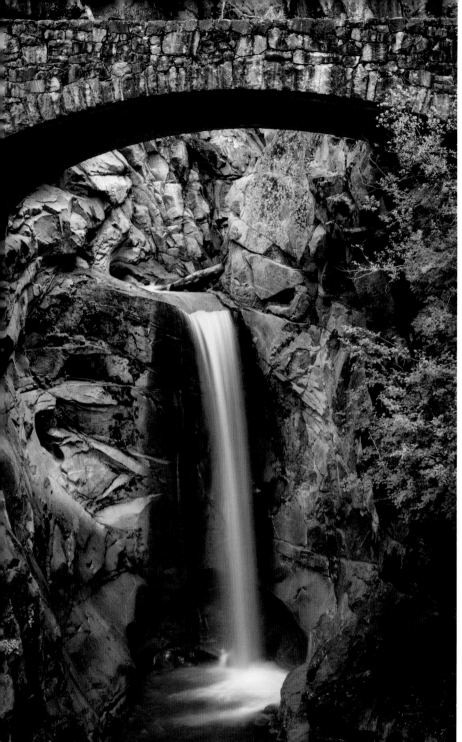

MOUNT RAINIER
NATIONAL PARK
WASHINGTON

The Mountain of Moods

This giant snow-covered volcano rises 14,410 feet above sea level. It is an iconic sight within the Washington landscape and is a favorite for hikers, mountaineers, photographers and sightseers. There are twenty-six named glaciers, bountiful waterfalls, rivers, ancient forests and wildlife to feed the senses. In spring, wildflowers adorn the meadows. This mountain takes advantage of the weather and puts on a show of moody cloud formations, another visual feast to inspire artists and photographers alike.

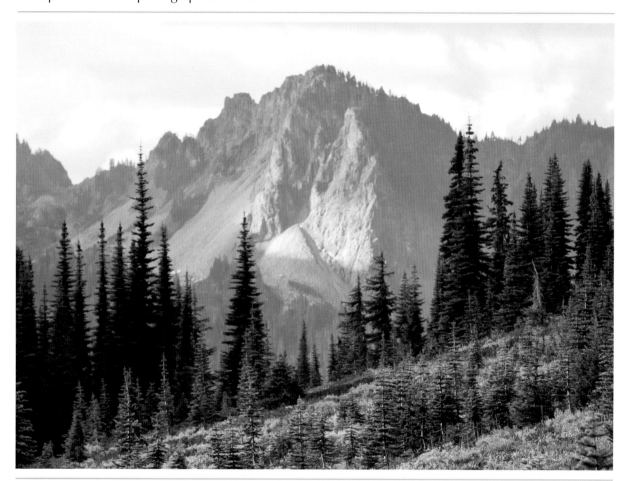

Location: Washington
Nearest city: Tacoma
Coordinates: 46°52'48"N 121°43'36"W
Area: 236,381 acres (95,660 ha)
Established: March 2, 1899
Visitors in 2015: 1,237,231

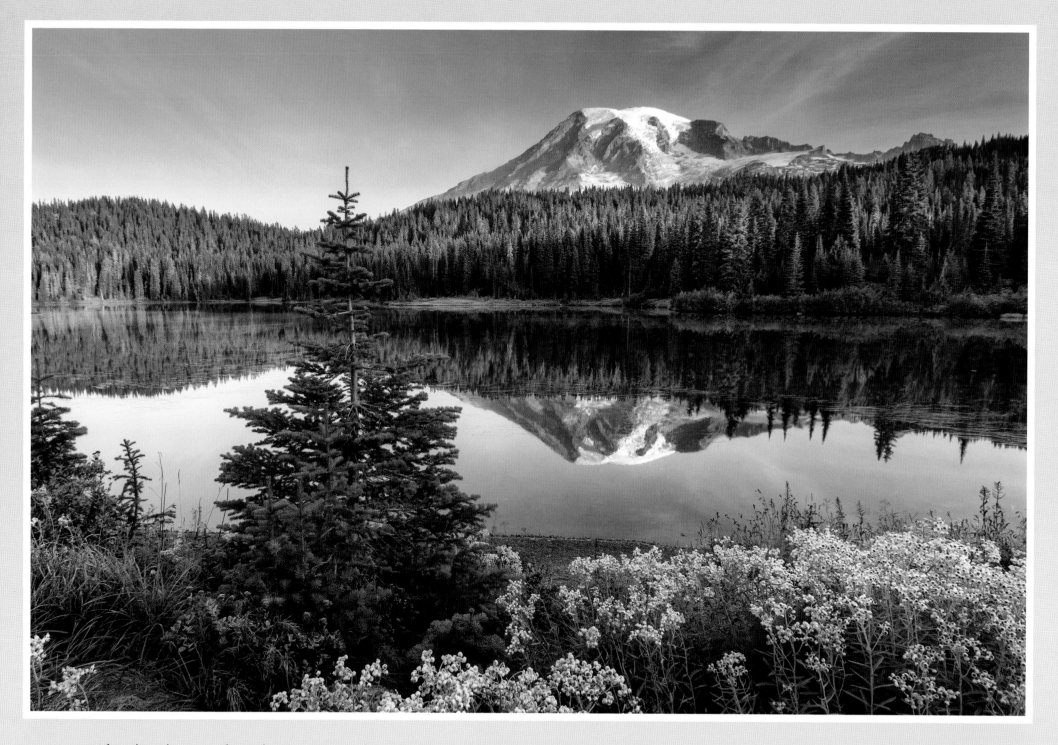

"After decades away from the mountains of my youth, seeing Mt. Rainier up close and personal, I was surprised to find tears running down my cheeks. This particular landscape and its features, stirring my emotions with memories, associations and wonderment at this old friend long absent from my horizon."

—Stephen Davidson, artist, Australia, 2016

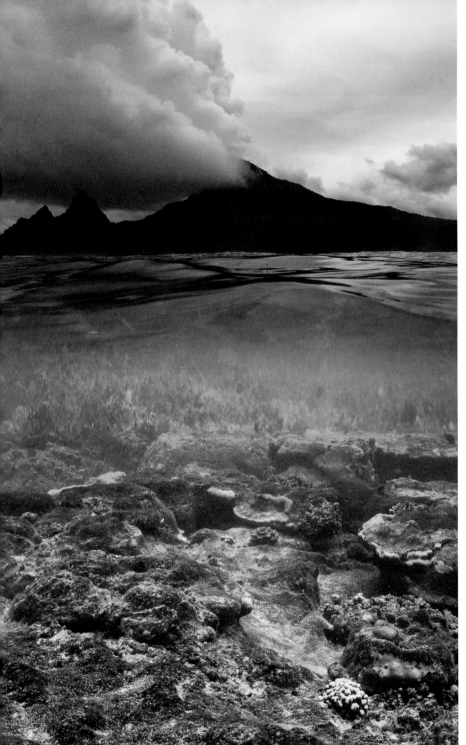

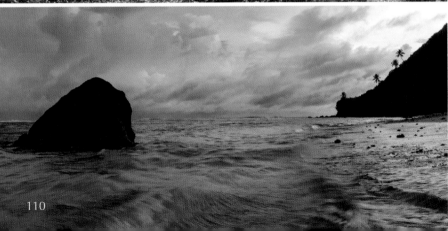

NATIONAL PARK OF AMERICAN SAMOA

A Beating Heart in the South Pacific

A rich ecosystem of rainforest, beach and coral reefs, sunshine, warmth and rain, and tropical flora and fauna. See flying fish and endangered fruit bats. Become immersed in the ancient culture of the Samoan people, among the friendliest people in the world, who are still wisely attuned to their island environment. Samoa means "sacred earth," and you will see why.

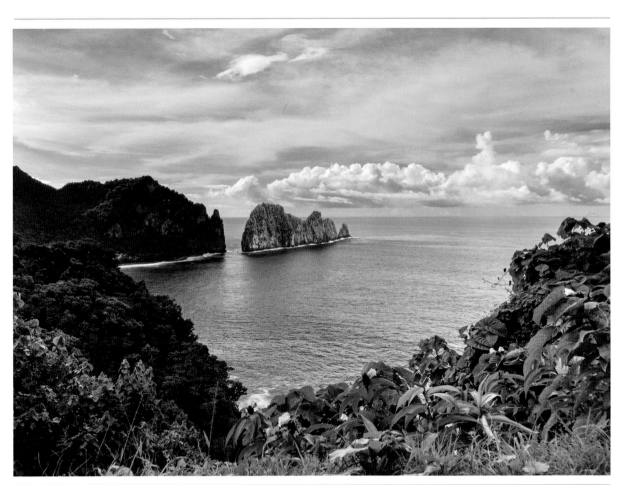

Location: American Samoa
Nearest city: Pago Pago
Coordinates: 14°15′30″S 170°41′00″W
Area: 13,500 acres (5,500 ha)
Established: October 31, 1988
Visitors in 2015: 13,892

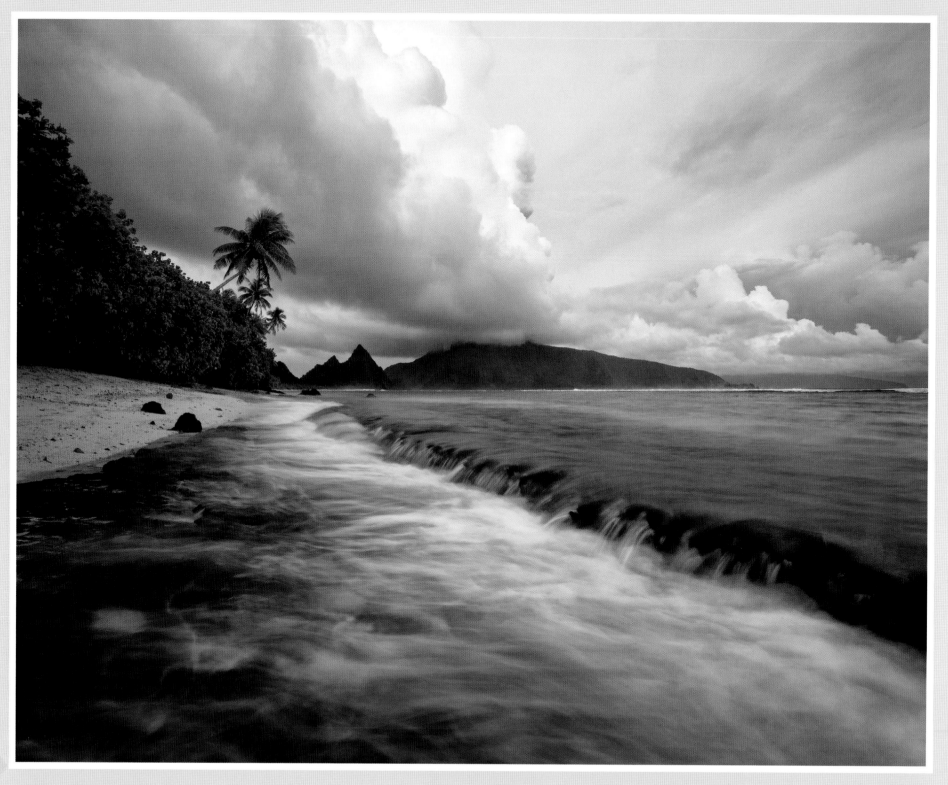

"Thousands of acres on Tutuila, Ofu, and Ta'u Islands span from mountain peaks to underwater reefs, making up the National Park of American Samoa. Just like a village chief, this park is a servant of its people—you—and a caretaker of the land."

—Eymard Bangcoro, park interpretation and education volunteer, 2015

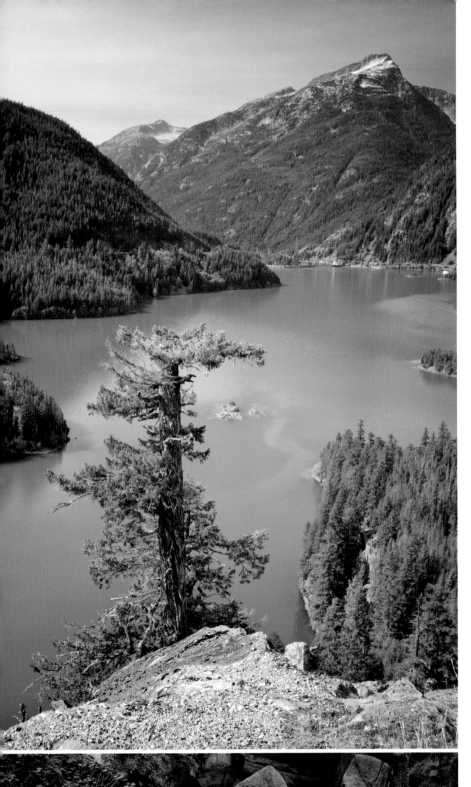

NORTH CASCADES
NATIONAL PARK

The American Alps–a Wilderness Wonderland

It may be named for its innumerable waterfalls, but the Cascades' jagged peaks beckon hikers, backpackers and mountaineers to come explore any of the park's nearly four hundred miles of trails through virgin forests, meadows and hidden lakes. However, if you drive the road you will see the snow-covered peaks and hundreds of glaciers from afar, and have time to search for wildlife, pause at popular Diablo Lake, or view one of the most photographed mountains in the United States, Mount Shuksan.

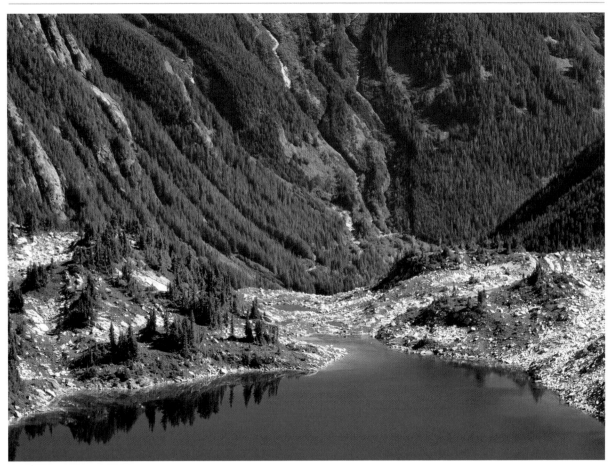

Location: Washington
Nearest city: Marblemount
Coordinates: 48°28'59"N 120°54'41"W
Area: 504,781 acres (204,278 ha)
Established: October 2, 1968
Visitors in 2015: 20,677

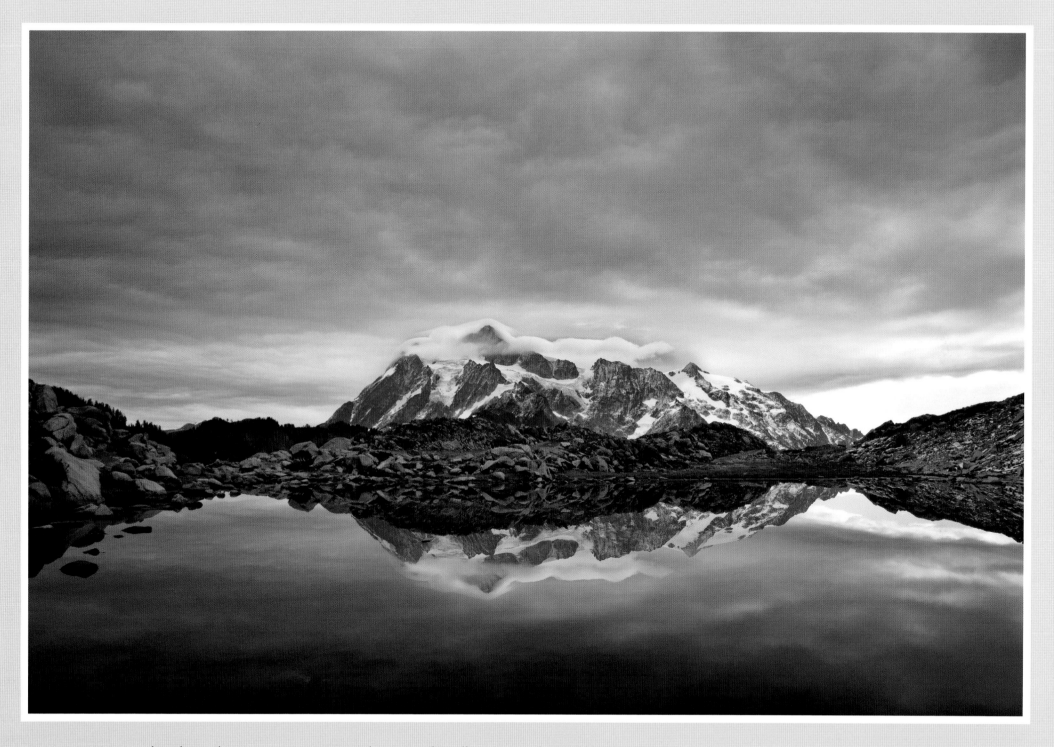

"National parks and reserves are an integral aspect of intelligent use of natural resources. It is the course of wisdom to set aside an ample portion of our natural resources as national parks and reserves, thus ensuring that future generations may know the majesty of the earth as we know it today."

—John F. Kennedy
thirty-fifth president of the United States

OLYMPIC
NATIONAL PARK

Mountain to Shore–Spoilt for Choice

From the top of Mount Olympus down to the sandy shoreline of the Pacific, with a temperate rainforest in between, Olympic has something for everyone. Three distinct ecosystems offer outstanding scenery at every turn. The dense green forest drips with moss, spectacular waves crash on the shore of the peninsula and snow-covered mountains paint a wondrous picture. The Hoh and Quinault Rain Forests are the wettest areas in the continental United States and make quite a splash!

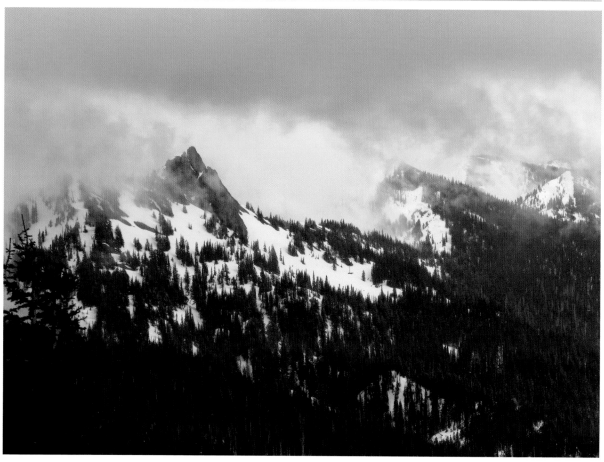

Location: Washington
Nearest city: Port Angeles
Coordinates: 47°58′10″N 123°29′55″W
Area: 922,650 acres (373,380 ha)
Established: June 29, 1938
Visitors in 2015: 3,263,761

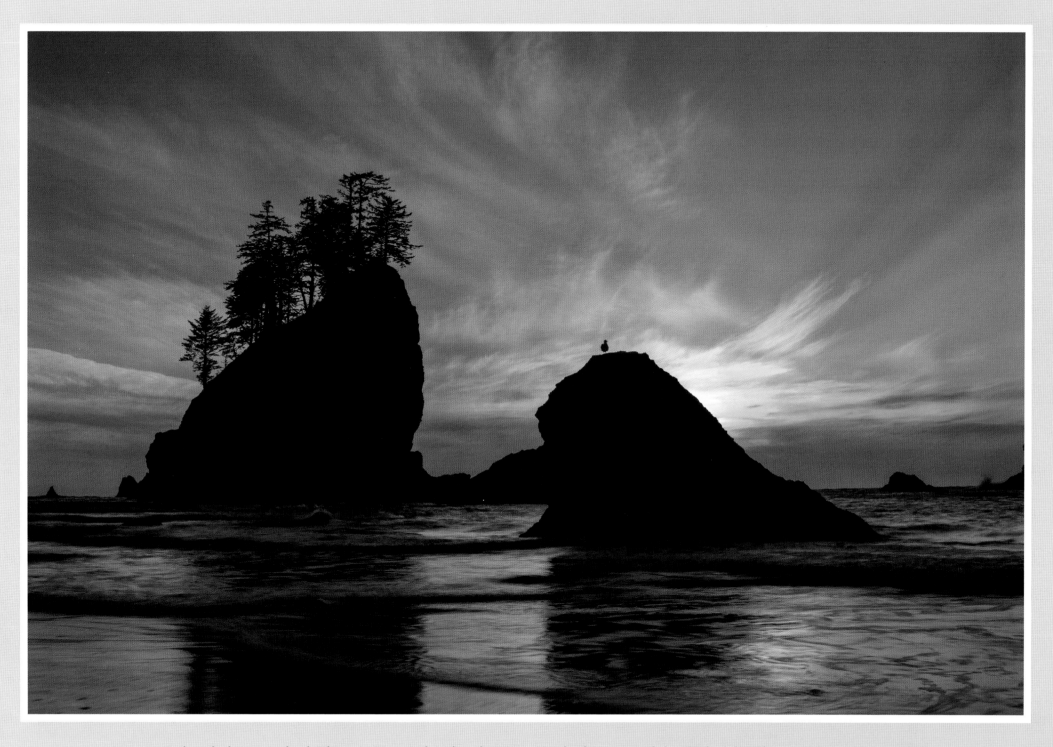

"I've visited and photographed Olympic National Park only twice, yet the beauty and the soul of the place never seem far from my consciousness. The light, the landscape, the variety of scenes and subjects—the fog among the sea stacks, the dripping of the rainforest, the crisp air of the mountains—all intertwine in a magic wildness that always lingers in my mind and my heart. I can't forget this place, nor would I want to."

—*Chris Nicholson*
Photographing the National Parks, *2015*

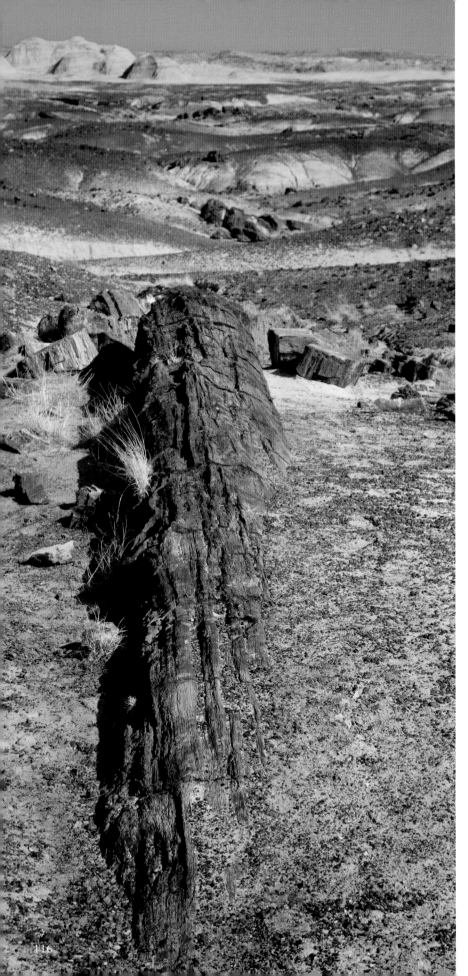

PETRIFIED FOREST
NATIONAL PARK
ARIZONA

Wood Turns to Stone, Minerals Turn to Rainbows

Nearby Route 66 has many stories to its name, but at more than 200 million years old, imagine how many stories the land in this park could tell! In those long-ago days the trees that died floated downstream to form log jams, silica-laden volcanic ash covered them and the organic matter within them was replaced with quartz crystals. The various "forests" in the park are those log jams. The 147 square miles of Petrified Forest also include the colorful painted hills and a grassland ecosystem.

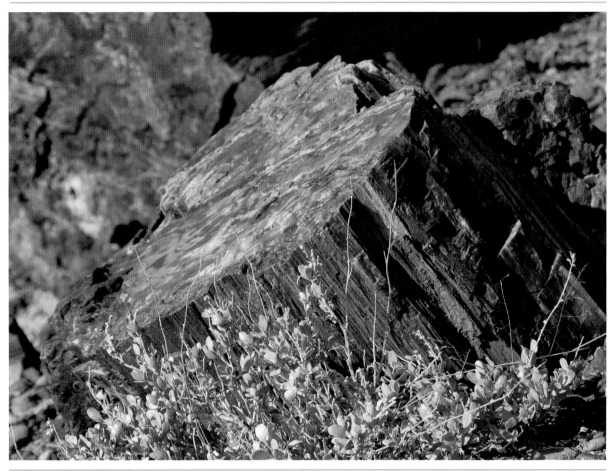

Location: Arizona
Nearest city: Holbrook
Coordinates: 35°05'17"N 109°48'23"W
Area: 221,552 acres (89,659 ha)
Established: December 9, 1962
Visitors in 2015: 793,225

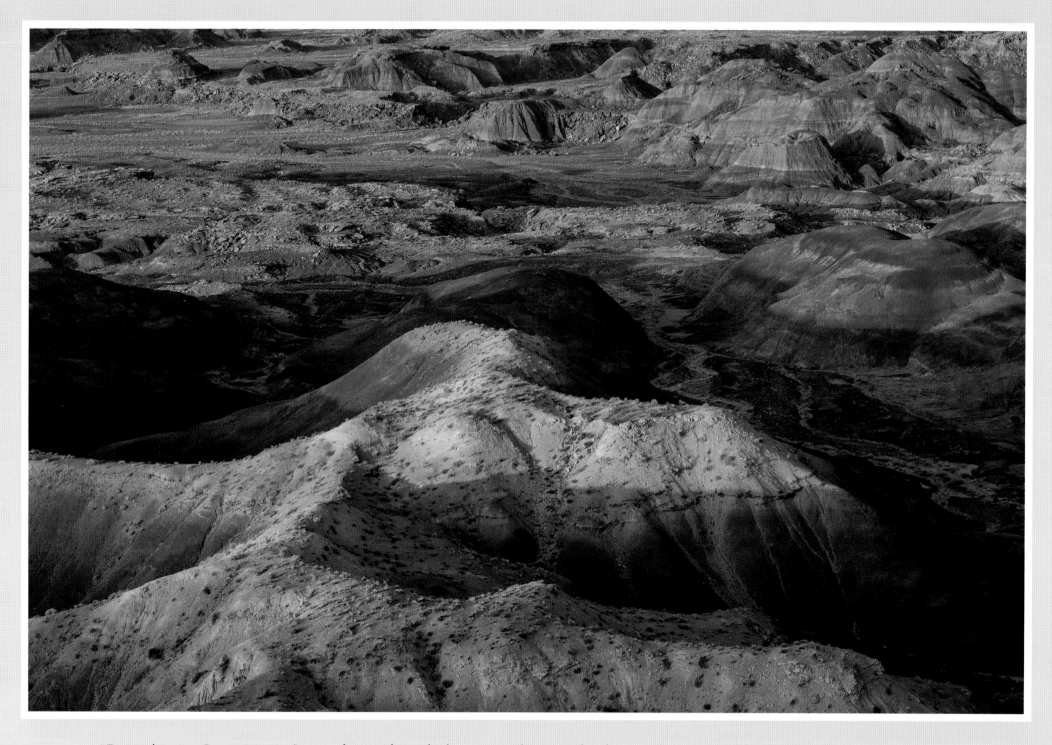

"December 2—Camp 76 . . . Quite a forest of petrified trees was discovered today . . . They are converted into beautiful specimens of variegated jasper. One trunk was measured ten feet in diameter, and more than one hundred feet in length . . . "

—Lieutenant Amiel Weeks Whipple,
military engineer and surveyor, 1853

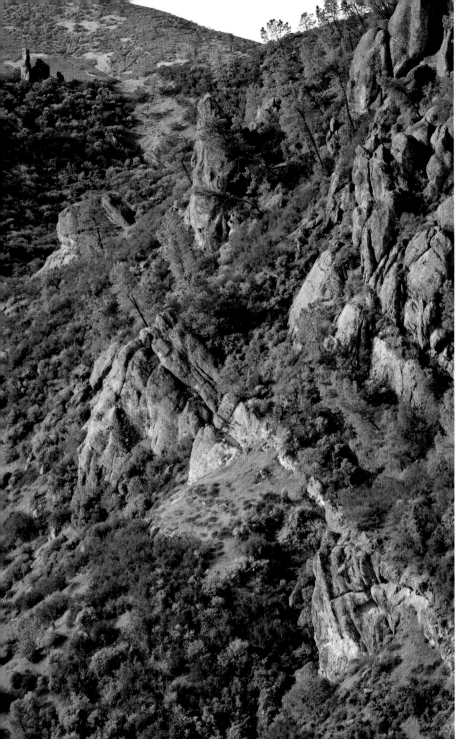

PINNACLES
NATIONAL PARK

A Place of Salvation

These rocky spires are the remains of an ancient volcanic field, now home to and protector of wildlife, including more than thirteen species of bat and the endangered California condor. Pinnacles is one of a few locations in the world where the condor can be seen in the wild. Its survival is still threatened. The bats make their home in talus caves, openings formed between boulders piled up on mountain slopes. This newest of national parks is a great location for camping, hiking, climbing and, of course, protecting valuable wildlife.

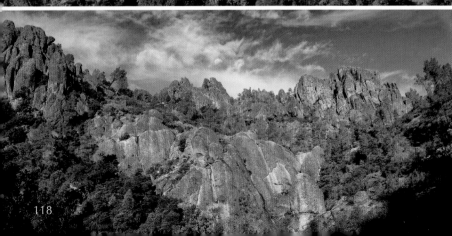

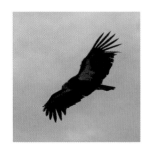

Location: California
Nearest city: Soledad
Coordinates: 36°29'13''N 121°10'01''W
Area: 26,606 acres (10,767 ha)
Established: January 10, 2013
Visitors in 2015: 206,533

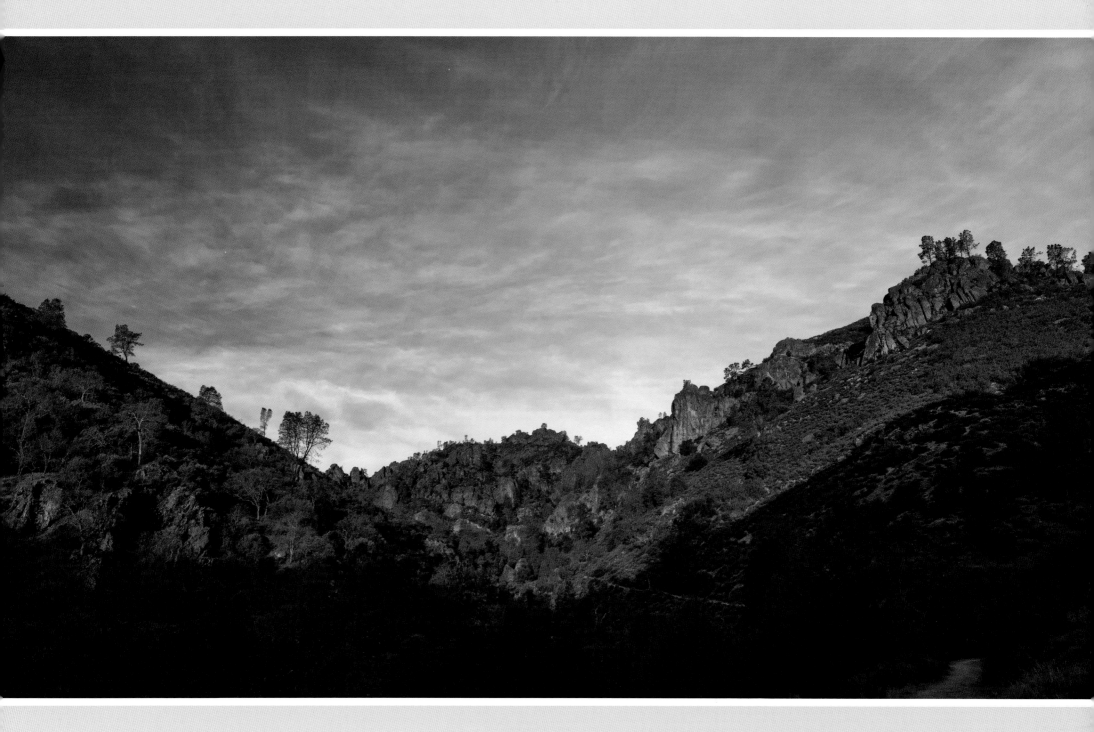

". . . the doorway to the Garden of the Gods, but on a grander scale. Here the cliffs of many-colored rock rise hundreds of feet in sharply defined terraces, or great domes or pinnacles. Beyond, and scattered over an area of some six square miles, is a mass of conglomerate rocks wonderful in extent and in fantastic variety of form and coloring."

—Schuyler Hain,
known as "the Father of Pinnacles"

REDWOOD
NATIONAL AND STATE PARKS

CALIFORNIA

Tall Timbers

Thirty-seven miles of protected coastline includes tide pools and sea stacks; the prairies, woodlands and riverways, too, support diverse wildlife. But visitors come primarily to crane their necks and look upward at the mighty coastal redwoods—the tallest trees on earth, standing in serenity and silence. Remember the logging that so quickly removed these magnificent giants from the Earth.

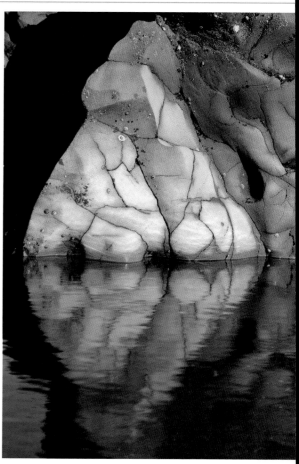

Location: California
Nearest city: Crescent City
Coordinates: 41°12'47"N 124°00'16"W
Area: 131,983 acres (53,411 ha)
Established: January 1, 1968
Visitors in 2015: 527,143

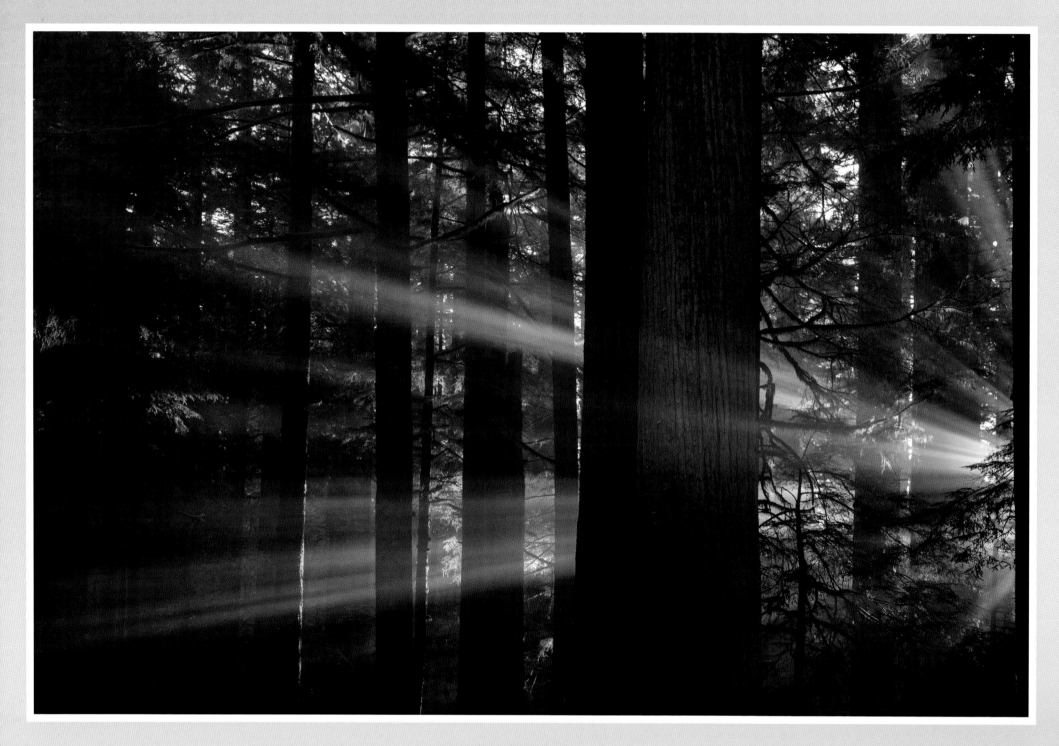

"Big trees are among nature's most impressive and inspiring living things. We are fortunate the giants in Redwood National Park have been preserved for all to enjoy!"

—John and Terry Binkele,
"Trekking the National Parks: The Board Game," 2015

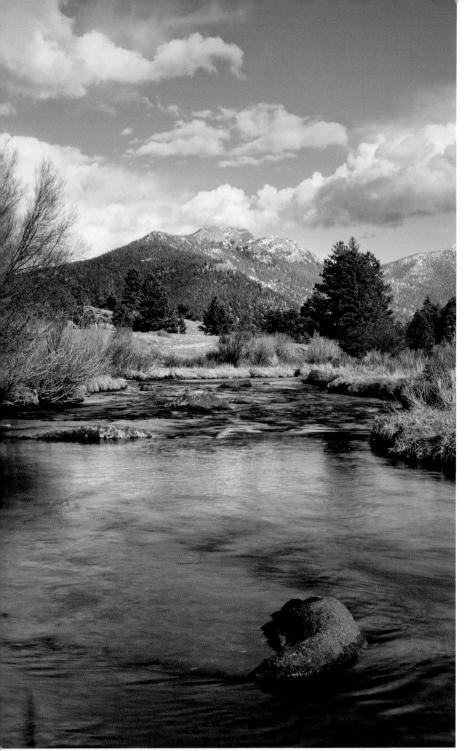

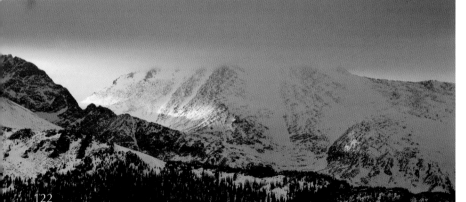

ROCKY MOUNTAIN
NATIONAL PARK
COLORADO

Rocky Mountain High

Sunrises and sunsets light the sky with pinks and golds, snow and ice are highlighted with slashes of blue, the glass-like surfaces of lakes reflect the surrounding scenery and sky, day or night. Wildlife and wildflowers appear, just to make you smile, and the skies are free to create mystic mood and mayhem, but the grand mountains are forever still, watching over what they have cultivated.

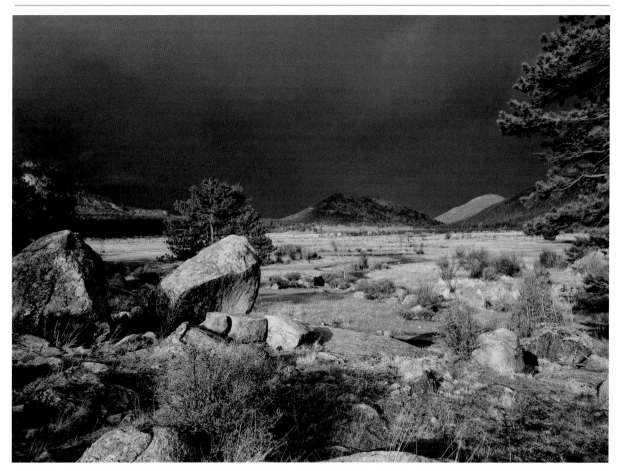

Location: Colorado
Nearest city: Estes Park
Coordinates: 40°20'00"N 105°42'32"W
Area: 265,761 acres (107,550 ha)
Established: January 26, 1915
Visitors in 2015: 4,155,916

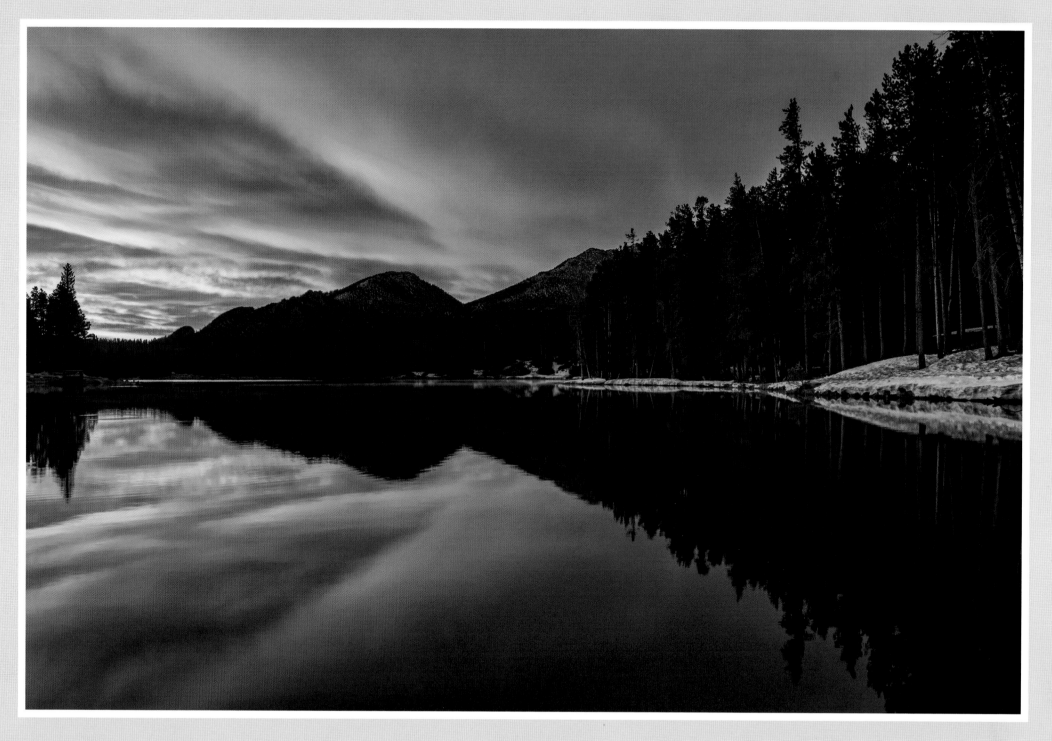

"I have dropped into the very place I have been seeking, but in everything it exceeds all my dreams . . . The scenery is the most glorious I have ever seen, and is above us, around us, at every door."

—Isabella Bird,
A Lady's Life in the Rocky Mountains, *1879*

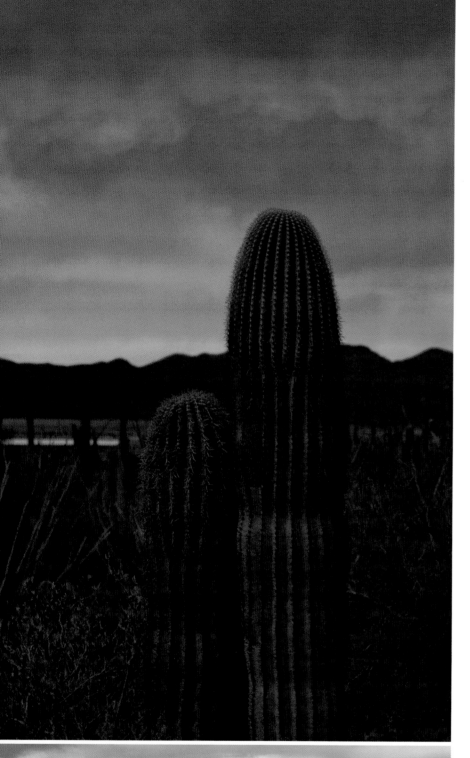

SAGUARO
NATIONAL PARK

Expressive Symbols of the American Southwest

With the establishment of this park in 1994, the giant saguaro cactus finally found protection from rampant "cactus rustling" and trampling of young cactus by cattle. With an east and a west side, divided by the city of Tucson and the Rincon Mountains, the park now protects the United States' largest cactus. The saguaro also protect desert wildlife, including the tiny elf owl that nests within its trunk or limbs. In the spring, beautiful blossoms adorn the tips of these magnificent succulents' outstretched limbs. But in any season they make a stunning silhouette, especially in front of a hot desert sunset.

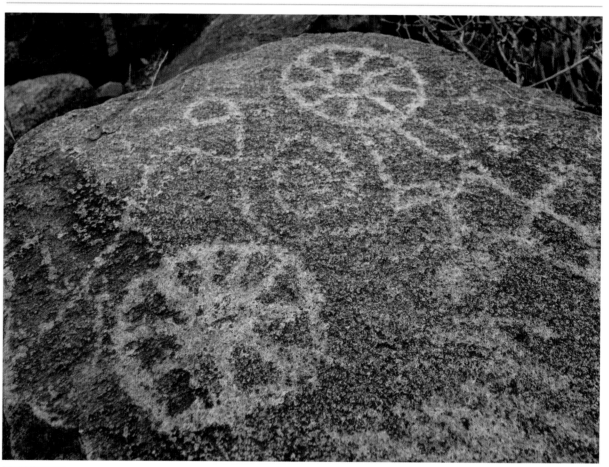

Location: Arizona
Nearest city: Tucson
Coordinates: 32°15'0''N 110°30'0''W
Area: 91,442 acres (37,005 ha)
Established: October 14, 1994
Visitors in 2015: 753,446

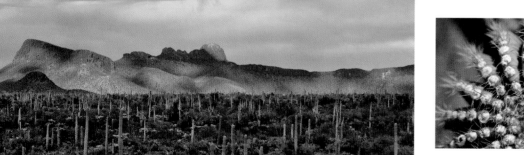

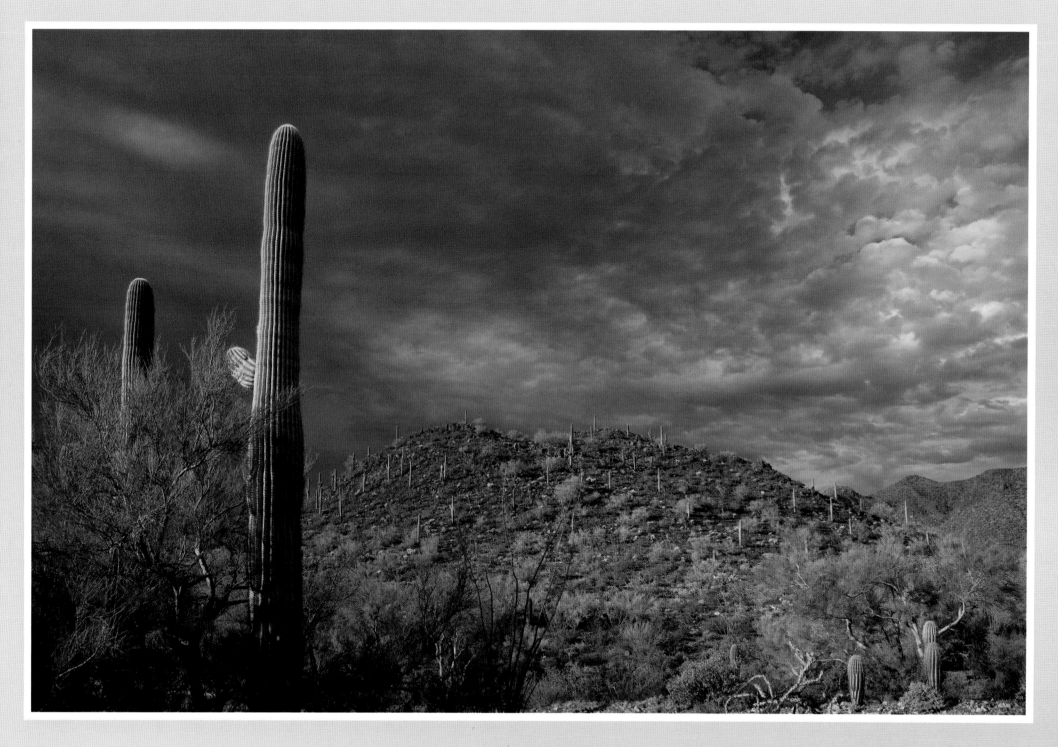

" . . . a great natural area for maintaining the botanical and zoological forms of the Southwest under natural conditions."

—Homer L. Shantz, President of the University of Arizona, 1933

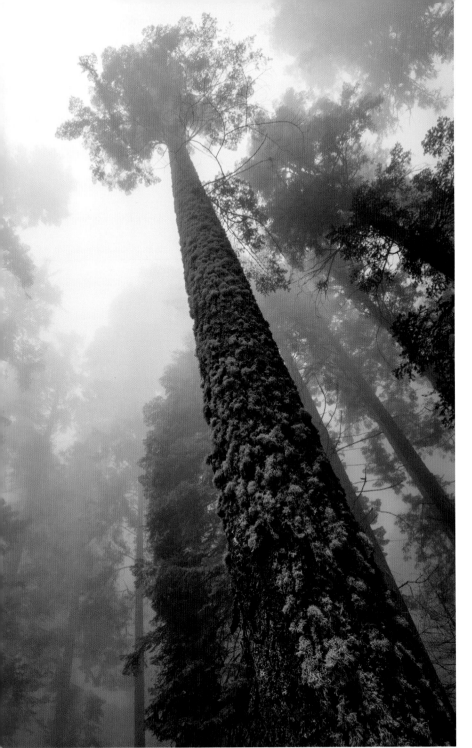

SEQUOIA
NATIONAL PARK

Groves of Giants

In Sequoia National Park you will find 275-foot-tall General Sherman, the world's largest tree, itself surrounded by more giants. Everything is big—trees, canyons, rocks and mountains. After seeing these giant trees from the ground, climb Moro Rock and stand at 6,725 feet to view from above. This perspective shows not only the landscape they inhabit, but the sky they unwittingly obscure when seen from below.

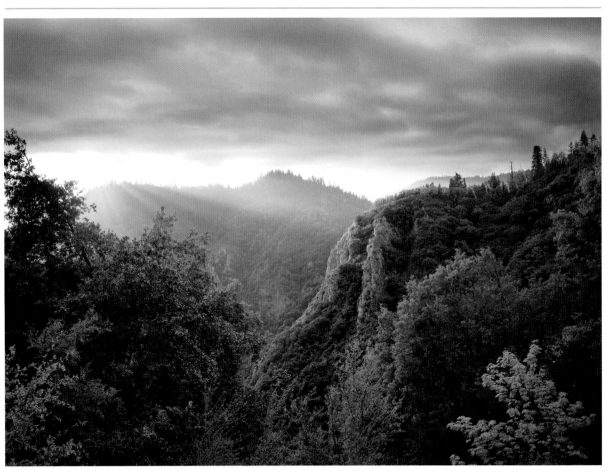

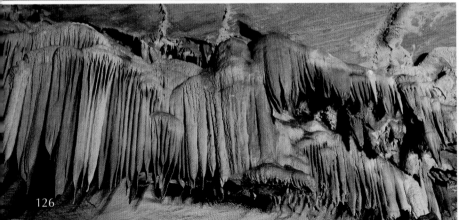

Location: California
Nearest city: Visalia
Coordinates: 36°33'53"N 118°46'24"W
Area: 404,063 acres (163,518 ha)
Established: September 25, 1890
Visitors in 2015: 1,097,464

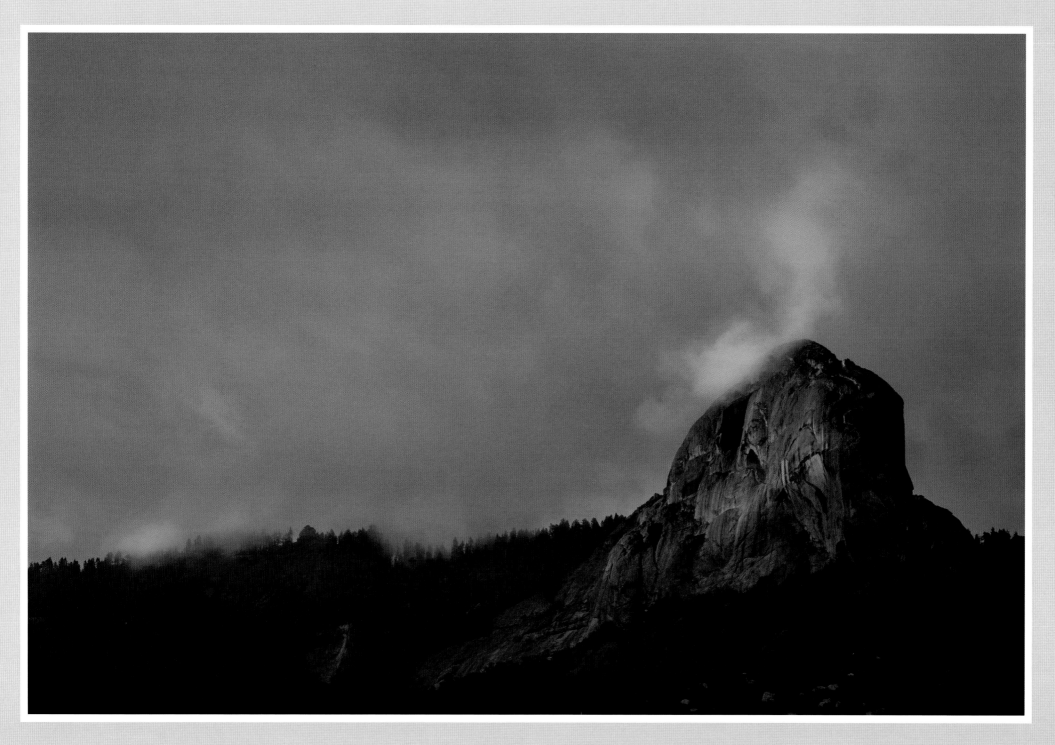

"In every walk with Nature one receives far more than he seeks."

—John Muir,
naturalist and conservationist, founder of the Sierra Club,
and "Father of the National Parks"

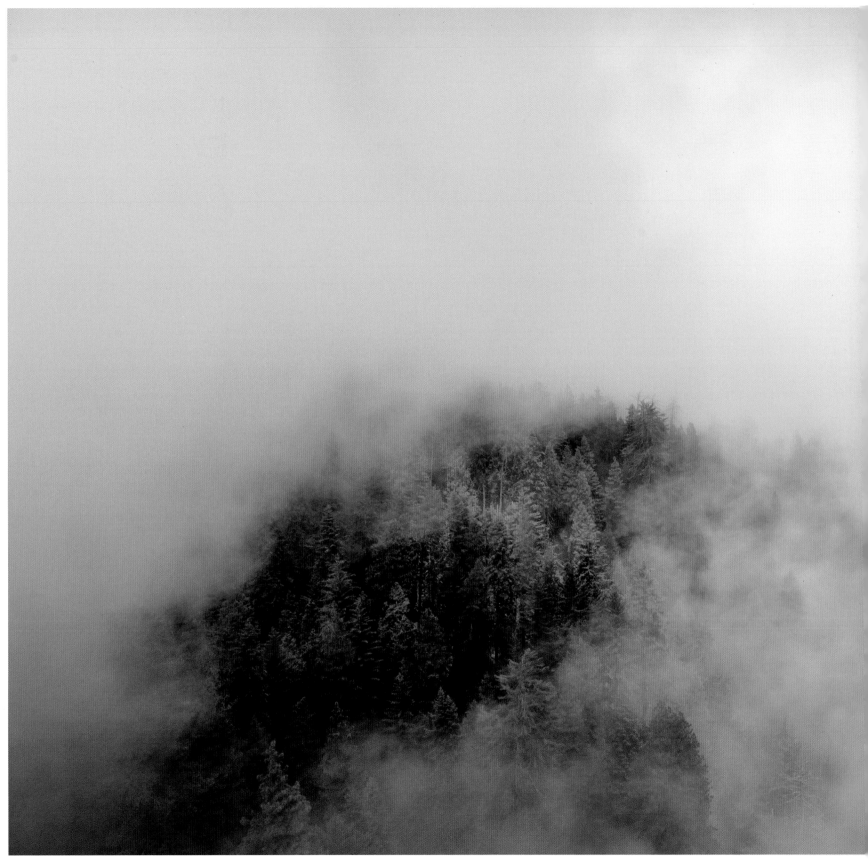

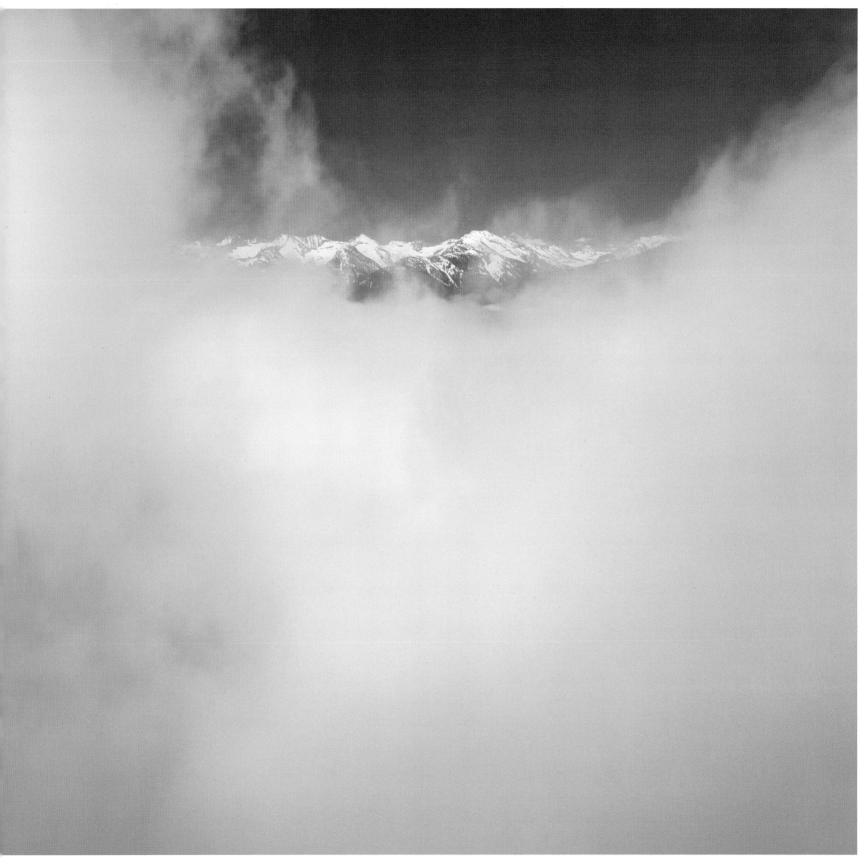

SHENANDOAH
NATIONAL PARK

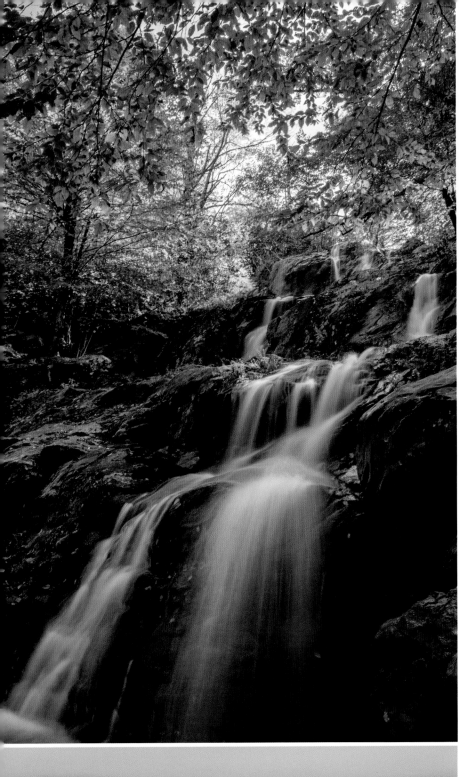

Virginia's Garden of Eden

Swirling mists in the mountains create hypnotic landscapes. Cascading waterfalls ramble through rich green hardwood forests. Wildlife peeps out at your every turn. Whether you hike the Appalachian Trail or one of the many other trails in the heart of the park, you will find yourself in a magical landscape.

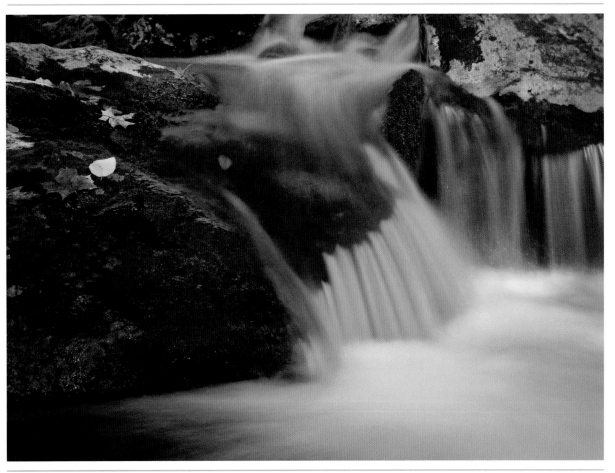

Location: Virginia
Nearest city: Front Royal
Coordinates: 38°17'34"N 78°40'46"W
Area: 199,100 acres (80,600 ha)
Established: December 26, 1935
Visitors in 2015: 1,321,873

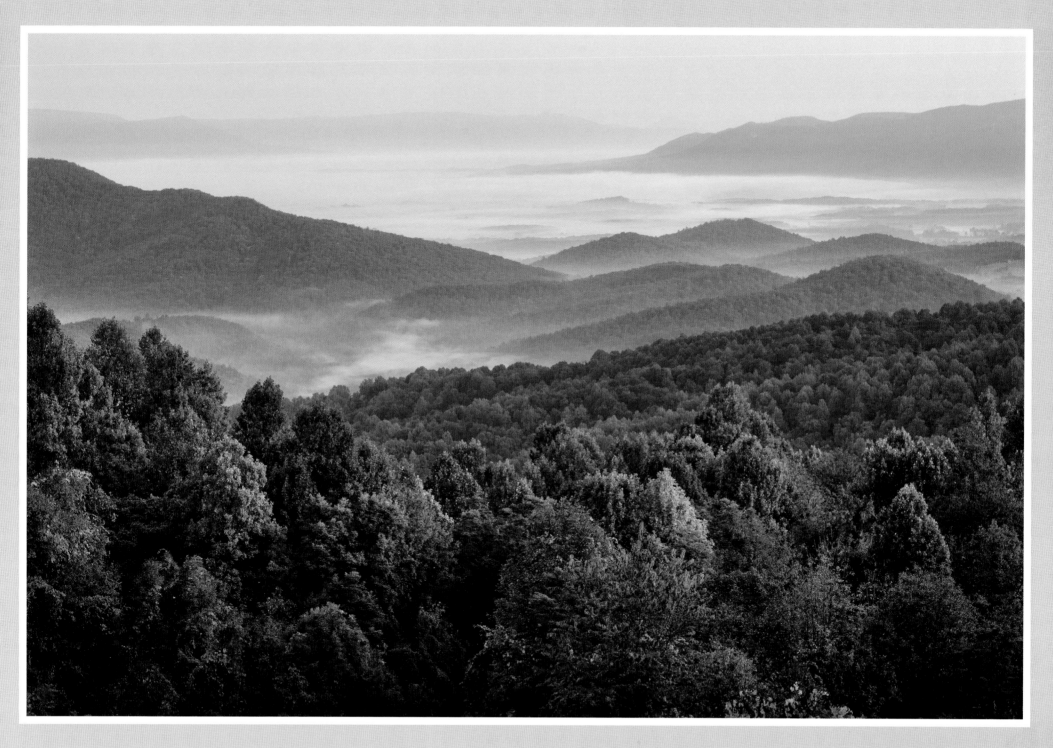

"The greatest single feature, however, is a possible skyline drive along the mountain top, following a continuous ridge and looking down westerly on the Shenandoah Valley . . . and commanding a view [to the east] of the Piedmont Plain . . . Few scenic drives in the world could surpass it."

—Report of the Southern Appalachian National Park Committee, 1925

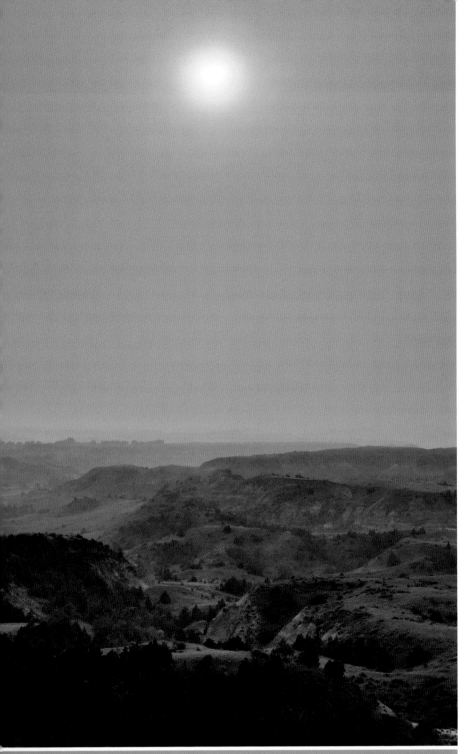

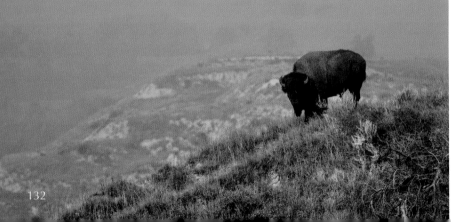

THEODORE ROOSEVELT
NATIONAL PARK

Of Presidential Importance

This park honors the memory of President Roosevelt for his conservation efforts. It also offers visitors views of the North Dakota Badlands, a transcendent landscape. Among the colorful hills, canyons and prairies live abundant wildlife, including American bison, pronghorn, prairie dogs, bighorn sheep and wild horses. All can be seen from the roads as you drive, but imagine seeing this and more while hiking a trail or the backcountry. Just like walking in Roosevelt's footsteps, perhaps?

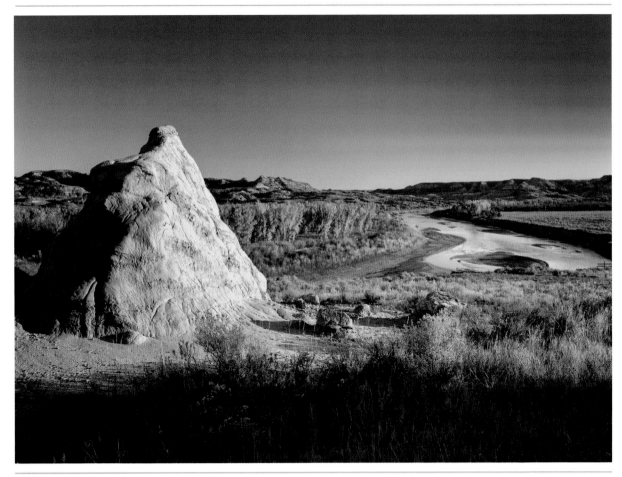

Location: North Dakota
Nearest city: Medora
Coordinates: 46°58'44"N 103°32'19"W
Area: 70,446 acres (28,508 ha)
Established: November 10, 1978
Visitors in 2015: 580,033

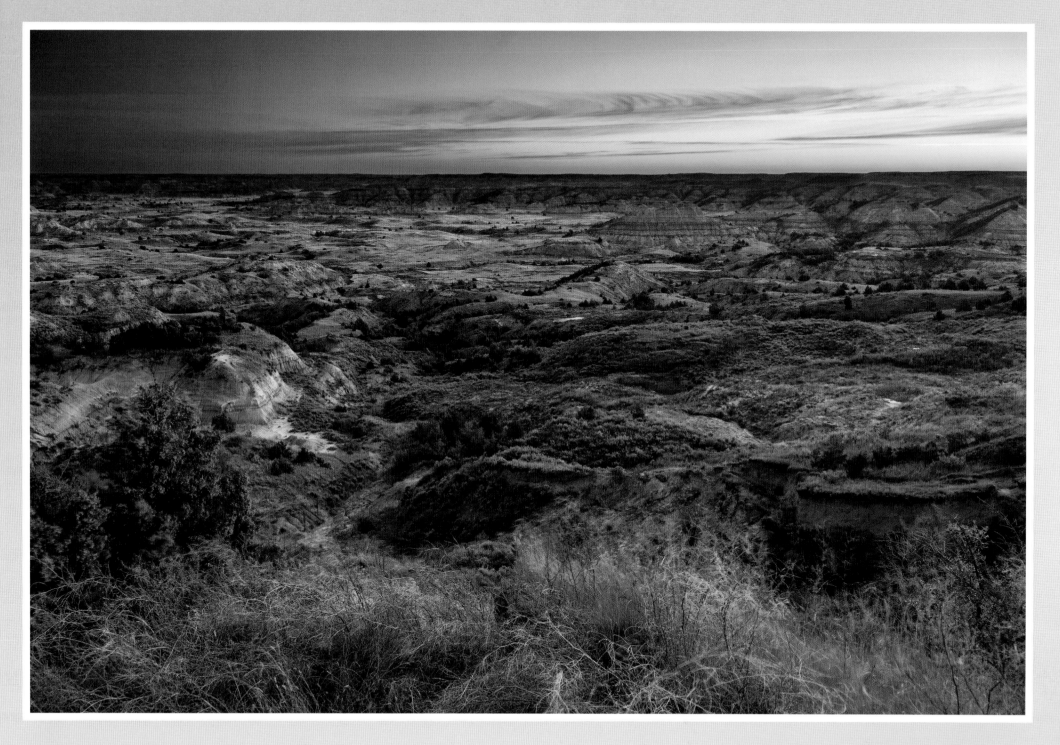

"I would not have been President had it not been for my experience in North Dakota."

— Theodore Roosevelt,
twenty-sixth president of the United States

VIRGIN ISLANDS
NATIONAL PARK

US VIRGIN ISLANDS

A Trip to Paradise

Remnants of colonization and sugar plantations are found in this national park in the Caribbean. Green hills sweep down to enticing white beaches, and turquoise ocean waters rich in sea life lap the shore, attracting visitors year-round. Snorkel, dive, sail, hike or just relax in a place of endless fun and beauty, where deer walk the beaches at sunrise.

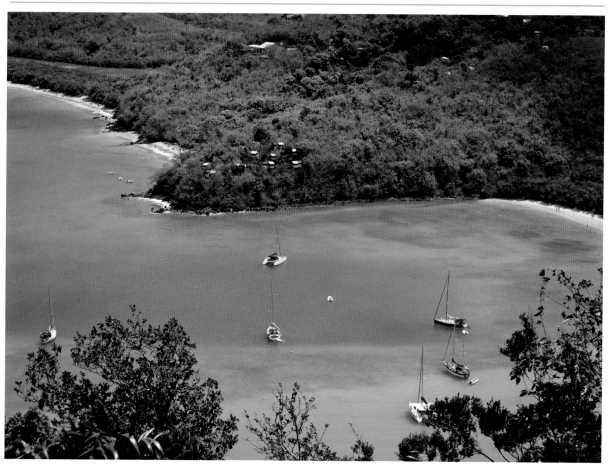

Location: US Virgin Islands
Nearest city: Charlotte Amalie
Coordinates: 18°20'0"N 64°44'0"W
Area: 14,737 acres (5,964 ha)
Established: August 2, 1956
Visitors in 2015: 430,372

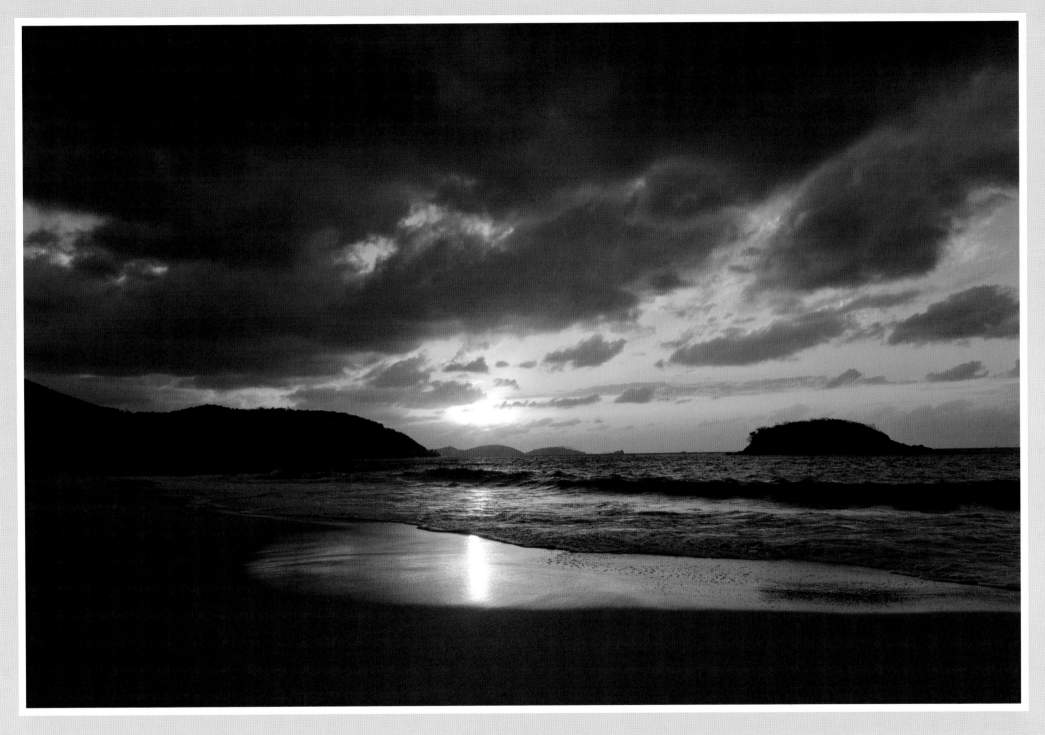

"Many parks encourage one to be busy and on the move. I find that Virgin Islands National Park encourages us to slow down. Soak in the sun, stroll along the beach, float on the gentle water, wander among the coral with a snorkel, and wait to see what beauty the day will bring. It never disappoints."

—Katie Campbell, 2016

"Virgin Islands National Park is a place full of happiness, cats, pancakes and smoothies."

—Maria Campbell, age 14, 2016

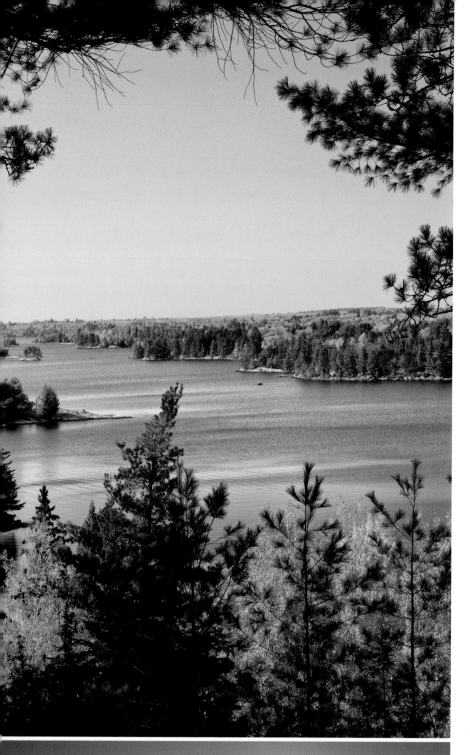

VOYAGEURS
NATIONAL PARK

A Voyage Worth Taking

Choose your mode of transportation—boat, canoe, kayak or foot—and explore this mosaic of land and water that carried and supported the fur traders. Forty percent of this park is water, the rest a landscape formed by ancient earthquakes, volcanoes and, more recently, glaciers. Drag your fingers through the water off the side of a boat, hike through the boreal forest in its colorful fall foliage, visit rock gardens, and watch the moon rise over dark waters at night.

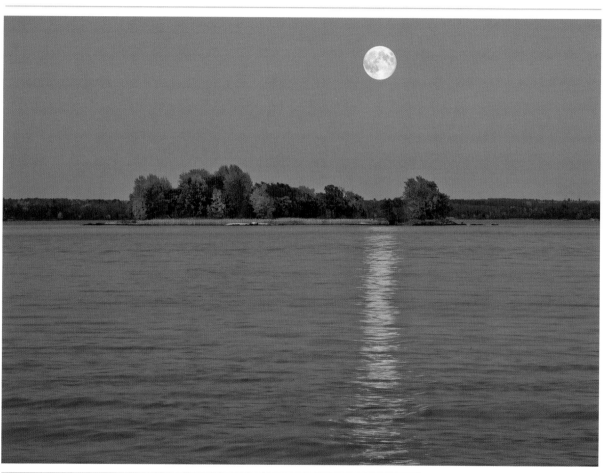

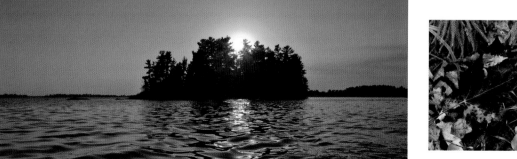

Location: Minnesota
Nearest city: International Falls
Coordinates: 48°35'03"N 93°09'42"W
Area: 218,200 acres (88,300 ha)
Established: April 8, 1975
Visitors in 2015: 238,313

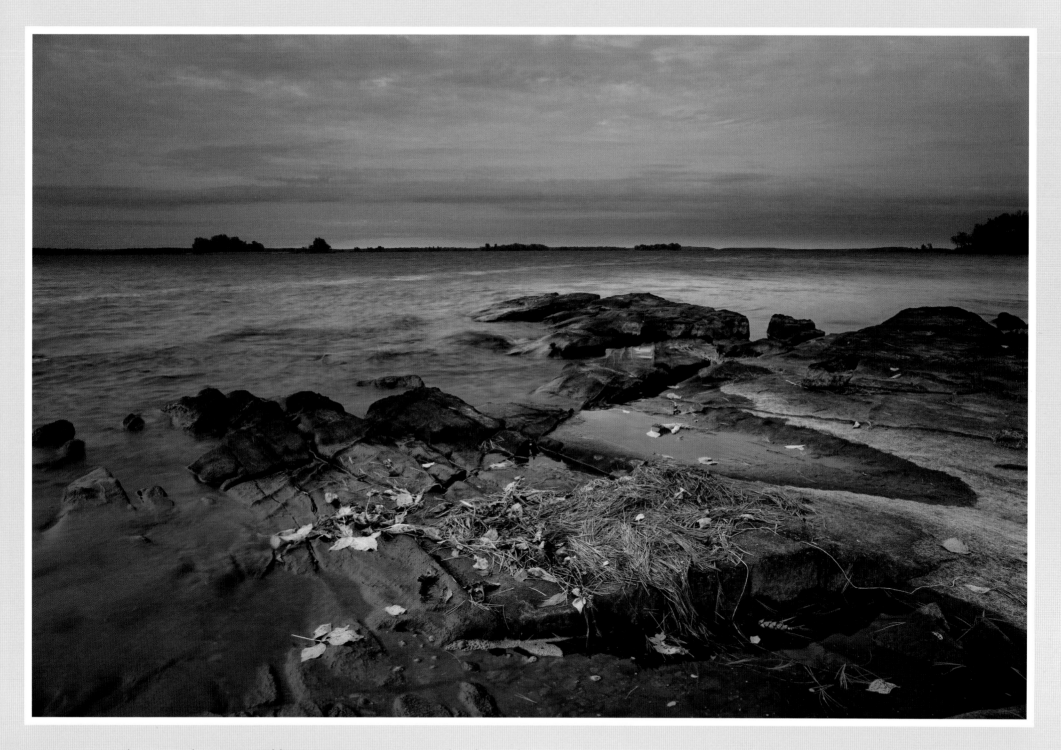

"The uniquely scenic and historic Voyageurs National Park stands as a monument forever to the dedicated citizens and conservation organizations whose vision, ingenuity and courage match the splendor of this superlative wilderness area. Rich in history of the early, exciting exploration of our great country, Voyageurs will serve as a living legacy linking generation to generation and century to century."

—Richard M. Nixon,
thirty-seventh president of the United States

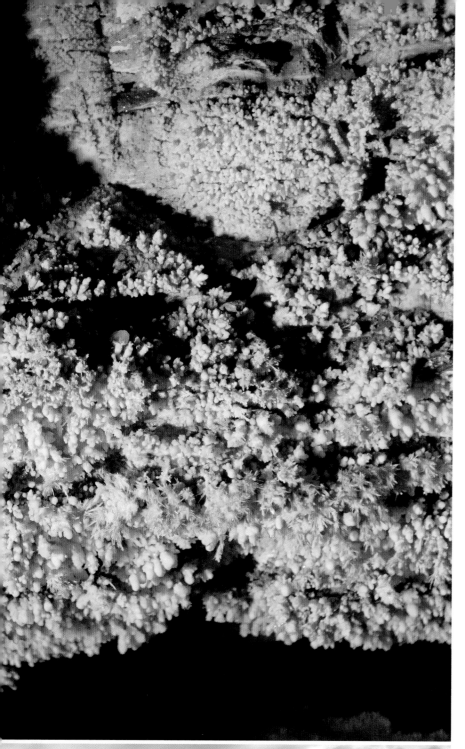

WIND CAVE
NATIONAL PARK

Two Halves to the Story

Above is a mixed-grass prairie dotted with bison, elk and other distinctive wildlife. Below lies a beautifully disguised cave system. The story of the ensuing exploration is just as intriguing as the unique calcite boxwork that the park protects.

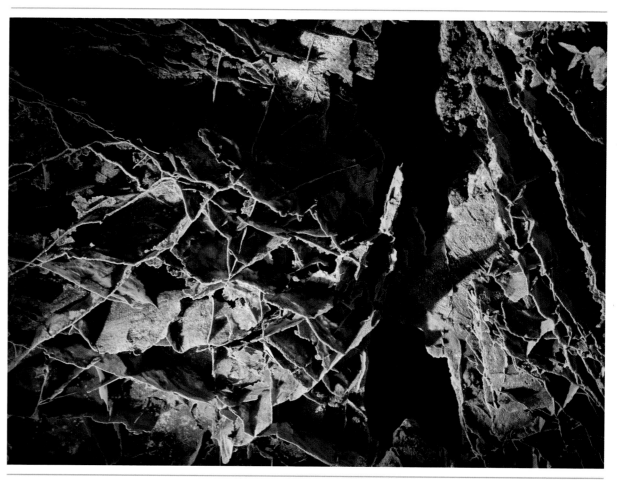

Location: South Dakota
Nearest city: Hot Springs
Coordinates: 43°33′23″N 103°28′43″W
Area: 33,847 acres (13,697 ha)
Established: January 9, 1903
Visitors in 2015: 612,198

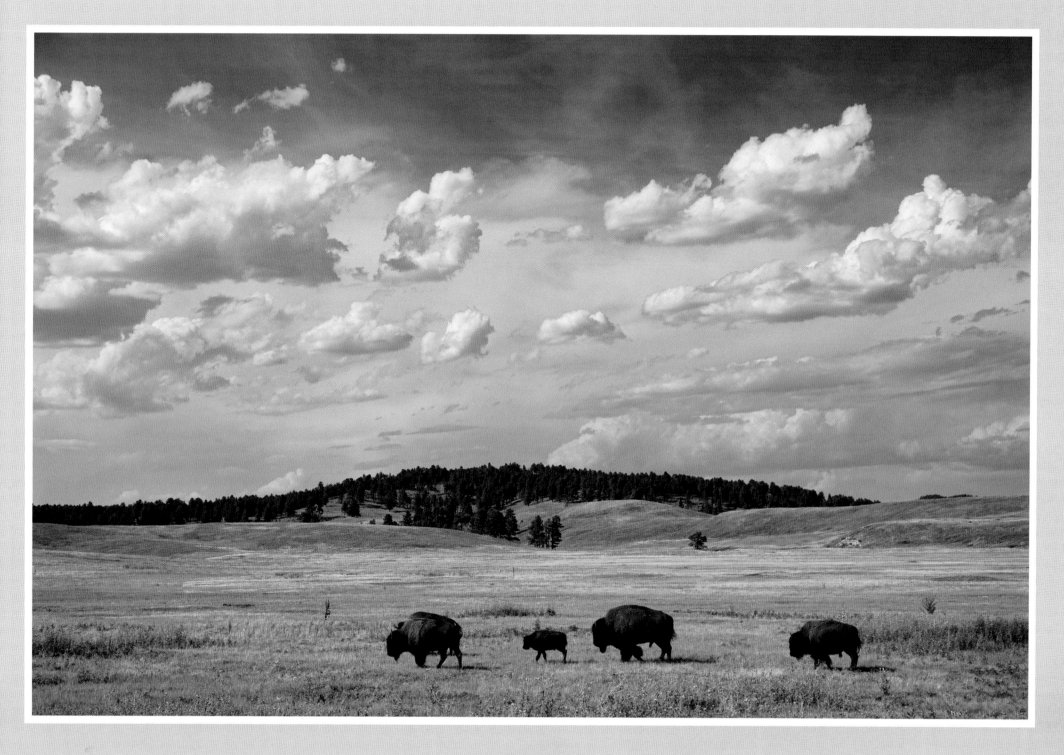

"Have given up the idea of finding the end of Wind Cave."

—*Alvin McDonald, 17-year-old early Wind Cave explorer, 1891*

WRANGELL–ST ELIAS
NATIONAL PARK AND PRESERVE

Size Does Matter

It is impossible to comprehend the 13.2 million acres of this largest of the national parks, unless you see it from the air. From above, you'll see rugged snow-covered mountains riddled with glaciers, and waterfalls cascading into rivers braided through a seemingly endless landscape. At ground level, walk on glaciers, ride the rivers and learn of the park's mining history, or drive the Richardson and Tok highways to experience Wrangell's spectacular panoramic mountain scenery. Whatever the view, it will be the ultimate treat.

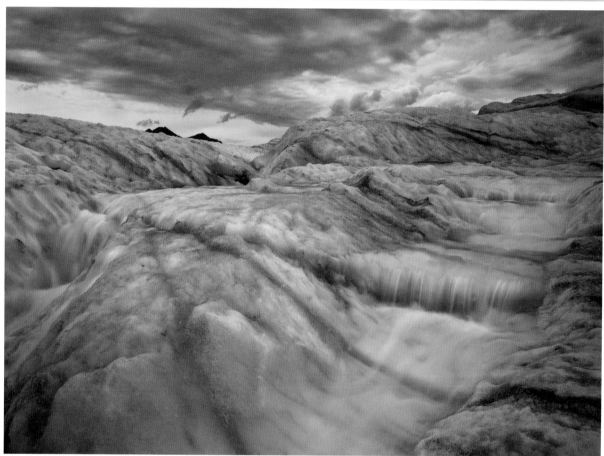

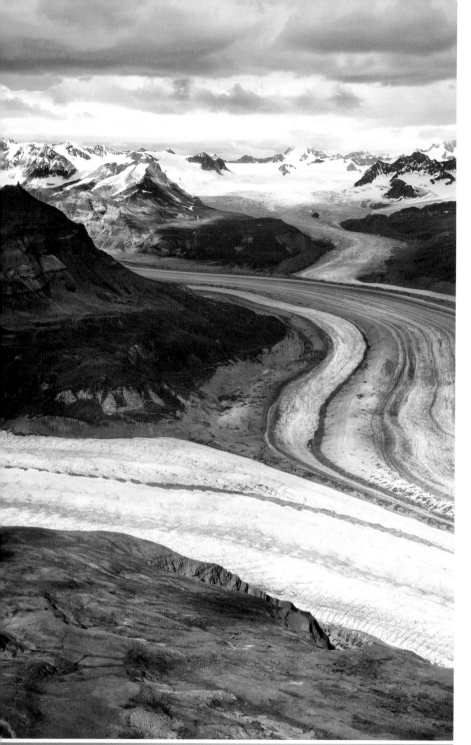

Location: Alaska
Nearest city: Copper Center
Coordinates: 61°42′37″N 142°59′08″W
Area: 13,175,799 acres (5,332,057 ha) (Park and Preserve)
Established: December 2, 1980
Visitors in 2015: 80,366

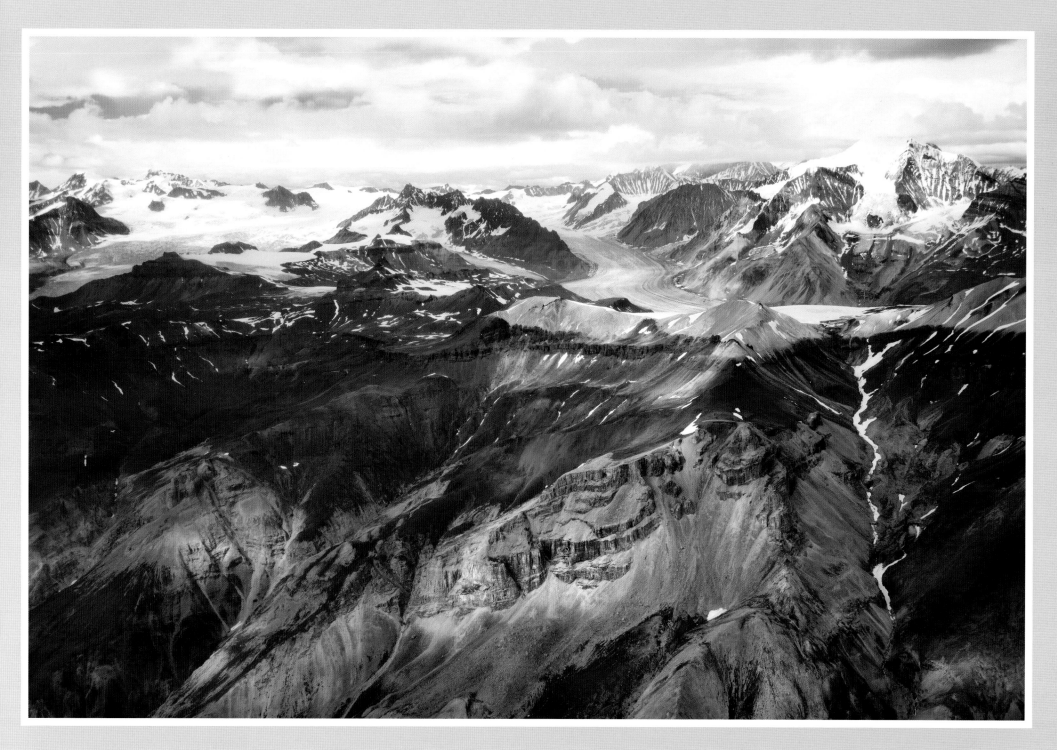

"Wrangell–St. Elias is truly the last frontier of the United States. No other park contains such remote, rugged wilderness, where humans have barely scratched the surface of exploration. Combining this rugged intensity with the tenacious history of local mining creates an ever-changing saga of the relationship and struggles between man and his surroundings."

—Sarah Ebright,
St. Elias Alpine Guides, 2016

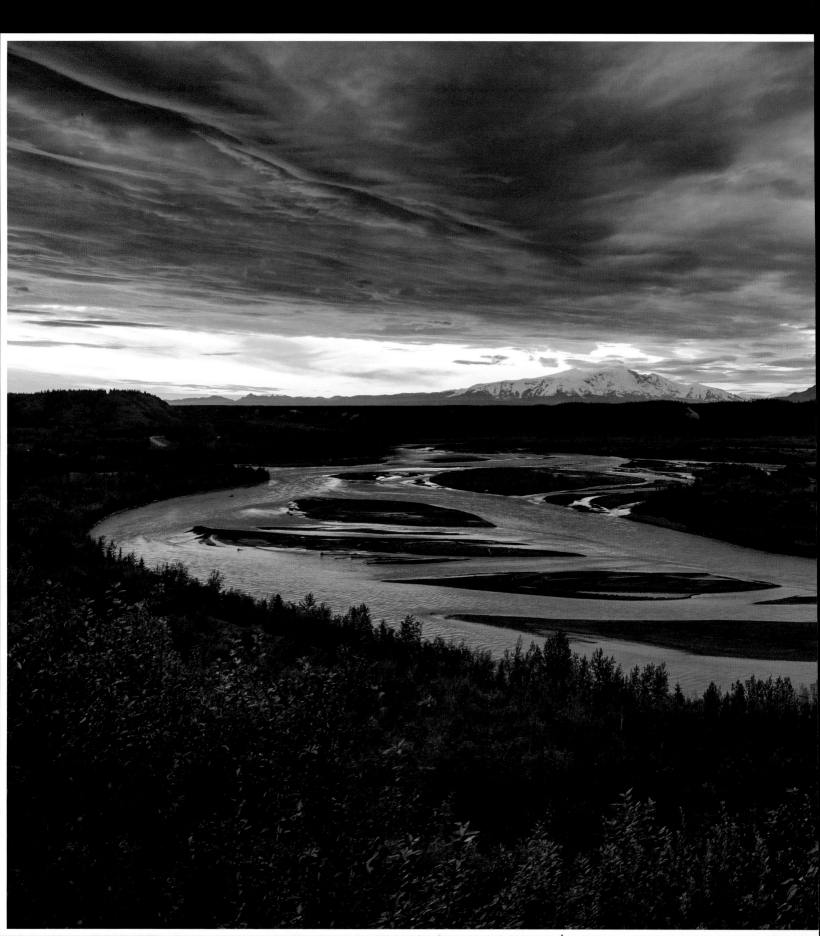

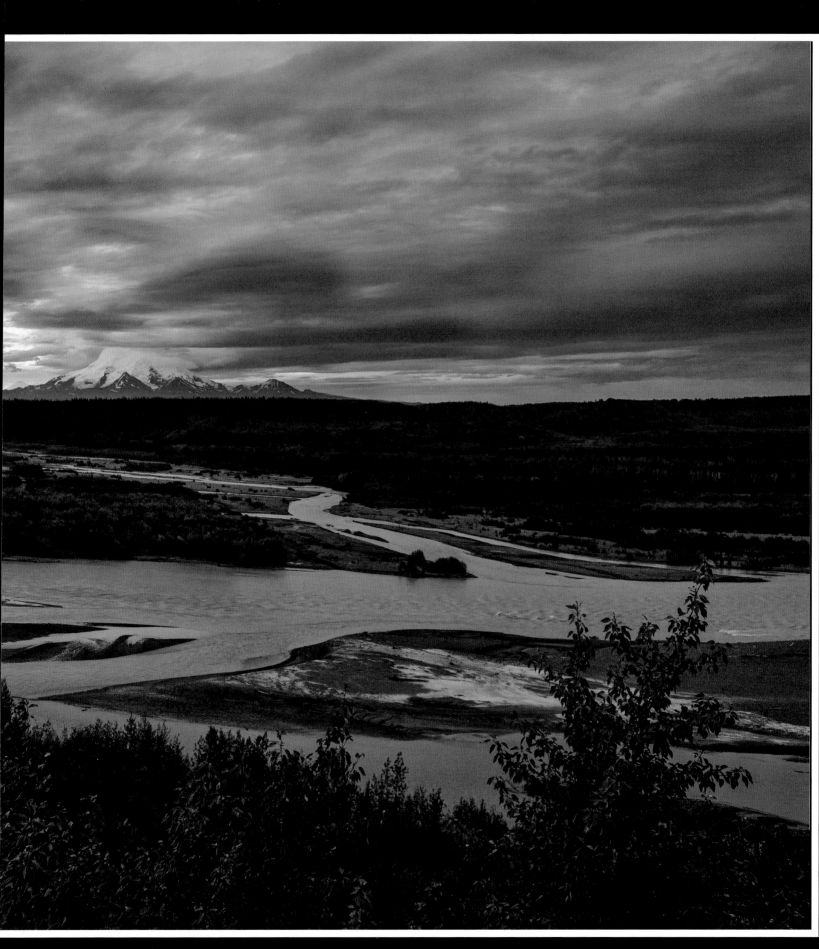

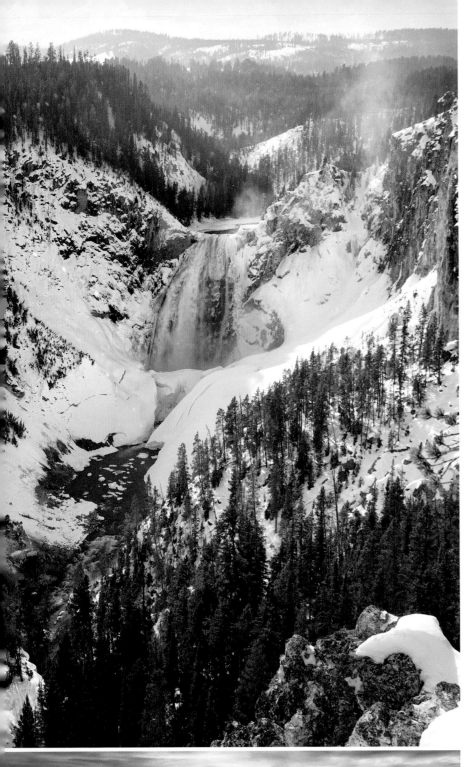

YELLOWSTONE
NATIONAL PARK
WYOMING MONTANA IDAHO

The Greatest Show on Earth

Geysers blow, waterfalls flow, wildlife roams—everywhere you turn, there is visible movement both above and from below. Mother Nature allows us to view this blockbuster in full-spectrum color. More monochromatic, though, is Yellowstone in winter when it is heavily laden with snow. It's quieter, and the wildlife have reclaimed their domain, unimpeded by the summer crowds. But no matter the season, this park is always a crowd-pleaser.

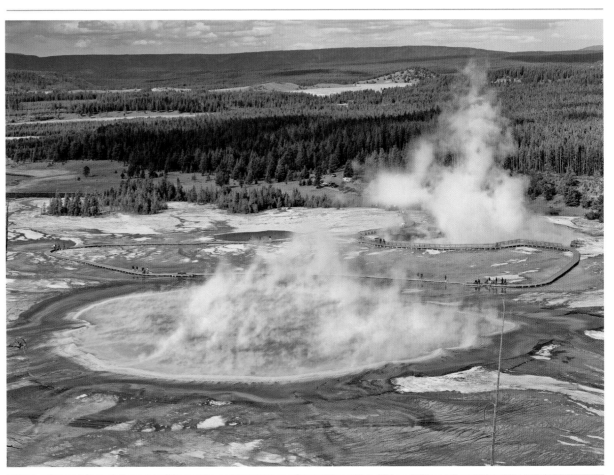

Location: Wyoming, Montana, Idaho
Nearest city: Gardiner
Coordinates: 44°25′40″N 110°35′18″W
Area: 2,219,791 acres (898,318 ha)
Established: March 1, 1872
Visitors in 2015: 4,097,710

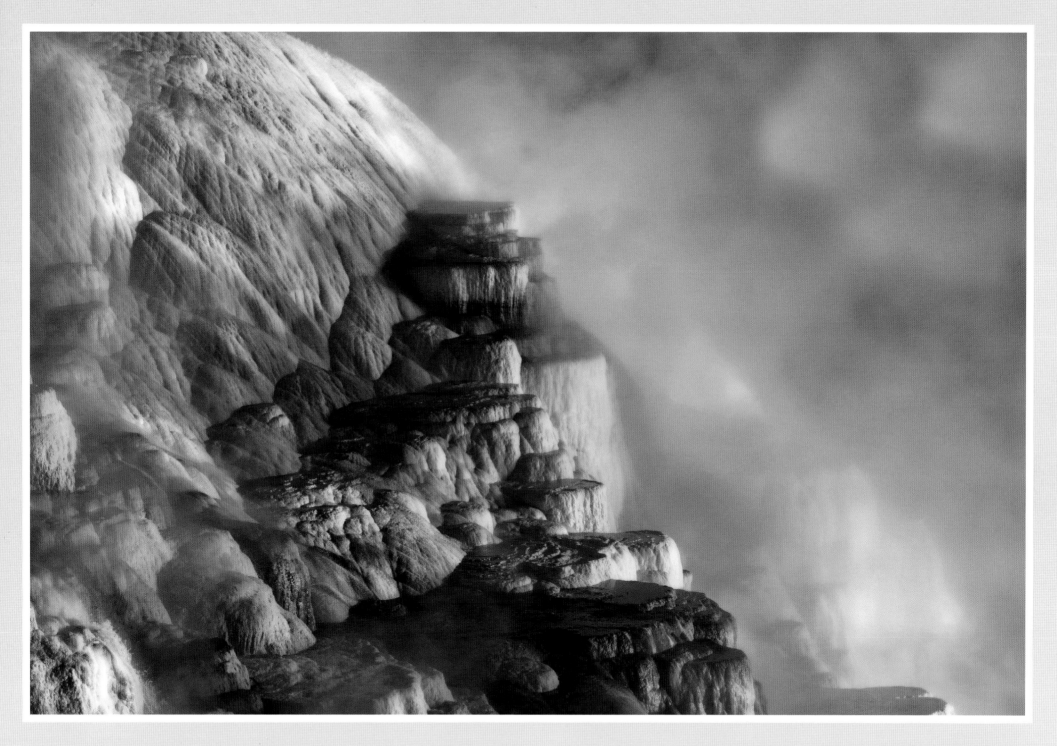

"'Wonderland.' That is how the Yellowstone region was first described in 1871. A place where the earth still exhibits its birthing pains, it is more whimsical than Lewis Carroll could have imagined. Nowhere else in the world can one experience more variety of creation—from wildlife, waterfalls, and mountains, to geothermal masterpieces. It is one of the most awe-inspiring places on earth. Know this when you come here: A bad day in the Park is better than a good day anywhere else."

—Bob Berry, Cody, 2016

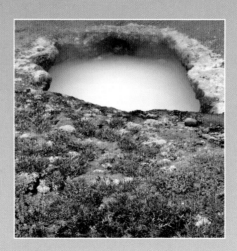
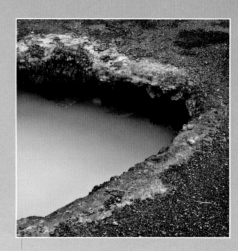

"There is something in the . . . scenery of this valley which I cannot describe . . . but can never efface from memory."
—*Osborne Russell*, Journal of a Trapper: Nine Years in the Rocky Mountains, 1834–1843

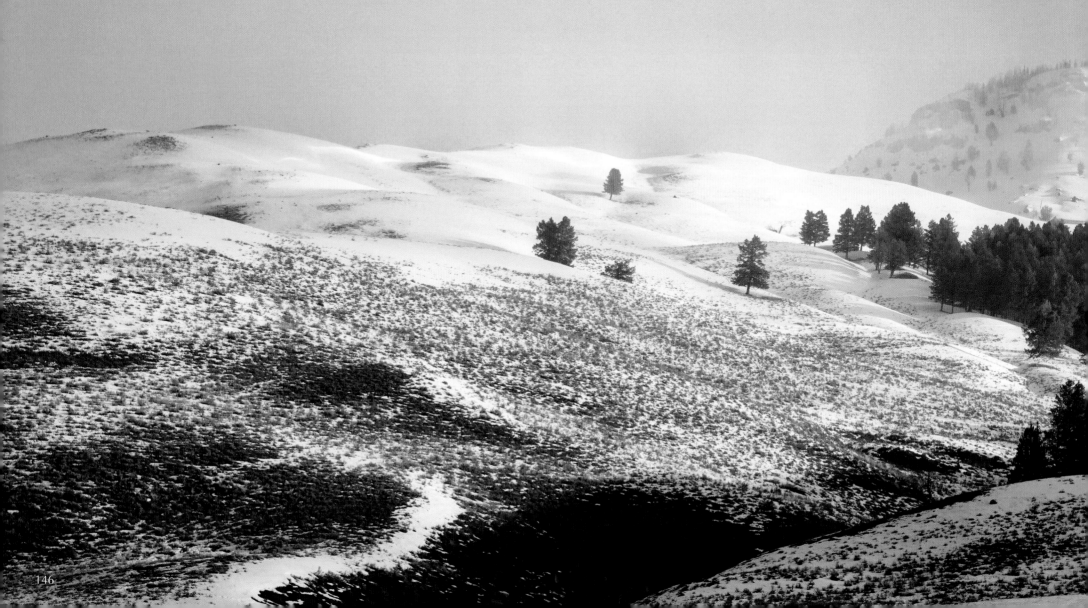

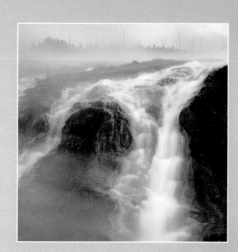

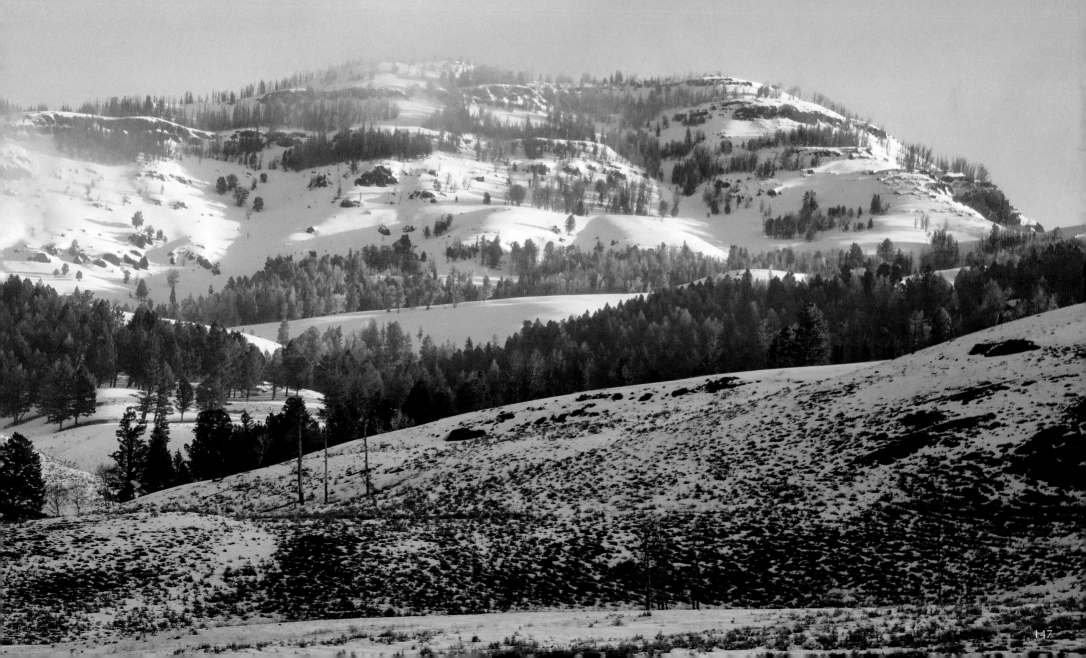

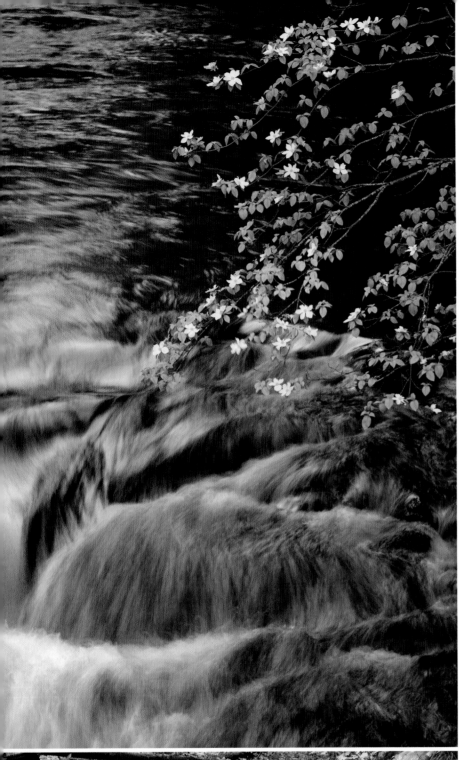

YOSEMITE
NATIONAL PARK

Endless Beauty

Yosemite boasts some of the most beautiful scenery on earth. The waterfalls, valleys, meadows and wilderness attract people like bees to a flower. Go beyond the valley into the High Sierra wilderness and find that the beauty continues, just in deeper isolation. El Capitan, the largest granite block in the world, and the 2,425-foot-high Yosemite Falls are two of the many highlights of the park. Though many have spoken of the wonders of Yosemite, this park speaks for itself.

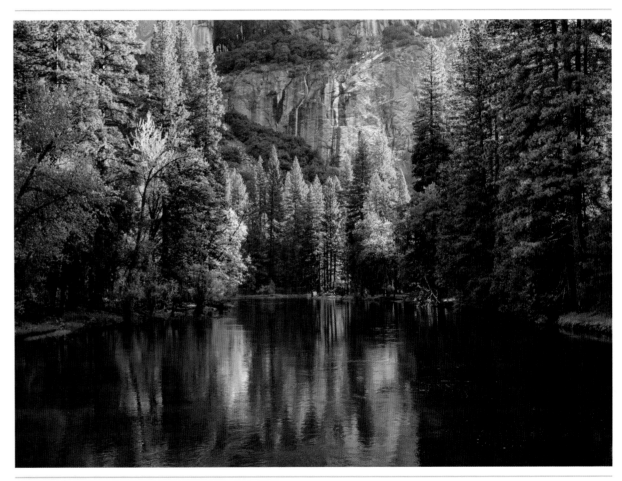

Location: California
Nearest city: Mariposa
Coordinates: 37°51′00″N 119°34′04″W
Area: 761,268 acres (308,074 ha)
Established: October 1, 1890
Visitors in 2015: 4,150,217

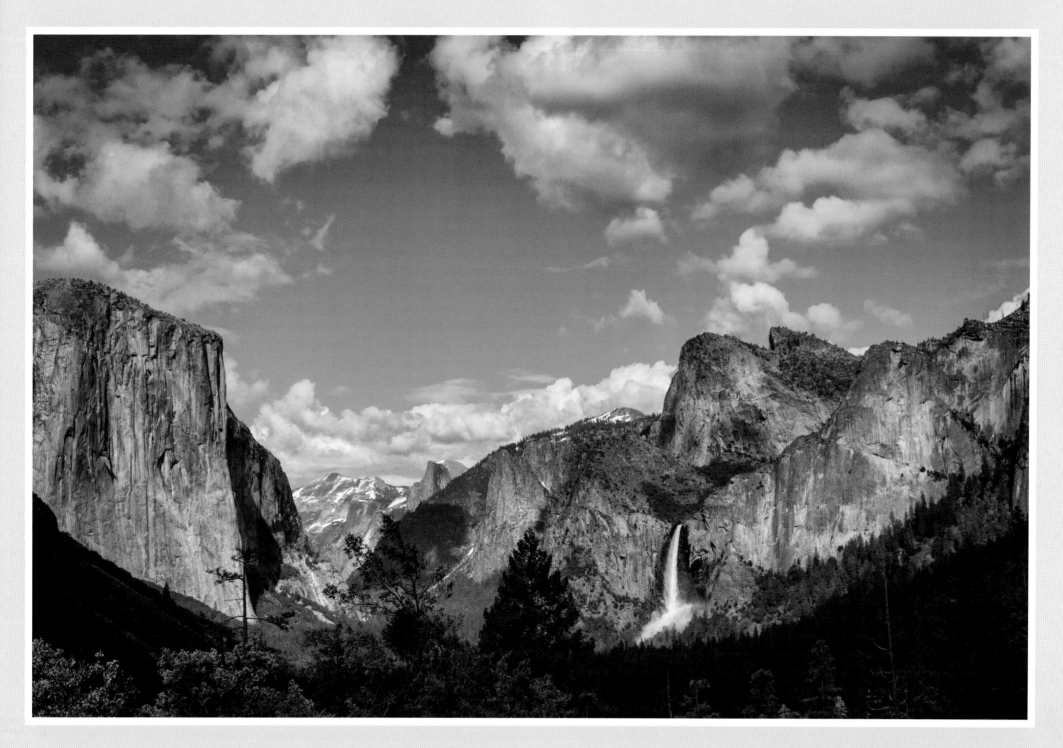

"Yosemite, oh where to begin. A core inspiration for naturalist John Muir. Home to some of the most impressive monoliths in the world—a palace formed of glacier and granite. Ansel Adams' first and everlasting love affair. An unutterably majestic gesture of Nature, yet at the same time a haven for solitude and reflection. No matter the poet, painter, photographer, there is no word or image that can convey the impact of experiencing the grandeur of this place. None of these can express the scale—its presence and nobility. "

—Alan Ross, Santa Fe, 2016

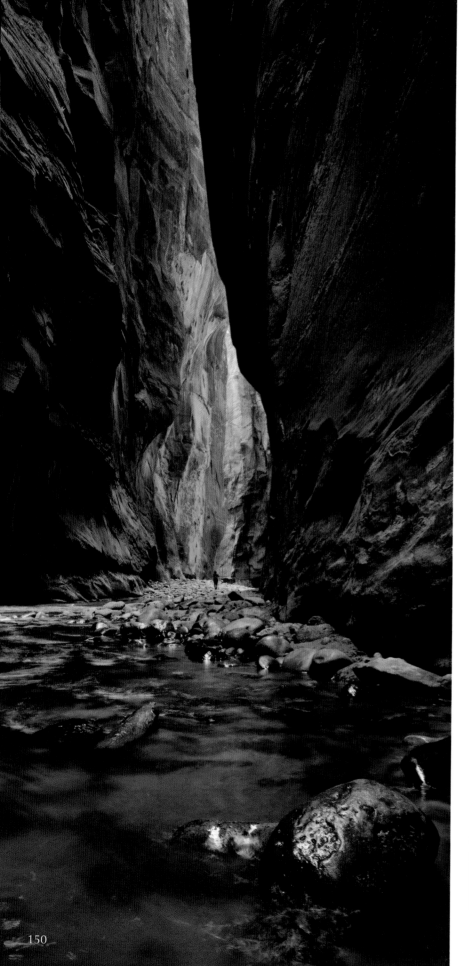

ZION
NATIONAL PARK

An Adventurer's Playground

Names like Angels Landing, the Three Patriarchs and Temple of Sinawava might make you curious. But Zion will take you beyond curiosity to adventure in this canyon, a sculpture formed by forces of nature. The stunning rock profiles, cliffs, buttresses and slot canyons could keep you coming back for a lifetime of visits.

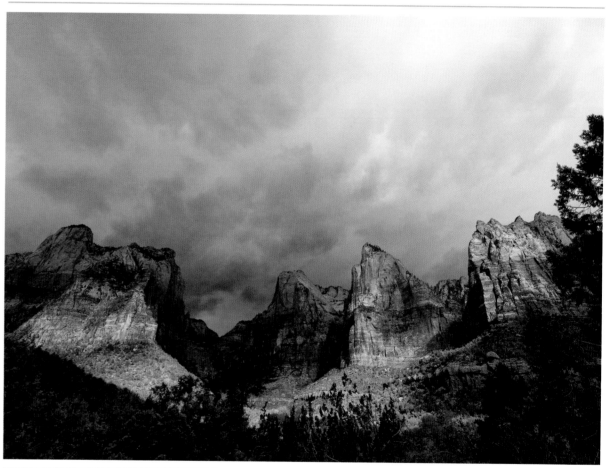

Location: Utah
Nearest city: Springdale
Coordinates: 37°12'09"N 112°59'16"W
Area: 146,597 acres (59,326 ha)
Established: November 19, 1919
Visitors in 2015: 3,648,846

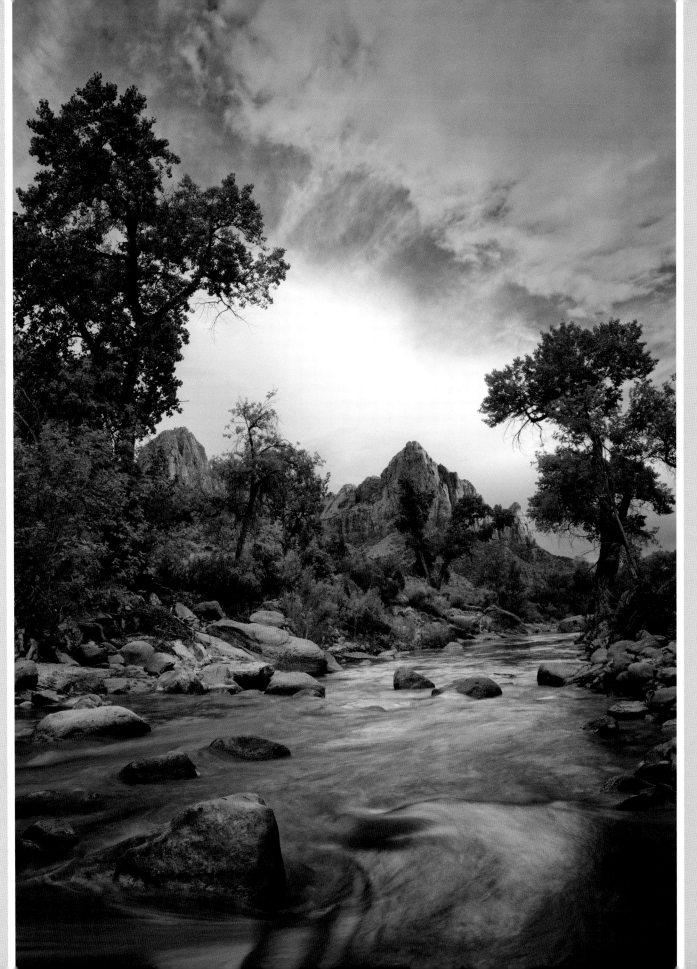

". . . nothing can exceed the wondrous beauty of Zion."

—Clarence E. Dutton, geologist, 1880

THE FORGOTTEN THREE

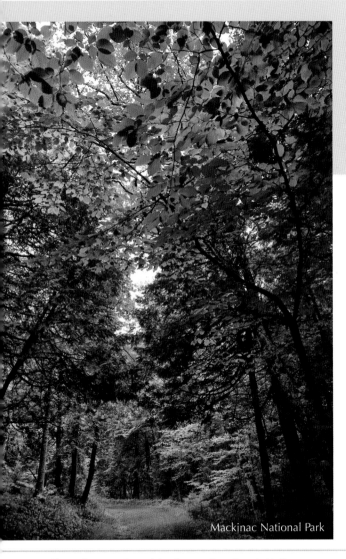

Mackinac National Park

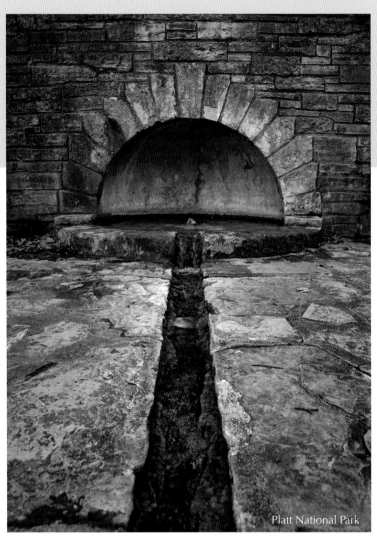

Platt National Park

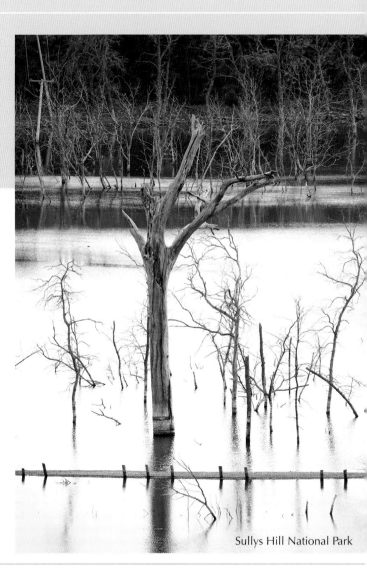

Sullys Hill National Park

Since the creation of the first national park, Yellowstone, in 1872, and the creation of the National Park Service in 1916, a number of parks have come and gone.

Five sites that were given the national park designation were later delisted. While two of these, Abraham Lincoln National Park and Fort McHenry National Park, were more closely related to the historical park classification, there were three parks that initially filled the criteria for a national park.

Only the second national park to receive the designation, in 1875, Mackinac National Park was handed over to the State of Michigan in 1895, and is now one of Michigan's most popular state parks.

Platt National Park in Oklahoma was originally established in 1902 as Sulphur Springs Reservation, becoming a national park in 1906, before being absorbed into the Chickasaw National Recreation Area in 1976. The former national parklands became the Platt Historical District.

Sullys Hill National Park, in North Dakota, was established by President Theodore Roosevelt in 1904 although it covers only 780 acres. In 1921 it was transferred to the Department of Agriculture as a big game preserve.

Though no longer meeting the criteria for national park status, these three parks deserve recognition as members of what is now commonly referred to as "America's Greatest Idea."

MACKINAC
NATIONAL PARK (1875–1895)

The Second National Park

With Yellowstone established as the first national park in 1872, the precedent was set to give the same designation to other significant landscape features. As a result, in 1875 Congress passed an act to make 80 percent of Mackinac Island in Lake Huron a national park, but responsibility for it was passed to the Secretary of War because of the army's presence at nearby Fort Mackinac. However, when the fort was decommissioned in 1895, title to the park was given to the state of Michigan.

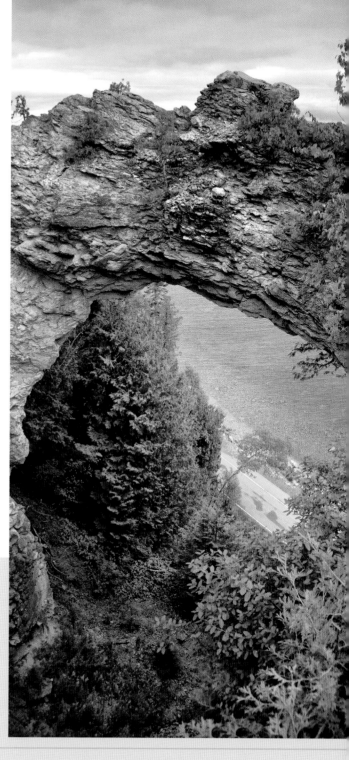

Location: Michigan
Nearest city: St. Ignace
Coordinates: 45°85′32″N 84°61′50″W
Area: 2,508 acres (1,015 ha)
Established: March 2, 1875
Visitors in 2014: 1,000,000 (approximate)

"The isle is full of noises, sounds and sweet airs that give delight and hurt not."

—William Shakespeare's words, etched in tile in the Mackinac Island library fireplace

PLATT
NATIONAL PARK (1906–1976)

A Long Evolution

In 1902 the federal government made a deal with the Chickasaw and Choctaw Nations of Oklahoma to purchase land on the Sulphur Springs Reservation to protect the unique freshwater and mineral springs along Travertine and Rock creeks. The new park was called Platt National Park, and in the 1930s the Civilian Conservation Corps built extensive camping infrastructure there. It was merged with the nearby Arbuckle Recreation Area in the 1970s and renamed the Chickasaw National Recreation Area.

"There's a charm here, where the western plains meet the wooded hills of the east. Quiet groves, paths, springs, and streams . . . an oasis in the prairie, where birds and small creatures live."

— Last Platt National Park brochure, 1967

Location: Oklahoma
Nearest city: Sulphur
Coordinates: 34°30'02"N 96°58'20"W
Area: 9,899 acres (4,006 ha)
Established: June 29, 1906
Visitors in 2015: 1,287,696

SULLYS HILL
NATIONAL PARK (1904–1921)

A Unique Community of Habitats

Although it is now known as Sullys Hill National Game Preserve, this North Dakota site was established first as a national park in 1904. In 1917 to 1918, it was restocked with elk, white-tailed deer and plains bison. It was then transferred to the Department of Agriculture in 1921 and designated as a big game preserve, refuge and breeding ground for animals and migratory birds. In 1940 the US Fish and Wildlife Service took on the management of the park's bison herd in an effort to conserve its genetic diversity.

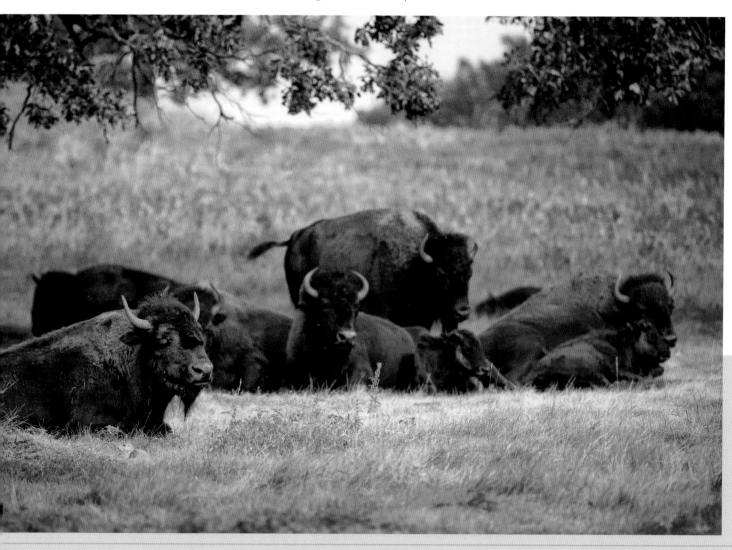

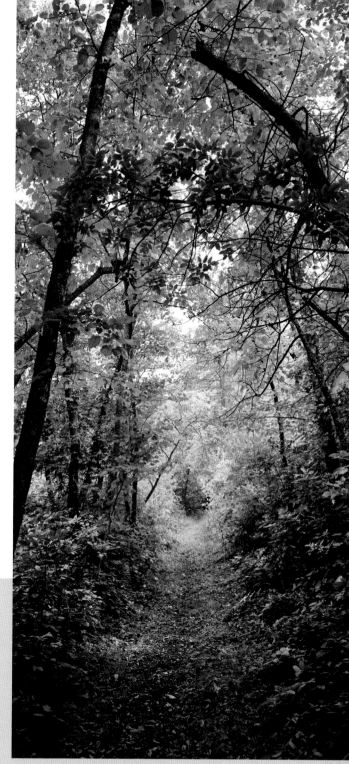

Location: North Dakota
Nearest city: Fort Totten
Coordinates: 47°98'62"N 98°97'48"W
Area: 1,674 acres (677 ha)
Established: April 27, 1904
Visitors in 2014: 60,000 (approximate)

"The wild things of this earth are not ours to do with as we please. They have been given to us in trust, and we must account for them to the generation which will come after us and audit our accounts."
—William Temple Hornaday, zoologist, conservationist and author

WILDLIFE
IN THE NATIONAL PARKS

As you make your way through any of the national parks, you will encounter wildlife; one without the other doesn't exist. A first sighting is likely to increase your pulse, start a rush of adrenaline and widen your eyes. Imagine a sunrise in the Tetons with a bull elk bugling in the distance, or encountering a black bear on your hiking trail. Share a sunrise on the beach of the Virgin Islands with white-tailed deer, or listen to the surreal sound of the coyotes howling at a full moon in the South Dakota Badlands. Watch a grizzly teaching her cubs to catch salmon in Katmai. Watch every step so as not to tread on a rattlesnake while hiking in Guadalupe. Find a scorpion beneath a small rock in

Death Valley. Spend an unscheduled hour up close with whales during a ferry crossing to the Channel Islands. You will find myriad possibilities for experiences with wildlife that you will never forget.

For all that you see, though, there will always be wildlife you still wish to encounter. You may still be hoping for your first wolf sighting in Yellowstone, or to find a tiny elf owl in its nest in a giant cactus in Saguaro. In the meantime, watching eagles soar over mountains, moose getting ready for the rut, or puffins floating atop the icy waves in the Alaskan waters will continue to thrill.

"Sam"—Kenai Fjords National Park, Alaska

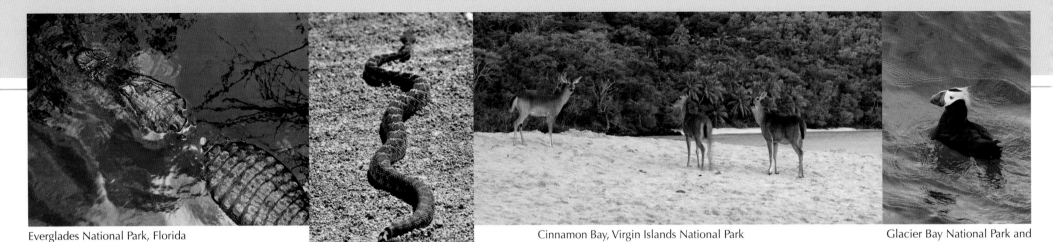

Everglades National Park, Florida

Saguaro National Park, Arizona

Cinnamon Bay, Virgin Islands National Park

Glacier Bay National Park and Preserve, Alaska

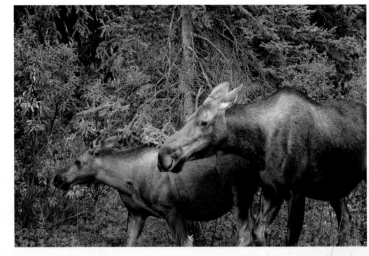

Denali National Park and Preserve, Alaska

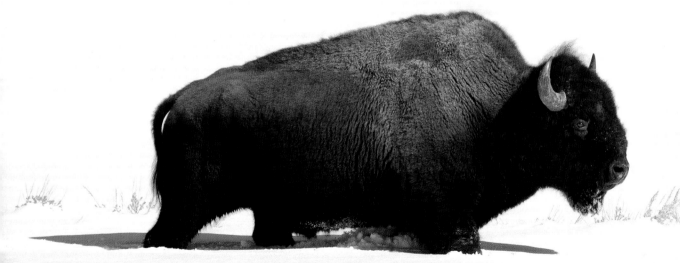

Yellowstone National Park, Wyoming

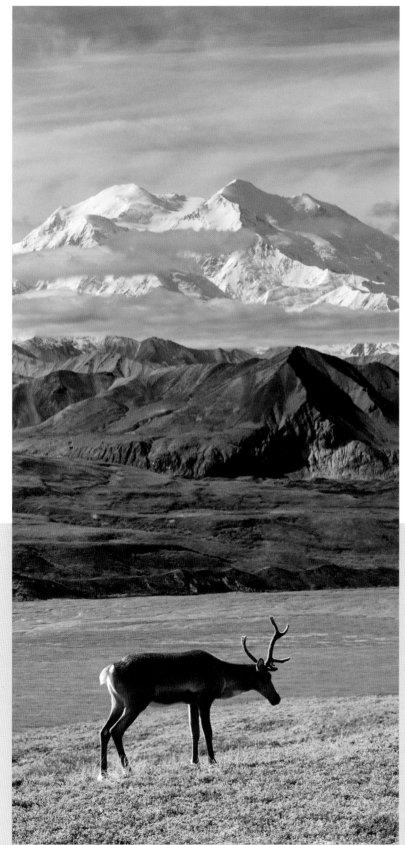

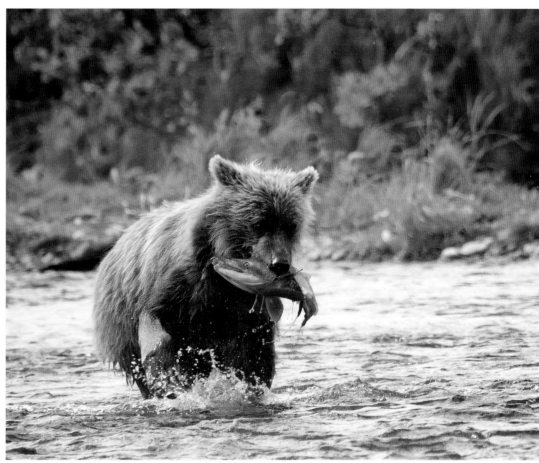

Katmai National Park and Preserve, Alaska

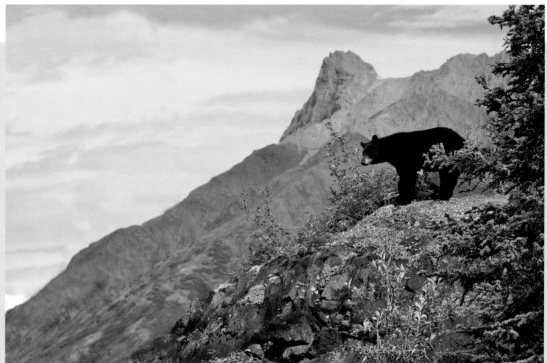

Denali National Park and Preserve, Alaska

Wrangell–St Elias National Park and Preserve, Alaska

WILDLIFE
IN THE NATIONAL PARKS

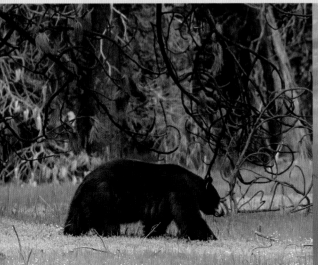

Yosemite National Park, California

Biscayne National Park, Florida

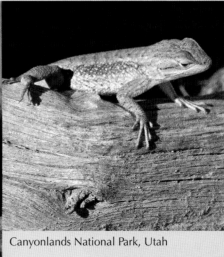

Canyonlands National Park, Utah

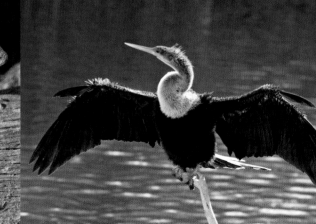

Everglades National Park, Florida

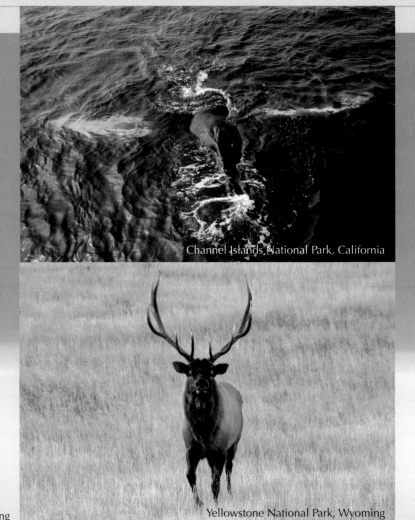

Channel Islands National Park, California

Yellowstone National Park, Wyoming

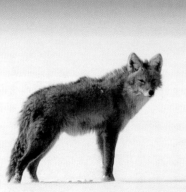

Yellowstone National Park, Wyoming

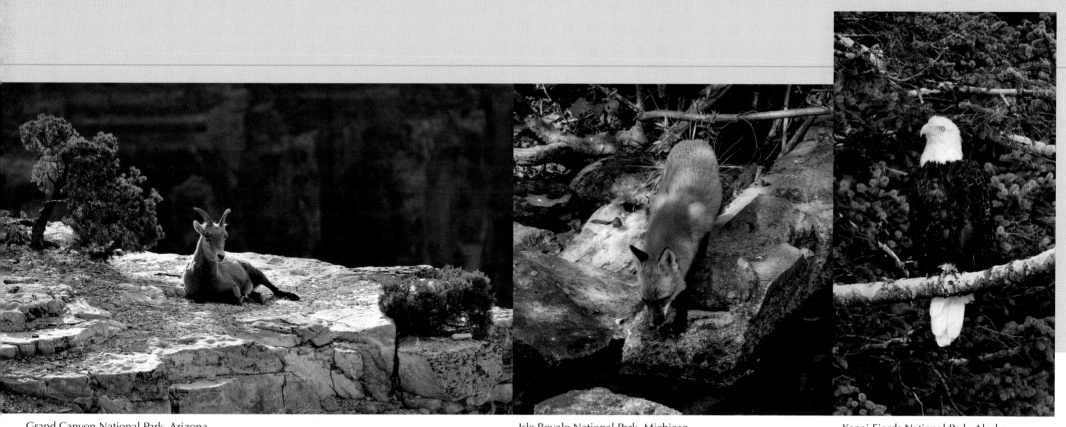

Grand Canyon National Park, Arizona

Isle Royale National Park, Michigan

Kenai Fjords National Park, Alaska

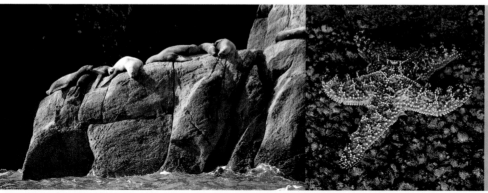

Kenai Fjords National Park, Alaska

Channel Islands National Park,
California

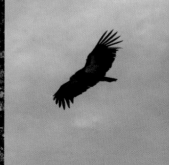

Pinnacles National Park,
California

Everglades National Park,
Florida

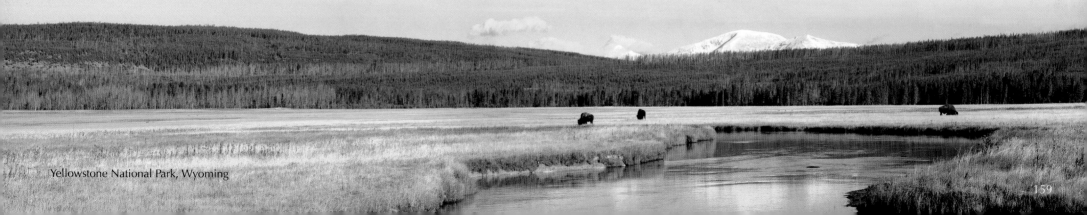

Yellowstone National Park, Wyoming

MORE THAN FIFTY-NINE:
OTHER UNITS OF THE NATIONAL PARK SYSTEM

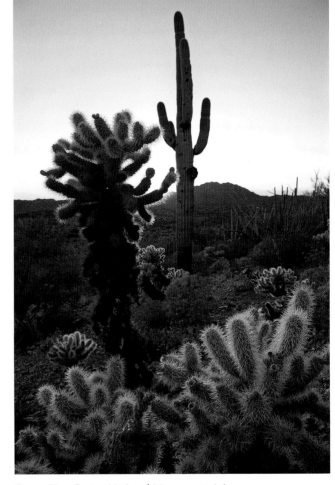

Natural Bridges National Monument, Utah

The US National Park Service is responsible for more than just the fifty-nine national parks, which preserve nationally and globally significant scenic areas and nature reserves.

As of 2016, the Service was responsible for the care and condition of 410 "National Park Units." A large number of these units were added to the Service's responsibilities in 1933 when President Franklin Roosevelt issued two executive orders to transfer the management of all the War Department's historic sites, the National Monuments that had been supervised by the Department of Agriculture, and all the parks in and around the Capital to the Parks Service. Over the years, the Parks Service also became responsible for such units as the National Recreation Areas, National Lakeshores, Marine Protected Areas, National Military Parks and National Parkways.

The Park Service's primary mission is to preserve unimpaired the natural and cultural resources and values of the National Park System for the enjoyment, education and inspiration of this and future generations. However, each type of "park unit" provides a different kind of challenge for the Service. Each National Monument, for example, preserves a single unique cultural or natural feature whereas a National Parkway means the management of miles of roadway.

The Park Service also cooperates with partners to extend the benefits of natural and cultural resource conservation and outdoor recreation throughout the United States and the world.

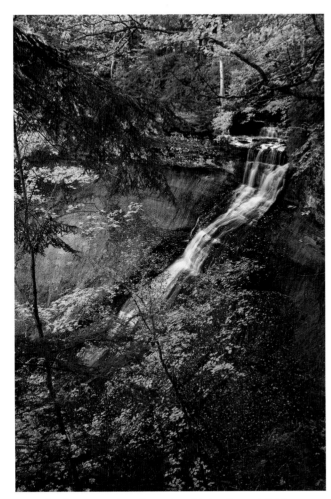

Chapel Falls, Pictured Rocks National Lake Shore, Michigan

Chaco Culture National Historical Park, New Mexico

Organ Pipe Cactus National Monument, Arizona

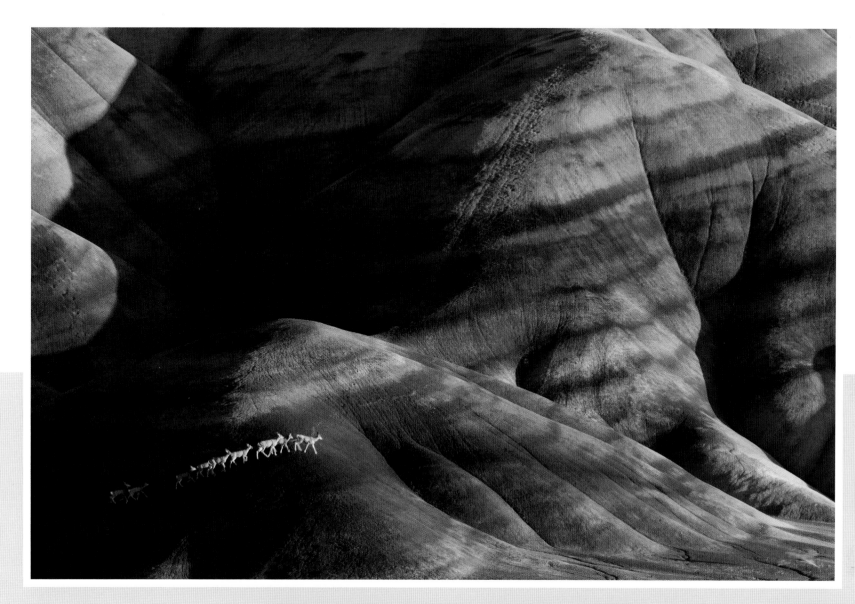

The Painted Hills, John Day Fossil Beds National Monument, Oregon

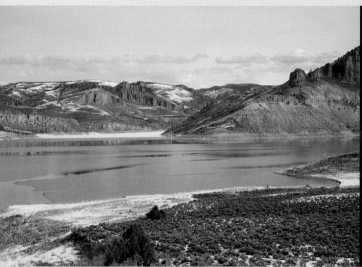

Curecanti National Recreation Area, Colorado

Mount Rushmore National Memorial, South Dakota

Gettysburg National Military Park, Pennsylvania

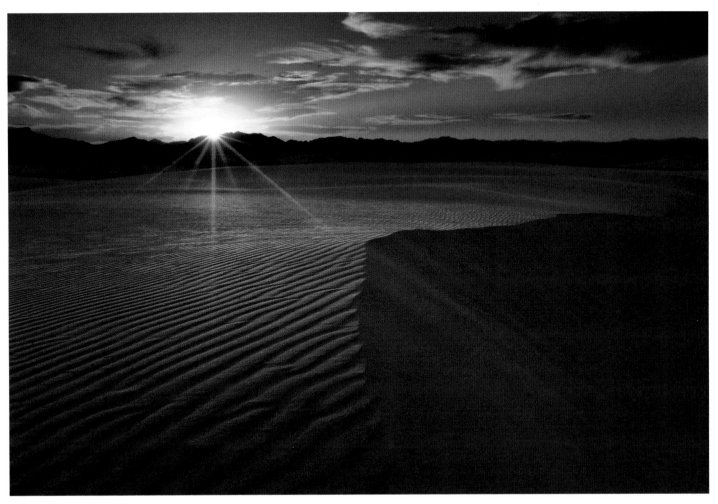

White Sands National Monument, New Mexico

Organ Pipe Cactus National Monument, Arizona

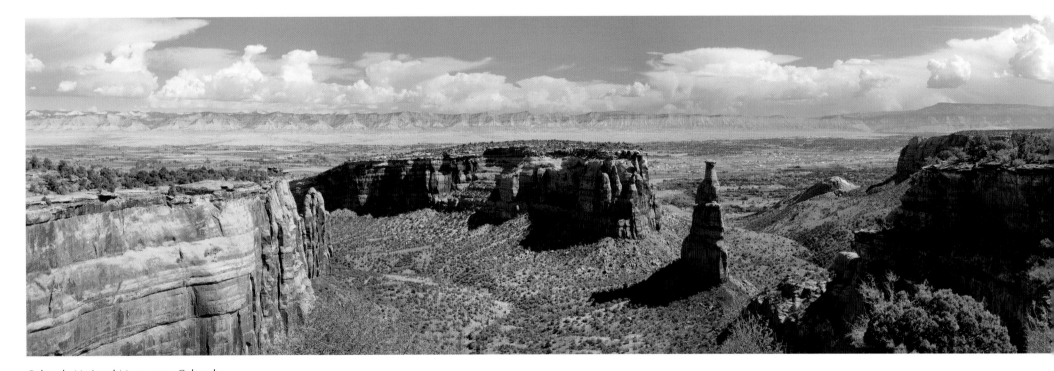

Colorado National Monument, Colorado

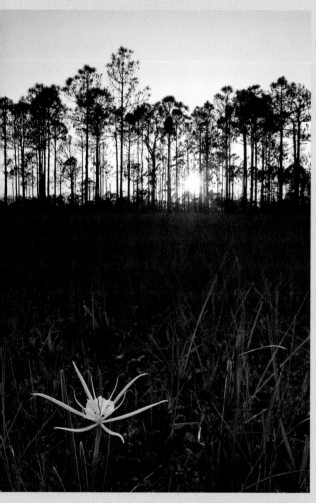

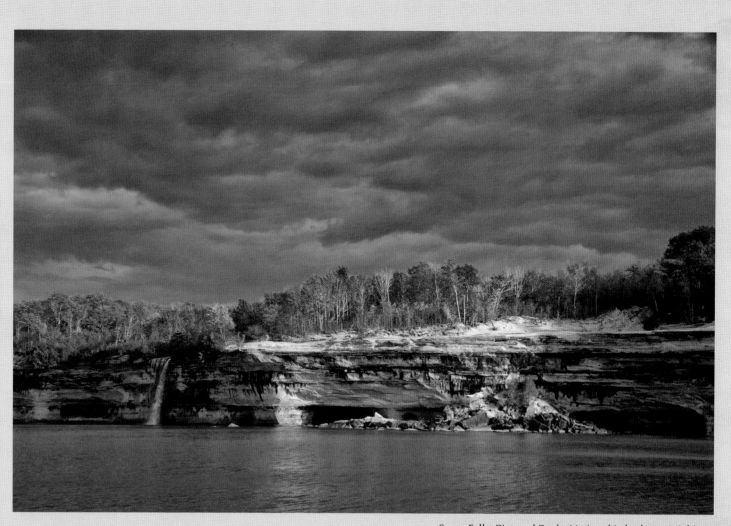

Big Cypress National Preserve, Florida

Spray Falls, Pictured Rocks National Lakeshore, Michigan

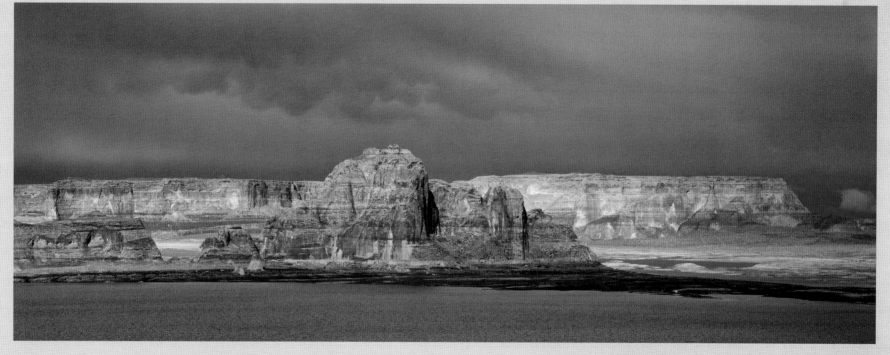

Glen Canyon National Recreation Area, Utah/Arizona

THE IMAGES

ACADIA
Gorge Trail Falls in the Fall
Hemlock Brook Bridge
Sunrise at Boulder Beach and the Otter Cliffs
Visits: 1
Time of year: September/October

ARCHES
Turret Arch Reflection
Delicate Arch
The Petrified Dunes and La Sal Mountains
Landscape Arch at Sunrise
Visits: 2
Time of year: September and March

BADLANDS
Conata Basin
Early Morning at Sage Creek Basin
The Sun Sets at Hay Butte Overlook
Badlands Wilderness Overlook
Visits: 2
Time of year: August and September

BIG BEND
Morning Light at Santa Elena Canyon
Message in the Sky at the Chisos Mountains
Lost Mine Trail
End of the Day at Cerro Castellan Peak
Visits: 1
Time of year: April

BISCAYNE
Shoreline Mangroves Morning
Elliott Island
Sunrise along the Channel, Biscayne Bay
Another Day Dawns at Biscayne Bay
Visits: 1
Time of year: April

BLACK CANYON OF THE GUNNISON
Winter from Pulpit Rock, South Rim
Cross Fissures, South Rim
The Gunnison River at Sunset, South Rim
Visits: 2
Time of year: March and September

BRYCE
Spectacular Sunrise Point
Carpet of Snow, Queens Garden Trail
Morning Light, Navajo Loop Trail
Day's End Drama at Sunset Point
Visits: 4
Time of year: May, September, December

CANYONLANDS
Icicles at Neck Spring Trail
Mesa Arch Morning
Layers of the Land
Moon at Sunrise, Grand View Point Overlook
Panorama: Green River Overlook
Visits: 2
Time of year: March and September

CAPITOL REEF
The Castle at Sunset
Fremont River Falls
Hickman Bridge
Sunrise at Panorama Point
Visits: 3
Time of year: March and September

CARLSBAD CAVERNS
On Show at the Chinese Theater
Reflecting Pool
The Giant and Twin Domes
Visits: 1
Time of year: May

CHANNEL ISLANDS
Morning Mist, Scorpion Anchorage
South Coast Kayaking, Santa Cruz Island
North Bluff Trail, Santa Cruz Island
Incoming Mist, Santa Cruz Island
Visits: 1
Time of year: May

CONGAREE
Gap in the Trees at Cedar Creek
A Touch of Color at Weston Lake
Bald Cypress
The Calm—Weston Lake
Visits: 1
Time of year: September

CRATER LAKE
Watchman Overlook
Last Light across the Shore
Wizard Island Winter
Sunrise, Sinnott Memorial Overlook
Panorama: Winter Wonderland
Visits: 2
Time of year: May and September

CUYAHOGA VALLEY
The Ledges
Blue Hen Falls
Towpath Trail in the Fall
Downstream from the Blue Hen Falls
 on Spring Creek
Visits: 1
Time of year: September

DEATH VALLEY
The Colors of the Valley
Cracked and Smooth
Under the Clouds, Dantes Peak
Mesquite Dunes after the Storm
Visits: 3
Time of year: May and December

DENALI
Mountain Colors
Morning Moose
McKinley Bar Trail
The Long Road from Eielson Outlook
Panorama: Mt. Denali, 20,310 feet
Visits: 1
Time of year: August

DRY TORTUGAS
Antique Moorings
Below the Surface
Early Morning at the Fort
Fort Jefferson Reflection
Visits: 1
Time of year: April

EVERGLADES
Spanish Moss
Anhinga Silhouette at Sunset
Mangroves at Sunset on Anhinga Trail
Pine Trees Horizon at Sunset
Visits: 1
Time of year: April

GATES OF THE ARCTIC
Takahula Lake
Falls Colors across the Alatna River Valley
Circle Lake Peaks
Arrigetch Peaks
Visits: 1
Time of year: August

GLACIER
Golden Cascades on McDonald Creek
A Touch of Fall on Lake McDonald
Hidden Lake
Sprague Creek Cascades
Visits: 1
Time of year: September

GLACIER BAY
Serene Seals at Johns Hopkins Glacier
Bartlett River Starfish
Venturing into Tidal Inlet
Mt. Orville, Fairweather Range, above the
 Johns Hopkins Glacier
Visits: 1
Time of year: August

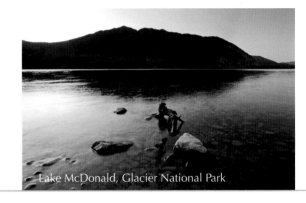
Lake McDonald, Glacier National Park

GRAND CANYON
Layers at Mather Point at Sunrise
Canyon Rainbow in Winter
Shoshone Point Sunset
Winter Light from Hopi Point
Panorama: Winter Light
Visits: 4
Time of year: March, Sept, December

GRAND TETON
Hidden Falls on Cascade Creek
The Tetons above Jenny Lake
Signal Mountain Sunset
Elk Crossing the Snake River
Panorama: Ox Bow Bend Morning
Visits: 3
Time of year: August, September

GREAT BASIN
Lehmann Caves
Morning View, Mather Overlook
Baker Creek Cascades
Wheelers Peak above the Bristlecones
Visits: 2
Time of year: May and September

GREAT SAND DUNES
Sand and Snow
Dunes and Sangre De Cristo Mountains
Winter Colors Along Medano Creek
Medano Creek Squall
Visits: 2
Time of year: March and May

GREAT SMOKY MOUNTAINS
Fall Colors along the Abrams Creek Trail
Clingman's Dome Layers
The Old Grist Mill, Cades Cove
Blue Ridge View
Visits: 1
Time of year: October

GUADALUPE MOUNTAINS
El Capitan from Guadalupe Peak Trail
Sunrise Silhouette
Salt Basin Dunes
Storm Brewing, Guadalupe Peak
Visits: 2
Time of year: March and September

HALEAKALA
Cinder Cone inside Haleakala Crater
The Bamboo Forest, Kipahulu
Seven Sacred Pools, Kipahulu
Along the Sliding Sands Trail
Visits: 1
Time of year: March

HAWAI'I VOLCANOES
Hardened Lava Flow, Chain of Craters Road
Nahuku Thurston Lava Tube
Sea Cliff Lava Flow at dawn
Kilauea Crater Brewing
Visits: 1
Time of year: March

HOT SPRINGS
Mens Bath Hall, Fordyce Bath House
West Mountain Scenic Drive
Hot Spring over Tufa
Bath House Row
Visits: 1
Time of year: October

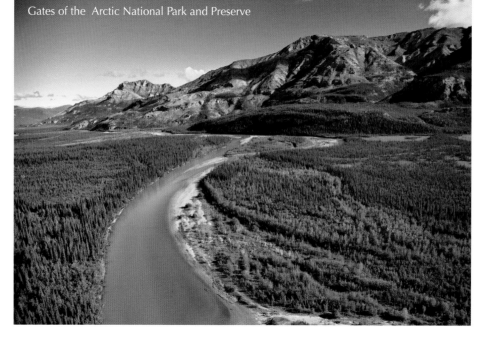

Gates of the Arctic National Park and Preserve

ISLE ROYALE
Washington Harbor Sunrise
Shoreline Rocks
Huginin Cove, North Shore
Island Sunset across Lake Superior
Visits: 1
Time of year: September

JOSHUA TREE
Arch Rock
Cholla Cactus Garden
Joshua Tress Reaching for the Sky
Visits: 2
Time of year: March and May

KATMAI
Across the Tundra
Mt. Martin Murmuring
Novarupta Crater, Valley of 10,000 Smokes
Visits: 1
Time of year: August

KENAI FJORDS
Northwestern Glacier
Along the Harding Icefield Trail
Harris Bay, Northwestern Fjord
Panorama: Atop the Harding Icefield
Visits: 1
Time of year: August

KINGS CANYON
Roaring Falls
Along the Kings Canyon Scenic Byway
Road's End
Misty Morn at Grants Grove
Visits: 1
Time of year: May

KOBUK VALLEY
Flying into the Park
Brewing Storm, Kobuk River
Mouth of the Kavett Creek
Great Sand Dunes View
Valley View towards Small Dunes
Visits: 1
Time of year: August

LAKE CLARK
Lake Clark Pass
Port Alsworth Sunrise
Turquoise Waters, Lake Clark
Changing Colors at Twin Lakes
Panorama: Tanalian Falls at Dusk
Visits: 1
Time of year: August

LASSEN VOLCANIC
Kings Creek Falls
Sulphur Works Winter Landscape
The Painted Dunes
Visits: 2
Time of year: May and September

MAMMOTH CAVE
Frozen Niagara
Stalagtites and Stalagmites
Green River Sunrise
Looking Up
Visits: 1
Time of year: October

MESA VERDE
Winter Moonrise at Mesa Verde
North Rim Cliffs
Cliff Top Palace
Visits: 2
Time of year: March and September

MT RAINIER
Christine Falls
Lenticular Clouds at Sunrise
Spruce Trees and Fall Color from Sunrise
Mirror Lake Morning
Visits: 1
Time of year: October

NATIONAL PARK OF AMERICAN SAMOA
Above and Below, Ofu Beach
Sunset, Ofu Island
Pola Point, Tutuila Island
Ofu Island Drama
Visits: 1
Time of year: March

NORTH CASCADES
Turquoise Waters, Diablo Lake
Newhalem Creek Cascades
Hidden Lake
Mt. Shuksan Reflection
Visits: 1
Time of year: September

THE IMAGES

OLYMPIC
Hoh Rainforest
Tumwata Creek Cascades
Winter View, Hurricane Drive
Second Beach Sunset
Visits: 2
Time of year: May and October

PETRIFIED FOREST
Broken Logs of Petrified Wood
Petrified Log Close Up
Painted Desert at Sunset
Visits: 1
Time of year: March

PINNACLES
High Peaks Trail
Pinnacles from East Side
Bear Gulch Cave
Early Morning, Bench Trail Peaks View
Visits: 1
Time of year: March

REDWOOD
Redwood Trees
Early Spring Color
Wilson Creek Beach
Misty Morning Magic
Visits: 2
Time of year: May

ROCKY MOUNTAINS
River View
Many Parks Curve at Sunset
Stormy Sky, Bear Lake Trail
Sprague Lake Sunrise
Visits: 1
Time of year: May

SAGUARO
Sunset Saguaros
Valley View Overlook
Petroglyphs
Afternoon Glow
Visits: 2
Time of year: May and September

SEQUOIA
Reaching for the Sky
Crystal Cave
Afternoon Light, Generals Highway
Moro Rock Farewell
Panorama: Twin Windows from Moro Rock
Visits: 1
Time of year: May

SHENANDOAH
Dark Hollow Falls
Sunrise, Shenandoah Valley Overlook
Fall Color Cascades
Morning along Skyline Drive in the Fall
Visits: 1
Time of year: October

THEODORE ROOSEVELT
Badlands Dusk, South Unit
Bison Viewpoint, South Unit
Little Missouri River, North Unit
Painted Canyon Morning, South Unit
Visits: 2
Time of year: August and October

VIRGIN ISLANDS
Catherineberg Sugar Mill Ruins
Shoreline Rocks, Cinnamon Bay
Blue Waters, Maho Bay
Cinnamon Bay Sunset
Visits: 1
Time of year: April

VOYAGEURS
Fall Colors, Blind Ash Bay Trail
Sunset on Kabetogama Lake
Moonrise Across the Waters
Sunrise Rocks, Kabetogama Lake
Visits: 2
Time of year: September and October

WIND CAVE
Popcorn Cave Formations
Wind Cave Canyon Trail
Box Work Formations
Bison Flats Prairie
Visits: 2
Time of year: August and September

WRANGELL—ST ELIAS
Nizina Glacier Aerial
Slana Morning, Nabesna Road
Root Glacier Cascades
Wrangell Mountains
Panorama: Sunrise View from Gakona
 Overlook towards Mt. Sandford and
 Mt. Drum
Visits: 1
Time of year: August

YELLOWSTONE
Winter, Lower Falls, Grand Canyon of
 the Yellowstone
Great Fountain Geyser
Grand Prismatic Spring
Canary Springs, Mammoth Terraces
Panorama: Lamar Valley
Visits: 4
Time of year: February, September
 and October

YOSEMITE
Dogwoods over the Merced River from
 the Pohono Bridge
Fern Spring
Merced River Reflection
Tunnel View Rainbow
Visits: 2
Time of year: May

ZION
Virgin River Narrows
Court of the Partiarchs
The Watchman and the Virgin River
Visits: 4
Time of year: May, August, September,
 and December

MACKINAC
Fort Mackinac
Arch Rock
Visits: 1
Time of year: August

PLATT
Travertine Creek Cascade
Lincoln Bridge
Visits: 1
Time of year: March

SULLYS HILL
North American Bison Herd
Along the Nature Trail
Visits: 1
Time of year: August

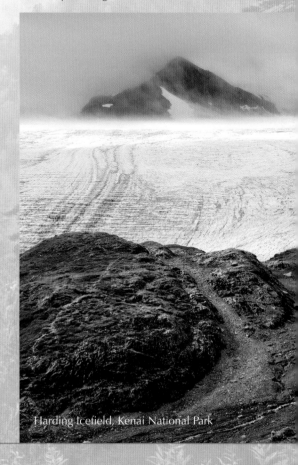
Harding Icefield, Kenai National Park

ACKNOWLEDGEMENTS

Planning and following our quest to visit the fifty-nine national parks (and more) has easily been the highlight of our lives. While our travels were always launched from home in Australia, it never felt overwhelming or too difficult. Doors opened when needed, and along with our passion and excitement, we were constantly fueled to continue the quest. Our gratitude goes out to all involved, past and present, in creating, preserving and protecting these beautiful and inspiring areas—the national parks of America.

Our travels would not have been so special without the people who supported us in so many different ways. As foreigners to the USA, we have been welcomed with open arms on every visit. We have experienced gracious hospitality and made many friends while immersing ourselves in this surprisingly wonderful and diverse land.

To Bob and Robin Berry, Mario and Michelle Bernheim, our gratitude always for helping make our trips more comfortable and memorable on numerous occasions.

A special thanks to all the local photographers who kindly gave their time in showing us their backyards.

To all who contributed their time and personal views to the quotes.

To those who have made our hiking and camping experiences more fun and memorable.

To family and friends who have supported us and listened to our travel tales time and time again.

A special thanks to the following:

Dennis and Chris Happel, Chuck Johnson, Stephen, Jennifer and Bayden Armstrong, Sally Smith, Janet Low, Meg Barry, Sharron and Jerry Dickman, John and Terry Binkele, Katie and Rich Campbell, Dennis and Sue, Myles and Marilyn, Terry and Marilyn Dolle, David Patterson, Rick Schump, Rory and Loli West, Oggie Olson, Pam and Greg Lockhart, Ricke and Mary Swaime, Bonnie and Leroy White, Butch and June Moore, Michael and Michelle Teasdale, Phil and Sandy Charles, Michael Comerford, Dan and Sharon Bullene, Susan Larsen, Leslie and Ron Passons, Bill and Kathy Lynn, Ann and Doug Markward— and to the many others we have been lucky enough to share tales and trails with.

Finally, a big thank you to my Mum, Pat, who unknowingly allowed us to finish our quest deep into Alaska.

Individual parks text written by Debbie Smith.

Book design by Andrew Thomas.

Sources: National Park Service

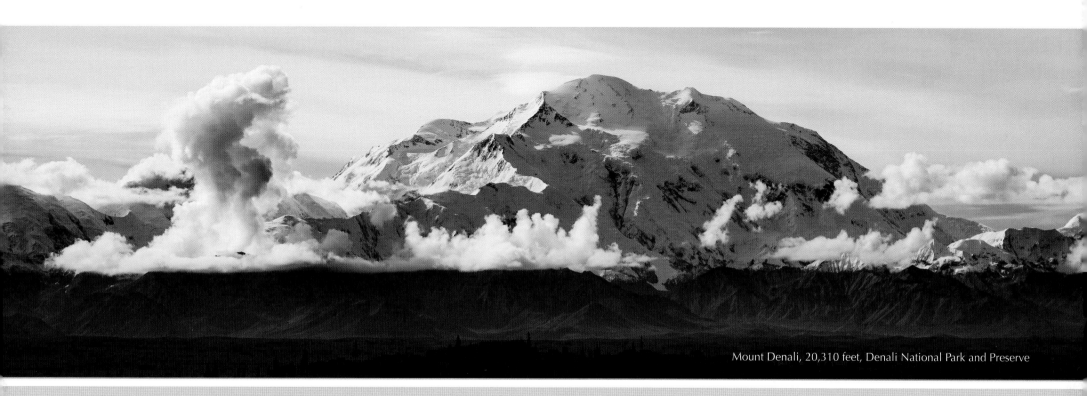

Mount Denali, 20,310 feet, Denali National Park and Preserve

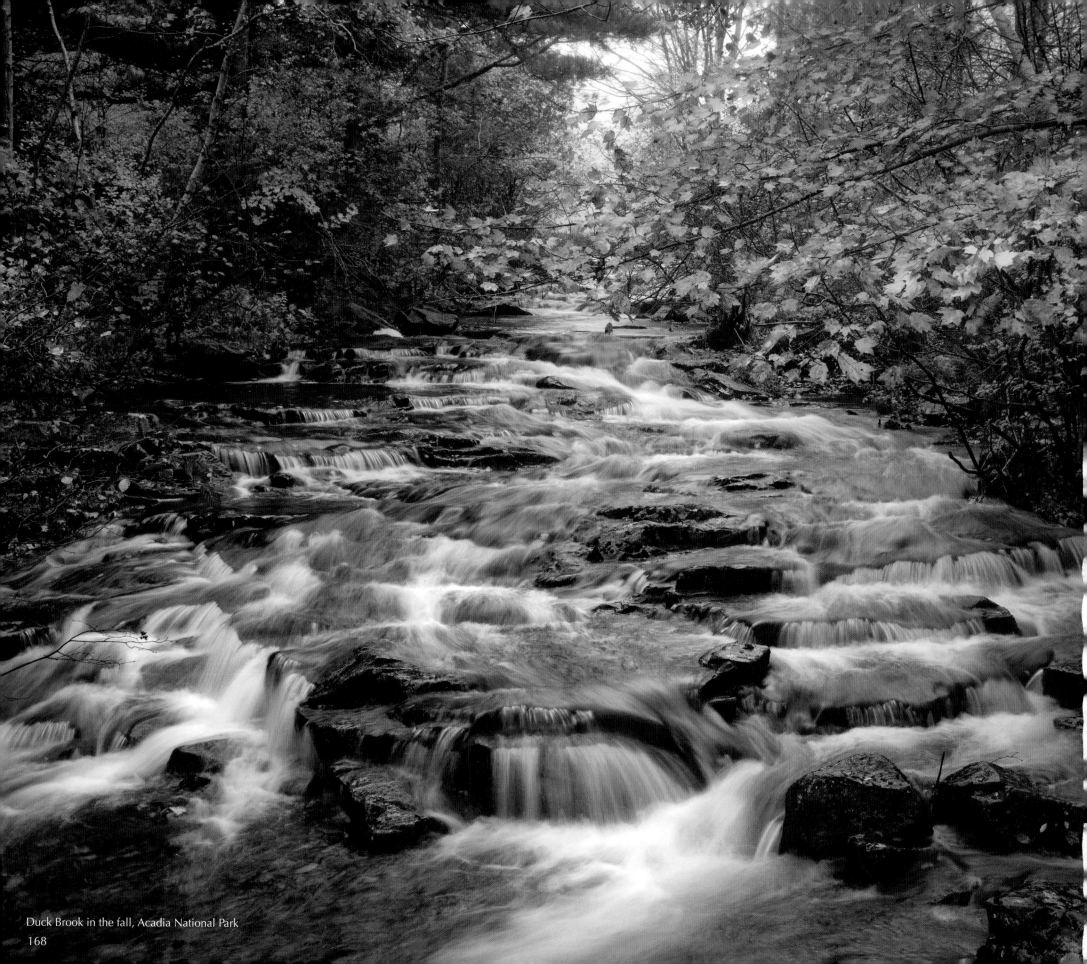

Duck Brook in the fall, Acadia National Park